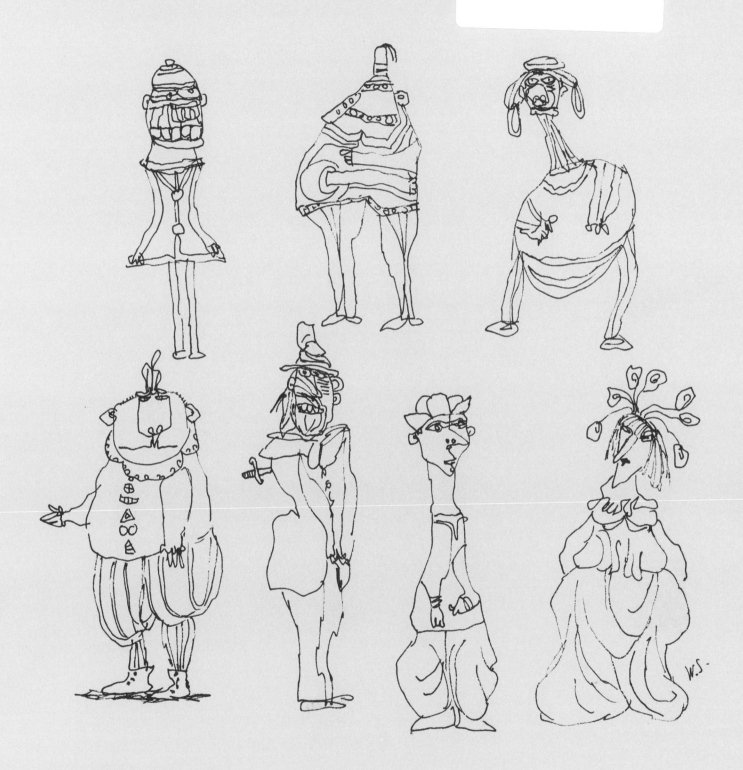

The Art of
William Steig

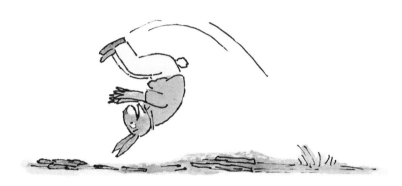

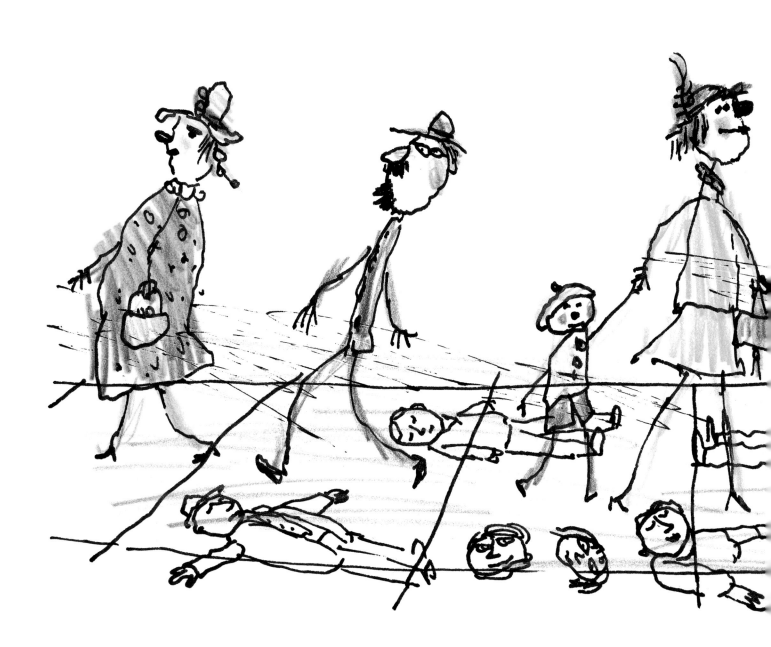

The Art of
William Steig

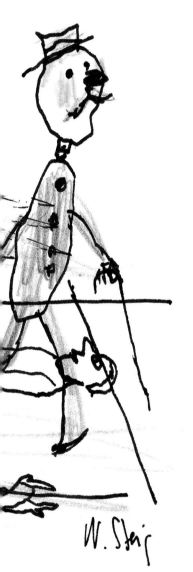

Claudia J. Nahson

Foreword by

Maurice Sendak

With contributions by

Robert Cottingham

Edward Sorel

Jeanne Steig

Maggie Steig

The Jewish Museum, New York
Under the auspices of the Jewish Theological Seminary of America

Yale University Press
New Haven and London

This book has been published in conjunction with the exhibition *From The New Yorker to Shrek: The Art of William Steig* organized by The Jewish Museum and presented from November 4, 2007, to March 16, 2008.

The Jewish Museum
Exhibition Curator: Claudia J. Nahson
Manager of Curatorial Publications: Michael Sittenfeld
Curatorial Program Coordinator: Phyllis Handler
Manuscript Editor: Stephanie Emerson
Exhibition Design: Dan Kershaw and Kris Stone
Exhibition Graphic Design: Katy Homans

Yale University Press
Publisher, Art and Architecture: Patricia Fidler
Editor, Art and Architecture: Michelle Komie
Manuscript Editor: Heidi Downey
Production Manager: Mary Mayer
Photo Editor and Assistant Production Coordinator: John Long

Designed and typeset in Century by Katy Homans, New York
Printed in Singapore by CS Graphics

All new photography of William Steig's works by Richard Goodbody.
Additional illustration credits can be found on pages 186–94.

The Jewish Museum
1109 Fifth Avenue
New York, New York 10128
thejewishmuseum.org

Yale University Press
P.O. Box 209040
New Haven, Connecticut 06520-9040
yalebooks.com

Library of Congress Cataloging-in-Publication Data

Nahson, Claudia J.
The art of William Steig / Claudia J. Nahson ; foreword by Maurice Sendak ; with contributions by
Robert Cottingham ... [et al.].
p. cm.
Catalog of an exhibition at the Jewish Museum, Nov. 4, 2007–Mar. 16, 2008.
Includes bibliographical references and index.
ISBN 978-0-300-12478-1 (cloth : alk. paper)
1. Steig, William, 1907–2003—Exhibitions. 2. American wit and humor, Pictorial—Exhibitions. 3. Illustrated children's
books—United States—Exhibitions. I. Cottingham, Robert, 1935- II. Steig, William, 1907–2003.
III. Jewish Museum (New York, N.Y.) IV. Title.
NC1429.S583A4 2007
741.5'6973—dc22 2007009254

A catalogue record for this book is available from the British Library.

Frontispiece: Untitled drawing, undated
Cover illustrations: front, Untitled drawing (page of faces), undated; back, Preliminary illustration for *Sylvester and the Magic Pebble*, 1969 (see page 186)

Contents

Donors to the Exhibition

The exhibition *From The New Yorker to Shrek: The Art of William Steig* was generously funded by the Eugene and Emily Grant Family Foundation in honor of Evelyn G. Clyman; Melvin R. Seiden; the Goldie and David Blanksteen Foundation; the Joseph and Joan Cullman Foundation for the Arts; and the Winnick Family Foundation.

 Major support was provided through the Skirball Fund for American Jewish Life Exhibitions and through endowed funds from the Horace W. Goldsmith Foundation.

Lenders to the Exhibition

Albright-Knox Art Gallery

Brooklyn Museum

DreamWorks Animation SKG

Collection of Melinda Franceschini

Lakeview Museum of Arts and Sciences, Peoria, Illinois

Museum of Art, Rhode Island School of Design

Melvin R. Seiden Collection

Smith College Museum of Art

Collection of Jeanne Steig

Collection of Lucy Steig

Collection of Maggie Steig

Collection of the William Steig Estate

The Wilhelm Reich Museum, Rangeley, Maine

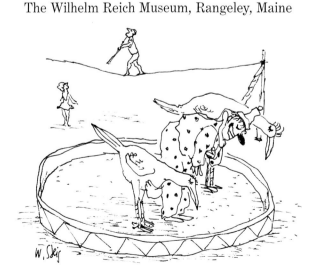

Acknowledgments

Putting together a large-scale exhibition and an accompanying catalogue in just over a year was a challenging endeavor completed only with the help and encouragement of many people. This project could never have come to fruition without the generous support of Jeanne Steig, wife of the artist for thirty years, who opened her home and collection to me, and did so with much warmth and kindness. She facilitated my research during numerous trips to Boston, and made sure to squeeze in a dinner invitation during each visit. I will always treasure those evenings, filled with memories of William Steig, and enlightening discussion about his work. Jeanne is also to be thanked for her wonderful contribution to this volume and for supporting our exhibition with loans.

William Steig's daughters, Lucy and Maggie, generously shared their collections, endorsed the exhibition with loans, and enlivened my research with reminiscences about their father. Despite their busy schedules, they accommodated me on very short notice and made special efforts to enable the photography of selected works from their collections. Maggie's moving essay offers a rare glimpse of the artist from the point of view of his own child. In his work, Steig often saw life through the eyes of children, and we therefore feel both fortunate and privileged to be able to feature Maggie's voice in this publication.

Thanks are also due Holly M. McGhee, William Steig's agent, who was instrumental in the earliest phase of this project, and H. Nichols B. Clark, director of the Eric Carle Museum of Picture Book Art, who shared his experiences putting together an exhibition of Steig's art for children in 2004. The Eric Carle Museum also kindly made available to us a number of images photographed for their catalogue. Donna Norkus, executrix of the William Steig Estate, was a constant supporter who generously gave of her time to answer queries and to make myriad arrangements during the research phase.

Several institutions and collections contributed important loans to the exhibition. Thanks are due Holly E. Hughes, associate curator, and Laura Fleischmann, senior registrar, at the Albright-Knox Art Gallery; Karen Sherry, assistant curator of American art at the Brooklyn Museum; Fumi Kitahara and Heather McLaughlin at DreamWorks; Kristan H. McKinsey, vice-president of collections and exhibitions, and Laura Gharst, collections manager, at the

Lakeview Museum of Arts and Sciences; Hope Alswang, director, Maureen C. O'Brien, curator of painting and sculpture, and Jan Howard, curator of prints, drawings, and photographs, at the Museum of Art, Rhode Island School of Design; Linda Muehlig, associate director for curatorial affairs and curator of painting and sculpture, and Louise A. Laplante, collections manager and registrar, at the Smith College Museum of Art; and Mary Boyd Higgins, director of the Wilhelm Reich Museum. Melvin R. Seiden, generous funder, also supported the exhibition with loans.

I am deeply indebted to Maurice Sendak for contributing such a personal foreword to this publication and for wholeheartedly endorsing my efforts when I curated an exhibition of his own work in 2005. It was Sendak's magnificent art, which reverberates on multiple levels while being firmly rooted in his own childhood, which led me to Steig's. This book is greatly enriched by the contributions of Edward Sorel, Steig's fellow cartoonist at the *New Yorker*, and Robert Cottingham, who, as an artist himself and a personal friend, offers a multifaceted view of Steig. The support of cartoonist Lee Lorenz, art editor at the *New Yorker* for twenty years, greatly benefited this project. His book *The World of William Steig* (1998) was a frequently consulted source for our research. Also helpful was Roger Angell's insightful profile of the artist, "The Minstrel Steig," published in the *New Yorker* in 1995.

Most of the works featured in this volume were photographed by Richard Goodbody, who was indefatigable and full of good cheer while photographing more than three hundred drawings. The quality of his images brings the crispness of Steig's line and the vibrancy of his original colors back to the printed page. The manuscript was deftly edited by Stephanie Emerson, who proved to be both an intelligent and a forgiving editor. The inspired book design is the work of Katy Homans. We are deeply indebted to the staff of Yale University Press, especially Patricia Fidler, Michelle Komie, Mary Mayer, Heidi Downey, and John Long.

Within The Jewish Museum, a number of staff members made this exhibition and accompanying book a reality. Words of thanks are not enough to acknowledge Phyllis Handler, curatorial program coordinator, who assisted me in all phases of this project, from the initial research and preparations for this publication to the last stages of exhibition planning and installation. She was a wonderful companion during research trips, and an indispensable participant in our discussions. Her graceful manner and generous disposition made every phase of this project a pleasure.

I am very grateful to Joan Rosenbaum, Helen Goldsmith Menschel Director of The Jewish Museum, for her support of the exhibition. Ruth

Beesch, deputy director for program, offered much-needed guidance, and Susan L. Braunstein, chair of curatorial affairs, esteemed colleague, and dear friend, was always ready with sound advice. Curatorial program assistants Emily Casden and Tamar Rubin cheerfully and eagerly lent valuable assistance with catalogue preparations.

It is a great pleasure when an editor not only shares with the exhibition curator a passion for the subject at hand, but is also well versed in it. Special thanks are due Michael Sittenfeld, manager of curatorial publications, for his extraordinary support of and contribution to this project. Spending long hours with Mike, going over the essays and selecting images for inclusion in this volume, always led to stimulating conversation and much laughter over Steig's cartoons.

Sarah Himmelfarb, associate director of Development, Institutional Giving, worked tirelessly on fundraising for the exhibition. Within the Collections and Exhibitions Department, thanks are due Jane Rubin, director, Amanda Thompson, assistant registrar, and Dolores Pukki, coordinator of exhibitions, for overseeing exhibition preparation and installation. Anne Scher, director of communications, and Alex Wittenberg, communications coordinator, worked diligently to promote this project. Al Lazarte, director of operations, and his staff did everything possible to expedite construction work in the exhibition galleries. Exhibition designers Dan Kershaw and Kris Stone created a magnificent installation that is both elegant and playful. Katy Homans applied the same creative talent that imbues this publication to the graphic design for the exhibition. Daria Kissenberth diligently oversaw all graphic production.

On a personal note, I am grateful to my sister-in-law and brother-in-law Rosanne and Clifford Levine and their children for their warm hospitality and for granting me the use of their own "ivory tower" in the uppermost story of their home so that I could work undisturbed on my essay for this publication. Last but not least, loving thanks to my husband, Arthur Mandel, who had to work extra hard at home and take care of our daughters during my many research trips and late nights and weekends at work. I dedicate my essay to him and to the three "Small Fry" in our life: our oldest daughter, Ariella, kind and brave like Irene, and our twin daughters Nina, who has an endearing penchant for sulking like Spinky, and Julia, whose favorite spell is the one used by witch Yedida to transform Caleb, the carpenter, into a dog: *Ammy whammy, / Ibbin bammy, / This is now / A bow-wow-wow.*

Claudia J. Nahson

ASSOCIATE CURATOR
THE JEWISH MUSEUM

Foreword

Maurice Sendak

We met on the porch of a rented beach house on Fire Island, New York, sometime in the late 1960s. I was thrilled to meet him. I was a fan, and Steig had sought me out, referring to me (I recollect) as the "kiddie-book maven." Our first encounter turned almost immediately into a brief, flat business meeting. He wasn't my type: furrowed brow, tight mouth, and very quiet. He made me *feel* like a kiddie-book creature.

"Hey, Maurice, can you really make a decent living doing this?" Bill Steig worried about money? The amazing artist who had made a Brooklyn adolescent's life (in the 1940s) almost bearable with his amazing "Small Fry," followed by *The Agony in the Kindergarten*, and further Freudian shake-ups. As I said, I was a great fan, but I was very wary of his questions. Who needed another grown-up artist meddling around in *my* precious profession? Surely, I assumed, he made pots of money with his *New Yorker* cartoons and covers. So why come stomping on my turf?

Yes, I regret to admit that I failed to realize at once that Steig had already produced his own one-of-a-kind books for children. He was a perfect fit. That became obvious soon after, when his major works were published, that astonishing parade of wildly original novels and picture books. I have so many favorites, most of them autographed and doodled in.

Bill could work himself up into incredible rages, mostly on how slow-moving the publishing process was. He would say, "I'm old, damn it! What the hell is taking so long?"

Now I am old and very cranky, and I understand his unforgiving anger. He'd be proud of me. Bill was brilliant and rare, and I miss him.

Did he make a decent living? Hope so.

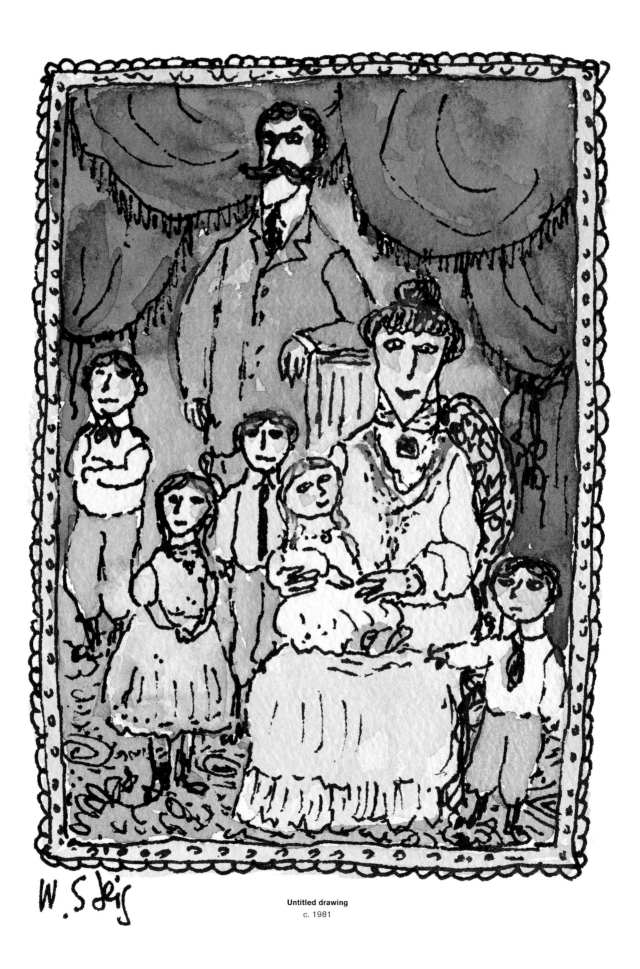

Untitled drawing
c. 1981

Introduction

Claudia J. Nahson

In his introduction to William Steig's book *Ruminations* (1984), Whitney Balliett discusses the "mysterious line that separates cartoonists from artists." In Balliett's view, "cartoonists are sketchers who deal in obsolescence," whereas "artists, more heavily equipped, aim at permanence." But "those few cartoonists, like Steig, who are also artists make you laugh, then lead you to their drawings," for he "draws well enough to keep you after the laughter stops."[1] The statement could not be more accurate. Steig's line is impeccable, and his drawings resonate long after our first encounter with them, creating an endless world of associations that ring true again and again. His work arises from keen observation and deep understanding of his fellow man, whether adult or child. His art is never sarcastic, and even in its most satirical moments—and there are many of those—it is filled with empathy.

Hailed as the "King of Cartoons," William Steig (1907–2003) had a long and acclaimed career as both a brilliant cartoonist and an award-winning, beloved author of children's picture books.[2] He drew his first cartoons for his high school newspaper and later spent two years at City College, three years at the National Academy, and five days at the Yale School of Fine Arts before dropping out. Prompted by the need to support his family during the Depression, Steig began illustrating for the *New Yorker* in 1930. His prolific association with the magazine is the longest by far of any of its cartoonists, with over 1,600 drawings and more than 120 covers published during a period of seventy-three years.

A son of Eastern European Jewish immigrants, Steig was born in Brooklyn on November 14, 1907. His father, Joseph Steig, had arrived in America in 1903 from Lemberg (Lvov) and soon secured passage for his wife, Laura, and young son, Irwin, who joined him in New York. The young couple first settled in Brooklyn, where their second son, Henry, and then William, were born. Soon after the artist's birth the family moved to the Bronx, where they welcomed the arrival of their youngest member, Arthur. While Joseph Steig made a living as a house painter, his wife worked as a seamstress, but they were also both artists in their own right and communicated that passion to their children.[3]

Like many Eastern European Jewish immigrants in the early twentieth century, Joseph Steig brought to America a tradition of political and labor activism. Although he was raised in an observant Jewish household, he had become an atheist as a young man and joined the Socialist Party in the Old Country.[4] In New York, where a vociferous Yiddish press championed socialist causes, he joined other new arrivals at political gatherings that sought to raise public awareness of the plight of workers. It is not surprising, therefore, that from his beginnings as a cartoonist William Steig would identify with the downtrodden. With his first submission to the *New Yorker* in 1930—a cartoon featuring a criminal telling his jail mate, "My youngest is a terror. We can't do a thing with 'im"—Steig made it clear that the magazine was in for something totally new.

The variety of styles of Steig's art—as Edward Sorel remarks in his essay in this volume—stands apart in the world of the *New Yorker*. Ranging from classic cartoon style to psychologically fraught pen-and-ink drawings to Picassoesque portraits to geometric figure studies to delicately rendered sketches to opulently colored watercolors, Steig was all in one. His protean artistic nature makes him hard to categorize—a trait he shares with that other colossus of the *New Yorker*, Saul Steinberg. As scholar Joel Smith has written, both artists "tapped a wide-open market for thoughtful drawings fueled by anxiety," with Steig having "reached the territory first," as seen in the comparison between Steinberg's early work and Steig's drawings for *About People* (1939) and *The Lonely Ones* (1942).[5] But the visions of the two artists differ: while Steinberg's is expansive, Steig's is ever so intimate; while Steinberg goes out into the world to see the individual, Steig can see a whole world through the eyes of one character. In Steinberg's drawings we are usually the spectators; in Steig's we are, more often than not, deeply involved with the protagonists. Steinberg's art was marked by his early experiences of displacement and exile as a Jewish artist who had to flee fascist regimes in Europe in the early years of his career. Steig's world, on the other hand, is that of an acculturated Jewish artist, born and bred in America. While his early art often surveyed the vicissitudes of Jewish immigrants as they make the transition from tenements to apartment houses, purchase their first automobiles, and fill with pride as their children graduate from American colleges, Steig's focus soon turned to more universal subjects. A couple of later cartoons, however, seem to deal with acculturation as a hopeful or comic state. In a drawing published in the *New Yorker* in January 1964, two content middle-class couples raise their glasses in a traditional Jewish toast "To life!" (usually offered in Hebrew: "L'Chaim!"), probably celebrating the New Year. In a second cartoon, published in the magazine in

William Steig, c. 1970
Photograph by Henry Humphrey

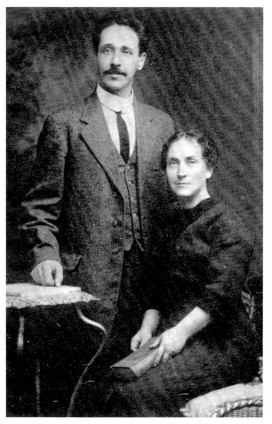

Joseph and Laura Steig, 1912

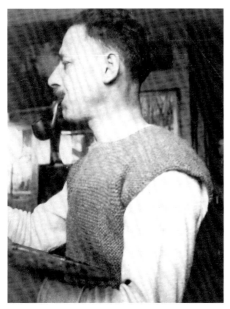

Joseph Steig painting, undated

Untitled drawing
Undated

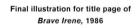

Final illustration for title page of
***Brave Irene,* 1986**

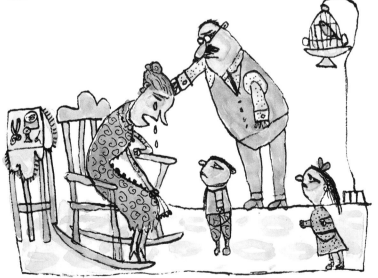

**"There were times when sad news would come from
the Old Country"**
Final illustration for *When Everybody Wore a Hat,* 2003

A bid for immortality
Final drawing for *About People: A Book of Symbolic Drawings,* 1939

Saul Steinberg (American, b. Romania, 1914–1999)
Artist's statement for *Fourteen Americans* exhibition at the
Museum of Modern Art, New York, 1946
Ink on paper, 3¾ x 7⅞ in. (9.5 x 20 cm)
Private collection, formerly collection of Dorothy C. Miller
© The Saul Steinberg Foundation/Artists Rights Society (ARS), New York

1992, a girl practices piano under the scrutinizing eyes of a composer's bust that utters "Gevalt!" the Yiddish equivalent of "Oh, my God!" or "Good grief!"

The range of Steig's art is remarkable. His world is full of curmudgeons, cranks, and complainers. These figures are a rich source of humor, but they are also crucial to one of his central insights—there is much to be dissatisfied with in the world, and much that can frustrate and bewilder us. The predominance of rural settings in Steig's later work stands in stark contrast to the urban grittiness of his earlier drawings. These pastoral scenes, sometimes idyllic and sometimes ironic, were published in the pages of the *New Yorker* at the same time as E. B. White, Rachel Carson, John McPhee, and others were contributing essays about rural life and the environment. Courtship and marriage,

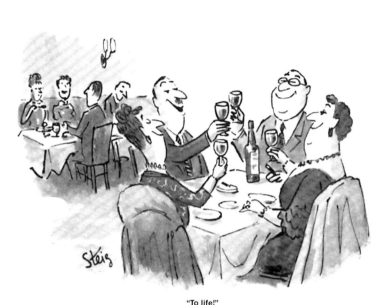

"To life!"
Published in the *New Yorker,* January 18, 1964

"Gevalt!"
Published in the *New Yorker,* April 20, 1992

other frequent motifs in Steig's work, are portrayed as full of yearning and tension; Steig dissects these subjects with a sharp pen and a caustic sense of humor. In addition to the grumps and hotheads in the adult world, Steig writes about grouchy children in such colorfully illustrated picture books as *Spinky Sulks* (1988) and *Pete's a Pizza* (1998), not to mention *Shrek!* (1990) and its incredibly ill-mannered protagonist.

One critic has rightly described Steig as an "idiosyncratic innocent in a never-never land of his own making, waging a private war against the craziness of modern life with the pen of a master and the eye of a child."[6] Steig often claimed that he not only enjoyed writing per se, but was also fascinated by the act of writing, which he viewed as a form of drawing. "I enjoy the physical act of writing," Steig has said. "When I was a kid, before I could spell, I'd take a pencil and paper and sit for hours 'writing' a story." In fact, if Steinberg viewed himself as a "writer who draws," it can certainly be said of Steig that he was an "artist who wrote," as his poetic prose in such children's novels as *Abel's Island* and *Dominic* shows.[7]

It is the paradoxical plight of cartoonists and illustrators that while their audience is familiar with their line and style, and while their art is widely disseminated in printed form, the public does not often get a chance to behold their original art. Savoring Steig's line first-hand rather than on the printed page and experiencing his vibrant watercolors and lush washes can only be

"Lovey Dovey" ("A lunatic living in Lvov . . .")
Preliminary illustration for *Alpha Beta Chowder*, 1992

described as a rare treat. Steig's deep love of drawing is evident in the sheer profusion of his art, no matter what the size or quality of the paper—from a shopping list to a sketchbook, from the back of a page with a rejected drawing to the scraps from some larger sheet of paper. Selecting works for The Jewish Museum's exhibition and the images for this publication was a challenge. How can one choose a small group of drawings out of more than 10,000 when they are all of such uniform quality, when each can disarm you with its artistry while keeping you giggling or pondering? Hence, the over 280 drawings featured in this volume are but a sampling from Steig's prodigious career.

Given the amazing breadth of Steig's work, it is not surprising that most people are familiar with only one aspect of his oeuvre. The artist's devoted following includes, on one side, the generations of readers of the *New Yorker* who have enjoyed his cartoons for decades, and, on the other, the millions of children who respond to his charming pictures and fanciful stories. But many fewer fans are acquainted with his symbolic drawings of the late 1930s and 1940s. When these forays into the unconscious first emerged from Steig's pen, the *New Yorker* was not ready to embrace them, but the psychiatric community took notice. In fact, it is this third and seminal body of work that enabled Steig to move from his early and more traditional style of cartooning to his mature and masterful output. In this centennial year of the artist's birth, The Jewish Museum's exhibition offers, therefore, the opportunity to view works from

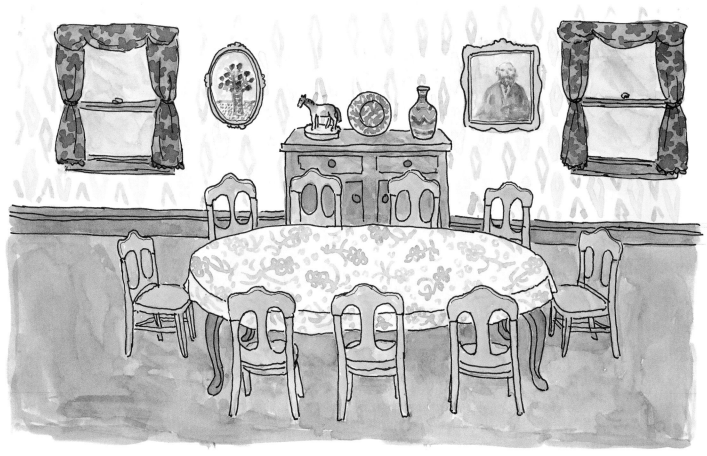

" 'Izzy,' my mother said as she brought in her prized platter of latkes"
Final background illustration for *The Flying Latke,* 1999

Steig's three bodies of drawings together for the first time, and a better under-
standing of the artist's journey from his earliest offspring—those young ras-
cals who peopled his cartoon series "Small Fry"—to his idiosyncratic creations
and existentialist characters.

Because most of Steig's original cartoon art from the 1930s and 1940s
has not survived—Steig seems to have regretted much of his early work and
is said to have personally disposed of it—this publication includes images of
original cartoon art from the early 1950s onward.[8] Images of unavailable works
are included only when those drawings are specifically referred to by the essay-
ists. Fortunately, original art for his symbolic drawings is extant. These works,
as well as almost all of the other drawings featured here, were photographed
especially for this publication. These wonderful images of the original art,
combined with personal reminiscences by William Steig's younger daughter,
Maggie, his friend Robert Cottingham, and his wife of thirty years, Jeanne
Steig, offer great insight into both Steig the man and the artist.

Steig frequently depicted artists deeply engaged in the act of creation.

He regarded the artistic process with both reverence and bemusement, but he often enjoyed puncturing the bombast of the art collector or the aesthete. This dichotomy might explain the modest scale of Steig's actual drawings — no matter how large the original sheet, the drawing was usually small — and the artist's unassuming attitude toward his own work, which he felt "was made to be reproduced" rather than appreciated as art.[9] As his canine hero Dominic discusses art with a mouse painter who "loves to paint in this *trompe l'oeil* style," the bewildered mutt "could hardly believe such highfalutin talk was coming out of his own yap."[10] One hopes that this profusely illustrated publication will let Steig's art do most of the talking, because, as the artist himself said, "My drawings are the best part of me."[11]

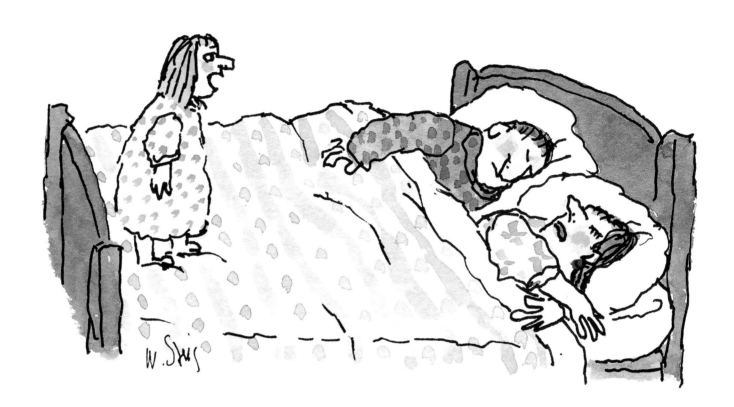

Grown-ups like to sleep late, 1987
Final illustration for *Grown-Ups Get to Do All the Driving*, 1995

Kids Get to Do
All the Driving

Claudia J. Nahson

In William Steig's charming picture book *Grown-Ups Get to Do All the Driving*
(1995), adults are in control of their young charges, or at least it seems so at
first glance: grown-ups demand to be kissed, they make children go to the den-
tist, they want children to be polite, and worst of all, they sometimes are just
plain mean to them. But, as often happens in Steig's world, nothing is what
it appears to be. Children, in fact, know exactly what adults are up to and
treat them with a healthy measure of skepticism, as in the drawings captioned
"Grown-ups are always having 'discussions,'" and "Grown-ups say they were
once children." Even when parents try to outsmart their children — as in "I call
your bluff!" first published in the *New Yorker* in 1932 and redrawn by Steig for
inclusion in *Small Fry* (1944) — kids have the upper hand, as the insecurities
of their adult counterparts are humorously exposed.

William Steig's interest in the doings of children runs deep in his work
and is firmly rooted in his own life experience. Born in Brooklyn, New York,
in 1907, to Eastern European Jewish immigrants, Steig grew up in the Bronx,
playing in the streets with his "old gang," hanging out on the stoops, and camp-
ing in Claremont Park. His entrance into the aristocratic world of the *New
Yorker* in the early 1930s is captured, as recently remarked by scholar Iain
Topliss, in a rare collaboration between the artist and fellow cartoonist Helen
Hokinson.[1] The cartoon depicts a group of well-dressed, upper-middle-class chil-
dren taking a guided tour of a museum (drawn by Hokinson), while at left a
boy sporting a pair of knickerbockers and a full head of spiky hair (drawn by
Steig) defiantly intrudes on the genteel proceedings. The docent asks the inter-
loper, "Pardon me, young man, are you a member of this Study Group?" Newly
arrived Steig, as Topliss has noted, was the antithesis of all other cartoonists
in the magazine: his Jewish background and Bronx upbringing, his interest in
street life and the dramas of the lower class, made him an outsider.

Steig's early work betrays a need to reconcile his desire to fit into the

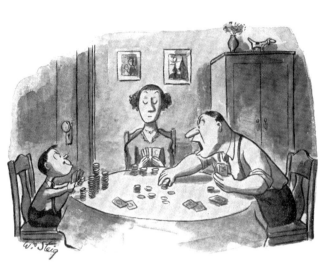

"I call your bluff!"
Published in *Small Fry*, 1944

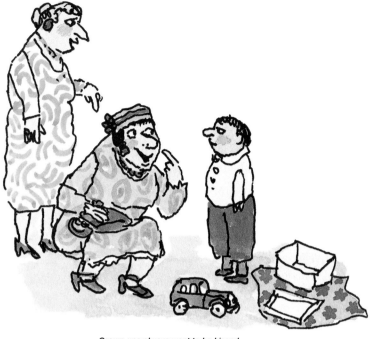

Grown-ups always want to be kissed
Final illustration for *Grown-Ups Get to Do All the
Driving*, 1995

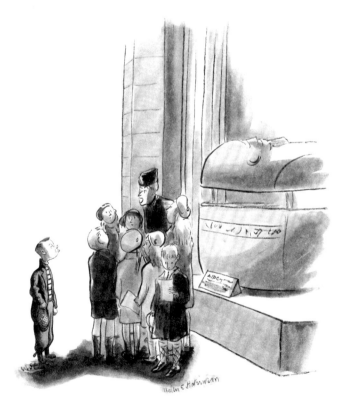

"Pardon me, young man, are you a member of this Study Group?"
Drawing by Helen E. Hokinson (1893–1949) and William Steig
Published in the *New Yorker,* January 26, 1935

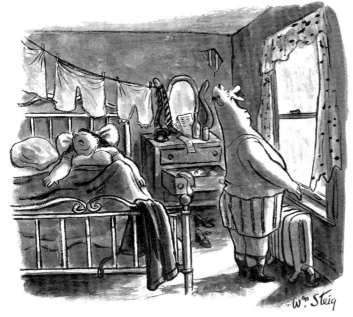

"What a beautiful morning!"
Published in *Collier's*, January 7, 1950

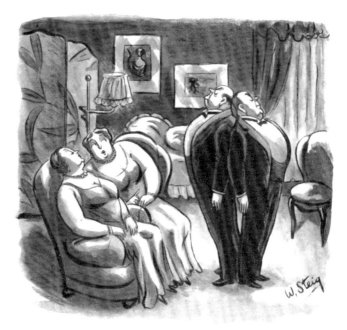

"Yes, but my George has broader shoulders."
Published in the *New Yorker*, January 23, 1932

cultured world of the magazine while remaining rooted in his own, his charac-
ters oscillating "between the tenement dwellers of his own childhood" and the
"Fifth Avenue 'swells,'" in the words of Lee Lorenz.[2] But, most important,
Steig ushered in a new era at the *New Yorker* by radically transforming the
way cartoons were created at the magazine. Before his arrival cartoons relied
heavily on gags — short comic episodes — and were the result of the collabora-
tion between writers, who supplied the ideas and the captions, and cartoonists,
who provided the illustrations. Steig became the first cartoonist at the *New
Yorker* to create his own ideas, write the one-line captions, and make the draw-
ings. "When I do cartoons," Steig later explained, "[pictures and words] hap-
pen at the same time, because the idea and the execution are one."[3]

Steig's second career as a children's book author and illustrator proved
to be a perfect fit. Even though he published his first children's book in 1968,
when he was sixty years old, it appears as if the artist had been preparing
for this task his whole life — there is a childlike air in much of his art geared
toward adults. His predilection for cowboys and knights, damsels in distress,
and fanciful monsters evinces the artist's lifelong need to remain in contact
with the child within him. For Steig, however, focusing on his inner child meant
overturning traditional narratives. In his cartoons damsels chase away serenad-
ing suitors or shield themselves from knights in the protective arms of mon-
sters. In his masterful picture book *Rotten Island*, the ugly inhabitants of a
landscape filled with gushing volcanoes painted in electric colors "were very

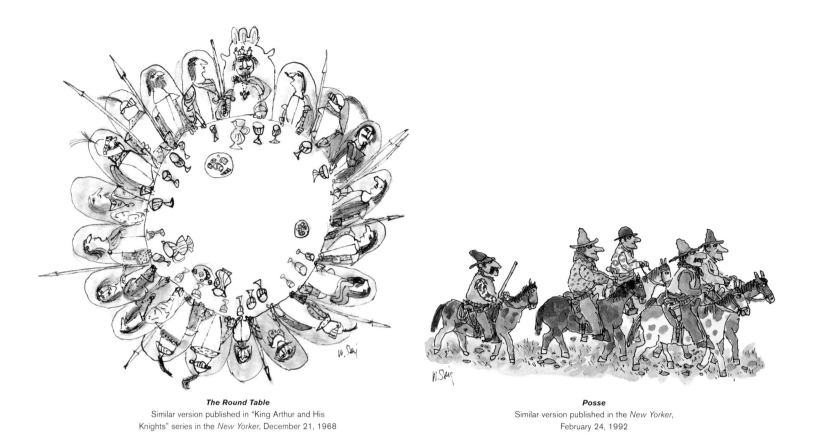

The Round Table
Similar version published in "King Arthur and His
Knights" series in the *New Yorker*, December 21, 1968

Posse
Similar version published in the *New Yorker*,
February 24, 1992

happy at being unhappy, and were very pleased to be mean and cruel. . . . To
them, this rotten island was Paradise." His 1990 picture book *Shrek!*—which
means "fear" in Yiddish—is the story of two monsters who passionately fall for
each other, defying the fairytale notion that love is only for the young and beau-
tiful. For Steig, this pairing communicates the essence of true love: "Shrek
snapped at her nose. She nipped at his ear. They clawed their way into each
other's arms. Like fire and smoke, these two belonged together." The artist's
empathy for the underdog is both intense and genuine, which explains why his
work speaks to children. Shrek's imperfections are what make him the perfect
kind of hero, because a flawed hero, in Steig's view, is the best kind.[4]

Steig's prolific career can be divided into three main periods: his begin-
nings at the *New Yorker*; a middle phase during World War II and the postwar
years, in which Steig produced many of the so-called symbolic drawings, his
most haunting and pessimistic work; and the final period, beginning in the
1950s, when Steig became more liberated and at peace with himself both as an
artist and as an individual, and created his freest drawings and his most lyrical
writing in the form of his children's literature. Linking all three periods is
Steig's connection with childhood. It was through his cartoons featuring street
children—most famously his series "Small Fry," which the artist created in the
early 1930s and continued into the early 1950s—that he remained in contact

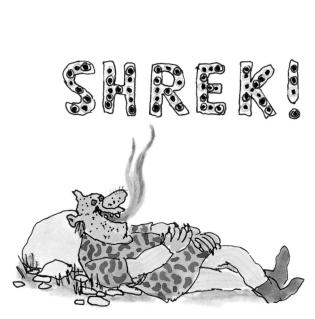

Final illustration for title page of *Shrek!* 1990

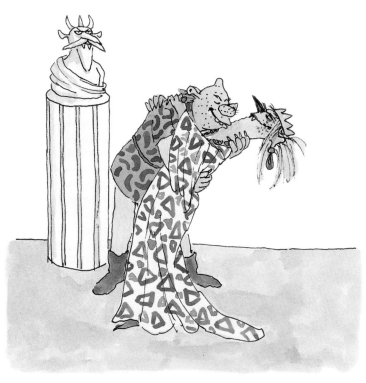

**"Shrek snapped at her nose. She nipped at his ear.
They clawed their way into each other's arms"**
Final illustration for *Shrek!* 1990

with the world of his Bronx Jewish childhood, a way of life that was on the verge of disappearing when he joined the *New Yorker*. His fear of American society's corruption of its children propelled the artist into his midlife explorations of the human soul in his symbolic drawings, with which he sought to find out why his "Small Fry" grew into his "Lonely Ones," in the view of Diana Trilling.[5] And it was his work with children's books that gave the artist renewed optimism later in life.

As Topliss notes, Steig gravitates between two visions of childhood in his "Small Fry" series: one that presents children just being children, filled with wonder and innocence, and another that surveys how the adult world interferes in children's lives, either by presenting youngsters as precocious—sometimes disturbingly so—or by showing the impact of World War II on children.[6] By 1942, however, all of Steig's "Small Fry" cartoons had become war-related, including his seven-cartoon series entitled "Total War" published in the *New Yorker* in November of that year. It showcases a gang of boys taking prisoners, practicing espionage and counterespionage, and fighting a battle with make-believe tanks. As the war raged on, Steig's "Small Fry" continued to engage in combat in the pages of the *New Yorker*. It soon became clear that the world was in desperate need of a few good heroes, and Steig came to the rescue with "Dreams of Glory." Beginning in 1944, this series features a young boy who

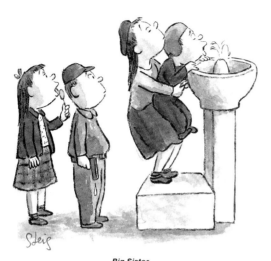

Big Sister
From "Small Fry: Park Playground" series,
published in the *New Yorker*, April 18, 1953

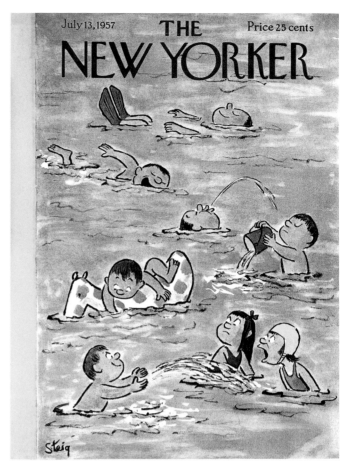

Cover of the *New Yorker*, July 13, 1957

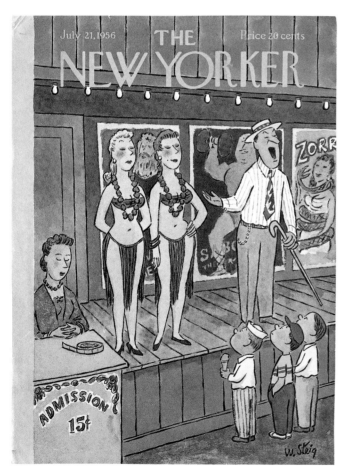

Cover of the *New Yorker*, July 21, 1956

Untitled drawing
c. 1956

Untitled drawing
From "Dreams of Glory" series, published in the
New Yorker, February 19, 1944

effortlessly saves the victims of a fire, survives forty days stranded at sea while his adult counterparts die of exhaustion, and, in the boldest of feats, manages to hold Adolf Hitler at gunpoint.

In his preface to the 1953 collection *Dreams of Glory and Other Drawings,* Steig explained that the drawings expressed "a kid's almost futile dream of living more than the usual dull routine—his only way of imagining heroic action in a world that affords little opportunity and that is so poor in good examples."[7] With a healthy dose of humor and great piquancy, the artist portrays a world saved by young heroes because grown-ups seem to have lost control. Steig's vision of the adult world at this time comes to the fore in his symbolic art— drawings that were deemed "too personal and not funny enough" by the *New Yorker*'s legendary editor Harold Ross.[8] In compilations such as *About People* (1939) and *The Lonely Ones* (1942), Steig began to delve more and more into the depths of the human soul. Through these explorations the artist seemed to find the path to a freedom of expression that, earlier in his career, had no precedent and would become his trademark as well as the answer to a lifelong quest: "I've always felt that something went wrong and it was my business to find out what happened."[9]

His encounter in 1946 with the Jewish psychiatrist Wilhelm Reich (1897–1957), a former disciple of Freud who had fled Vienna in 1939, proved pivotal. Reich's theory provided Steig with the answer to what went wrong with humankind: man's natural energy, in Reich's view, was constantly being

thwarted by society. It was therefore imperative, the psychiatrist proclaimed, for the individual to recover this lost energy by daily retreating to his "orgone energy accumulator," a sort of box built of layers of organic and inorganic material where this energy was collected. Steig embraced Reich's controversial treatment wholeheartedly, sitting in his own orgone box regularly for the rest of his life.

After illustrating Reich's manifesto, *Listen, Little Man!* (1948), a call for action to the ordinary folk, Steig dedicated the seminal *Agony in the Kindergarten* (1950), his own wake-up call to America—and a nod to William Blake's *Songs of Innocence and Experience* (1789–94)—to his spiritual mentor. The economy of the pen-and-ink drawings and the directness of the captions heighten Steig's message. The book is filled with warning signs on the abuse and repression of children: "Come in my room—I want to have a talk with you" sends chills down one's spine, and a stern "Don't" is powerful enough to keep a child's mouth and hands in check. Later, in his children's books, Steig would return to many of the same topics in a more lyrical and humorous fashion and in a more forgiving vein. His transition from "Mother's got an awful headache today" in *The Agony in the Kindergarten* to "Grown-ups get headaches" in *Grown-Ups Get to Do All the Driving* (1995) is a case in point. In the former, the parent—a repressive off-stage presence—dispenses a considerable amount of guilt to her youngster, whose mouth is depicted as tightly shut. In the latter drawing, however, adults are sympathetically depicted and hilariously placed at their children's mercy.

Steig often professed a dislike for illustrating books in which the same character needed to be reproduced page after page—a staple in the art of children's books. His desire to draw freely and whimsically, oblivious to pre-liminary sketches, pervades much of his work. In fact, by the time he began illustrating children's books, Steig had "transcended the problem of roughs altogether," and "his roughs *were* his finishes," according to Lee Lorenz, who reviewed many of Steig's cartoons as art editor for the *New Yorker* from 1973 to 1993, and as its cartoon editor until 1997.[10] Still, if Steig did not enjoy the process of illustrating children's books, it does not show in the final product. From Gorky, the flying frog, to Zeke Pippin, the harmonica virtuoso pig, and from the charming green ogre Shrek to the resourceful mouse dentist Doctor De Soto, Steig regales his readers with a splendid feast for eyes and ears. His children's books are best enjoyed when read aloud, to better savor his poetic language. His intense love of color is manifested in the vibrant illustrations— "with no preliminary sketches or pencilings," writes Roger Angell in his profile of the artist, "his paintings always feel as if he had just placed them in your

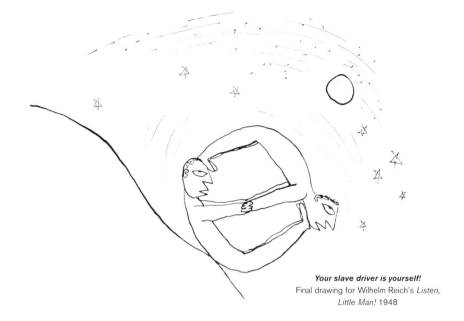

Your slave driver is yourself!
Final drawing for Wilhelm Reich's *Listen, Little Man!* 1948

Mother's got an awful headache today
Preliminary drawing for *The Agony in the Kindergarten,* 1950

Grown-ups get headaches
Final illustration for *Grown-Ups Get to Do All the Driving,* 1995

Family Reunion
c. 1978–80

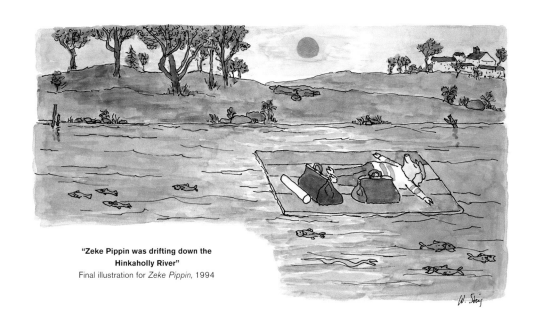

**"Zeke Pippin was drifting down the
Hinkaholly River"**
Final illustration for *Zeke Pippin*, 1994

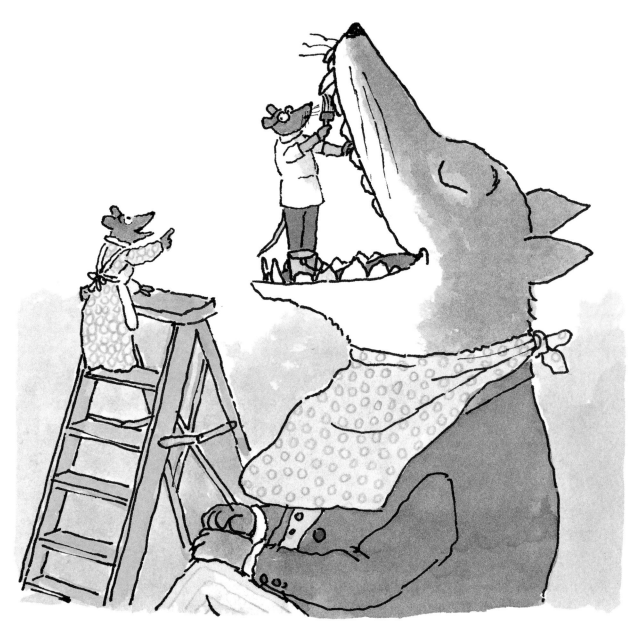

"Doctor De Soto stepped into the fox's mouth"
Final illustration for *Doctor De Soto,* 1982

hands."[11] For Steig, color has an almost medicinal quality: "I'm sure that play-
ing with color is good for the soul," the artist once said, "and is one of the
many reasons that painters outlive by far all other creative types."[12] Steig him-
self certainly proved that point, living to be almost ninety-six years old.

His third picture book, *Sylvester and the Magic Pebble* (1969), which, like
most of Steig's children's books, features an animal as protagonist to best com-
municate meaningful ideas to young readers, captured the Caldecott Medal for
distinguished illustration in picture books for children. In Steig's stories, pigs,
mice, donkeys, and dogs embark on quests of self-discovery, struggle with their
emotions, and survive through self-reliance. "I think using animals emphasizes

the fact that the story is symbolical—about human behavior," Steig once said. "And kids get the idea right away that this is not just a story, but that it's saying something about life on earth."[13]

"In Steig's books," wrote Angell, "clarity and comedy feel as easily conjoined as words and picture, and a little magic sometimes helps as well."[14] In fact, "magic is music for children," the artist himself has said, and it certainly abounds in his stories: Sylvester the donkey turns into a rock, Pearl the pig's bone speaks in tongues, Caleb the carpenter gets turned into a dog, and Solomon the rabbit discovers that he can turn into a rusty nail if he scratches his nose and wiggles his toes at exactly the same time.[15] But even as Steig understands children's need for magic, he points to its absence in adult life. In a preliminary version of *Solomon the Rusty Nail* (1979), the artist has his rabbit hero grow into adulthood. "But as he grew older," Steig writes, "his rusty nail trick bored him. He felt it was nothing to be so proud of after all." And then, in one of those beautiful phrases that often come from his pen, Steig simply explains that Solomon "put it away in the attic of his mind and forgot about it."[16] This candid—and sad—acknowledgment of adult life as one devoid of magic might explain Steig's decision to have Solomon remain a child in the final version of the story. His books for children are always filled with hope, something the artist said was an unconscious rather than an intentional choice.[17]

Steig's characters' sense of hope and love of life are beautifully verbalized and artistically rendered in *Abel's Island* (1976). Published not long after his marriage to Jeanne Steig, his wife of thirty years to whom he dedicates the book, *Abel's Island* lyrically communicates the bliss of early marital life—a distant relative of Steig's many cartoons depicting battling couples, such as the one with an elderly duo wearing hearing aids and still arguing. Featuring superb washes, the book is also emblematic of Steig's journey from his beginnings, looking back at his difficult middle period and forward to his mature years. Stranded on a deserted island, Abel the mouse "was imagining ahead to Amanda, and beyond her to his family, his friends, and a renewed life in society that would include productive work, his art; but he was also remembering his year on the island, a unique and separate segment of his life that he was now glad he had gone through, though he was also glad it was over."[18]

In his literature for children Steig often brings up universal questions, ever present in the mind of youngsters yet often set aside by adults. This "wrestling with the overwhelming and mysterious concept of eternity," in the words of James E. Higgins, is often brought to the fore by Steig's characters, such as Sylvester, the donkey turned into rock by wishing on a magic pebble

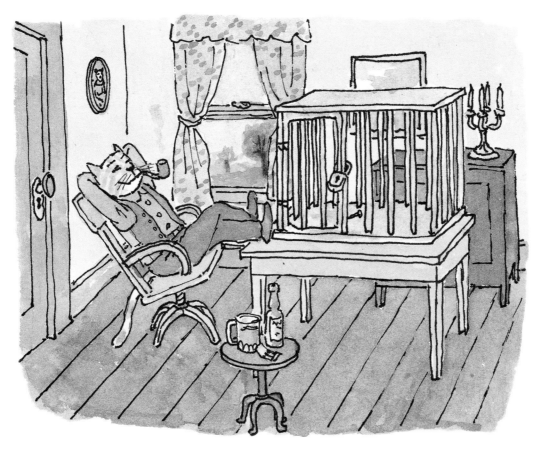

"They decided to take turns keeping an eye on the cage"
Final illustration for *Solomon the Rusty Nail,* 1985

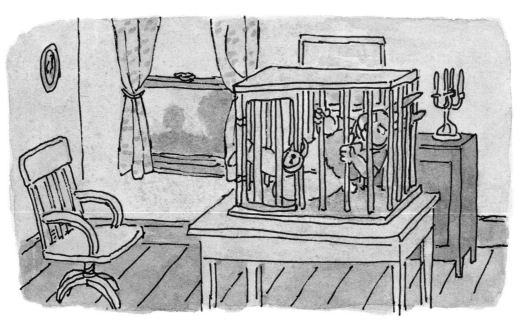

**"Solomon would quietly become himself and try to
bend the bars or force the lock"**
Final illustration for *Solomon the Rusty Nail,* 1985

"The feeling that he could visit Amanda in dreams
haunted Abel"
Final illustration for *Abel's Island,* 1976

William and Jeanne Steig, Kent, Connecticut, 1973
Photograph by Nancy Crampton

("What it would be like to be a rock forever . . . to be caught in a situation in which the odds were stacked one billion to one against you"), or Amos, the mouse "overwhelmed by the beauty and mystery of everything" and curious about where his soul would go should he drown in rough seas ("Would there be other mice there?").[19]

Although Steig was a city child, in his cartoon art the bucolic abounds, and a number of his children's stories take place in the countryside, the locale of romance, according to the artist, and of dramatic weather changes: young Irene braves a powerful snowstorm, Shrek the ogre gobbles some lightning with gusto, Spinky decides to stop sulking during a heavy downpour, and Sylvester witnesses the change of seasons. The artist's early desire "to be a seaman like Melville" is vicariously realized through Amos in the moving tale of friendship *Amos & Boris* (1971), or through his other mouse, Abel, the Robinson Crusoe–like hero of *Abel's Island.*

In Steig's sensitivity to the child's point of view, he refuses to be patronizing. He acknowledges children's sophistication and their love of learning and language by introducing difficult words while keeping his young readers utterly absorbed. As Donald Phelps recently remarked, Steig's children's

"Dominic was inspired to take out his piccolo and play"
Final illustration for *Dominic,* 1972

books embody an "epiphany: the triumphant emergence of Steig's devotion to language long encountered, usually obliquely, in the suites of humanistic cartoons."[20] In his books there are many wonderful phrases: Boris the whale, stranded on a beach, is "breaded with sand"; Dominic the dog "blushed under his fur"; and Zeke the pig threads his way through a forest "with the half moon half helping" and, upon arriving home, is "covered with a blanket of kisses."

Steig's ideal of social justice, instilled by his parents at an early age, finds its most vivid expression in his children's books. In *Dominic* (1972), the protagonist, a kind and resourceful canine with a musical streak—he loves to play the piccolo—chooses a path of adventure that somewhat mirrors Steig's own, although the artist saw the figure of his own father in the heroic mutt.[21] Dominic bids farewell to his friends by "sniffing them with love" in his parting message and embarks on a perilous yet rewarding journey. By fighting the evil Doomsday Gang, nursing elderly Mr. Badger, an ailing swine, and sharing the treasure he later inherits from the pig with a number of animals that cross his path, Dominic is engaged in the traditional Jewish concept of *tikkun olam,* or repair of the world. By the time the story is over, the utterly charming dog has fulfilled a great number of *mitzvot,* or commandments, and has embraced

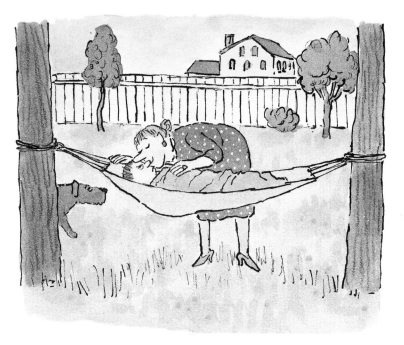

"Then she covered him with a blanket and kissed him again"
Final illustration for *Spinky Sulks*, 1988

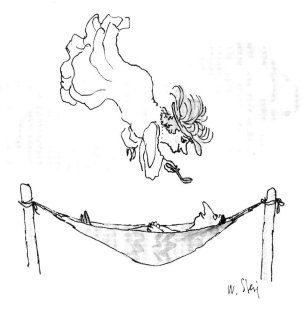

A Dream of Chicken Soup
Published in the *New Yorker,* June 28, 1982

tzedakah, or charity. Young readers witness how the more Dominic shares his wealth, the happier he feels; material possessions are viewed as burdensome and heavy—the more one gives away, the lighter and better one feels.

Although the protagonists of Steig's children's books are primarily animals, his "Small Fry" characters make a comeback in his later work. *Spinky Sulks* (1988) is a candid survey of one of childhood's most annoying afflictions—that frequent and inexplicable urge to withdraw from the world, to dwell on pestering thoughts that won't go away. Steig's protagonist is so credible, and the "emotion is so strongly felt," says Leonard Marcus, "that it doesn't seem it could have been contrived."[22] This is not the common stuff of picture books, and it reflects a truthfulness on Steig's part that is virtually unsurpassed in children's literature. The parade of friends and relatives who come to pay tribute to sulking Spinky as he holds court in a hammock acknowledges a child's thirst for attention and his need to regain his place at the center of the family. In discussing *Sylvester and the Magic Pebble,* Steig said, "Many kids . . . feel locked up inside themselves—misunderstood and armored [a Reichian concept]— trying to be human beings. In *Sylvester* the child is unlocked by the love of the parents, which brings him out of himself."[23] A doctor prescribes "lots of love"

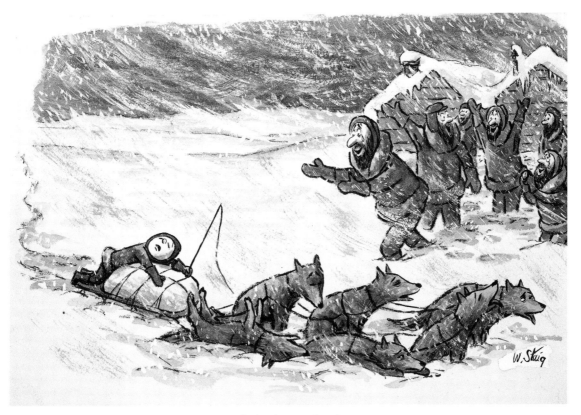

Getting the serum through
From "Dreams of Glory" series, published in the
New Yorker, March 15, 1952

**"She pounced and took hold, but the ill-tempered
wind ripped the box open"**
Final illustration for *Brave Irene,* 1986

Untitled drawing
c. 1968

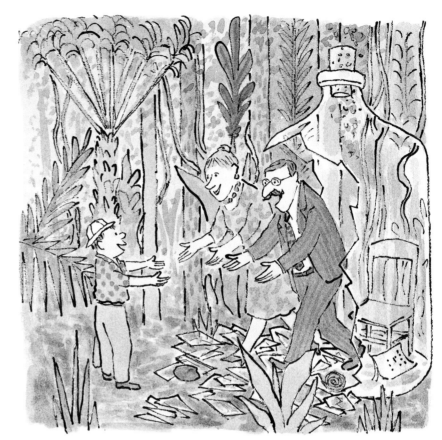

"He finds a rock and smashes a hole in the bottle"
Final illustration for *The Zabajaba Jungle*, 1987

for the sick child in one of Steig's old drawings, and the artist often portrays
the self's need to be mothered or nurtured well into adulthood. "A Dream of
Chicken Soup" is a cartoon based on a real-life event: Steig's father, imprisoned
as a young man for socialist activities in the Old Country, was visited in jail by
his mother, who would bring him chicken soup, an Ashkenazi staple and the
ultimate panacea, according to many Jewish mothers.

The hero of "Dreams of Glory," who had saved the inhabitants of an
Arctic village stricken by illness by transporting the much-needed serum
through inclement weather, returns in the form of *Brave Irene* (1986). As
Irene's mother takes ill, the young girl must defy a terrible snowstorm in
order to deliver the dress her mother had made for the duchess to wear to
a royal ball. A story of courage and filial love, the book is filled with wonderful
illustrations and might be interpreted as Steig's tribute to his own mother,
who, like many immigrant Jewish women from Eastern Europe, was a dress-
maker. The young boy who had arrived "in the nick of time" in "Dreams of
Glory" to save his parents from robbers (see page 42) returns as Leonard, a
child who must face the perils and temptations of a paradisiacal flora and fauna

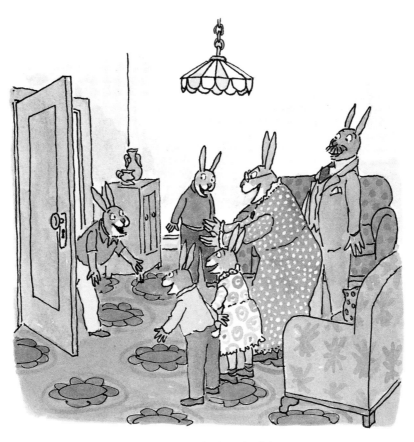

**"It was almost too much for them when Solomon, as
alive as possible, came bursting into the house"**
Final illustration for *Solomon the Rusty Nail,* 1985

and a dangerous band of mandrills in order to liberate his mother and father
from their imprisonment in *The Zabajaba Jungle* (1987). A seminal work in
the artist's career, the book covers enormous territory, alluding to the biblical
story of original sin and addressing sexual awakening, parent-child relations,
societal mores, and existential questions such as the one posed by the narrator
as Leonard enters the gaping mouth of a monster: "So others *were* here before
him." The book is so multilayered that it demands multiple readings and is a
formidable recapping of many of the topics the artist contended with through-
out his career. By freeing his parents, Leonard seems also to be liberating all
of Steig's "lonely ones" who had been imprisoned in their own bottles for
years. One critic has also suggested that the climactic scene embodies the
child's fears of being excluded from his family once he has ventured on his or
her own.[24]

At the end, William Steig's personal and artistic trajectory takes him back
to where it all began—his childhood. As in many of his books where the pro-
tagonist culminates his or her journey by returning to the safety of home and
loved ones, in *When Everybody Wore a Hat,* published a few months before his

Sketches and notes for
When Everybody Wore a Hat
Undated

death in 2003, Steig, the protagonist of his own life story, goes back to the safety of his home and family. The artist himself had said that "coming back to a family in the end is natural for kids."[25] *When Everybody Wore a Hat* surveys the artist's early life in the Bronx, telling of a time when "there were almost no electric lights, cars or telephones—and definitely no TV," when "there were lots of immigrants" and "no such a thing as a hatless human being."

The illustrations are done in pen and ink and vivid watercolors in a style that is both mature and genuinely naïve—a perfect combination that strengthens the connection to Steig the child without ever losing sight of Steig the artist. A number of drawings featured in *When Everybody Wore a Hat* had first appeared in pen-and-ink-and-wash form in the *New Yorker* in 1959 under

"During one of those crazy quarrels"
Final illustration for *Caleb & Kate,* 1977

"Sometimes Mom and Pop quarreled"
Final illustration for *When Everybody
Wore a Hat,* 2003

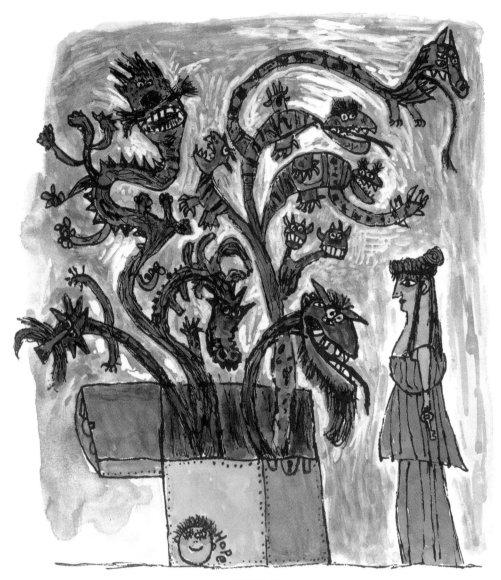

Pandora's Box
Final illustration for *A Gift from Zeus,* 2001

the Proustian heading "A la recherche du temps perdu," and were later published in the compilation *Continuous Performance* (1961).[26] Many of the drawings were originally accompanied by different captions, which Steig modified in preparation for their publication for children. One of the most remarkable and honest drawings in children's literature, as stressed by Edward Sorel in his insightful review of the book, is the one accompanied by the caption "Mom and Pop who came from the Old Country quarreled in four languages: German, Polish, Yiddish, and English" (originally it was ironically entitled "Mama and Papa never quarreled in front of the children").[27] "Who knows what they were saying? But we learned the important words," writes Steig to his young readers. His drawing and text reflect a thorough understanding of children's worst

fears—that of their parents not being there for them—while reassuring them that they are not the only ones to endure this trauma. Or, as Steig puts it best in *Caleb & Kate* (1977), couples love each other "but not every single minute."

Above all, Steig's work is about the redeeming power of nature, art, and love, to which we seem to be most receptive as children, or when we are in touch with our own childhood as adults. "I think I feel a little differently than other people do," Steig has said. "For some reason I'd never felt grown up."[28] "Why do I concentrate my attention on kids?" asks the artist in his preface to *Dreams of Glory and Other Drawings*. "Children walk with God . . . they are touched in the head and therefore fascinating."[29] No wonder that, in Steig's imagination, when Pandora decided to take a peek at the contents of that dreaded box—filled with "truculence, toothache, and dandruff," and many other evils—hope, that last survivor, bore the shape of a child's smiling face.[30] So, if I were to be asked "What would you rather be, a small fry or a big fish?" I would not hesitate for a moment. I would hit the stoop and even put up with the sulking and the bullying just to be part of Steig's universe, a world in which kids get to do all the driving.

Untitled drawing
Published in *Ruminations*, 1984

The Ever-Evolving Art of William Steig

Edward Sorel

Like Picasso, whom he revered, William Steig was an artist of change, continually moving from one style to another, but always in the direction of the more spontaneous. Late in life Steig regarded any kind of drawing that required tracing or preliminary sketches an unwelcome labor. Only "free drawing" brought him joy. "I often ask myself, 'What would be the ideal life?' I think an ideal life would be just drawing."

What Steig—always "Bill" to everyone—meant by "just drawing" was, presumably, allowing an image to escape from his unconscious. Art that was personal was the only art that had value. By middle age he considered drawings that required planning and reworking not only less enjoyable than free drawing, but less worthy artistically.

It's impossible to know at what point in his life this dichotomy between the premeditated and the spontaneous began to gnaw at him, but it was of no concern in 1930. At that time, agonizing about the inhibiting nature of illustration was a luxury he didn't have. He was twenty-three, and the Great Depression had made him the sole support of his parents and his youngest of three brothers. That year, when the high-paying *New Yorker* ($40 a cartoon) began buying his drawings, it was a lifesaver. And, of course, it was a boon to the magazine as well. Prior to Steig's arrival the cartoons largely depicted upper-class twits. Peter Arno was drawing playboys and chorus girls, Helen Hokinson was poking fun at fatuous clubwomen, and others created gags about bootleggers and millionaires. Steig's cartoons about the struggles, aspirations, and pretensions of lower-class families like his own were a fresh turn for the magazine.

But it wasn't simply the subject matter (a sort of *Remembrance of Things Past* from the viewpoint of a Bronx Jew) that made him a favorite with readers, it was the warmth and originality of his drawings. Outlined with a brush to which he added tones of wash, his scenes had a three-dimensional quality that created an air of believability. Equally convincing was the way he showed

"Are you carrying a cane tonight?"
"No. I'm going to rough it."
Drawing by Peter Arno (American, 1904–1968)
Published in the *New Yorker,* October 22, 1927

character through body language and facial expression. He was a master of gesture, and when he focused on family life, it fairly exuded gemütlichkeit.

A case in point is his wordless twelve-panel sequential drawing titled "The Accident in the Street." The first two panels show an ordinary middle-aged woman idly looking out of her tenement window. Suddenly she witnesses an accident in the street below. Horrified, she shouts for her husband. He and their little daughter join her and watch the tragedy unfold. Suddenly realizing the capriciousness of fate, they impulsively embrace each other. Steig's comic verve keeps it from being saccharine, but the feelings it evokes are universal.

This sort of tenderness for the common man was novel territory for American comic art, and its creator did not welcome trespassers on his property. When the *New Yorker* began publishing another cartoonist who also used the urban poor as his subject matter and drew in a style much too close for comfort, Steig declared war. In the exchange of letters that followed between the incensed cartoonist and chief literary editor Katharine S. White, Steig threatened to leave if the "vulgar imitations of my work" continued to appear. He didn't follow up on his ultimatum, but he did begin selling more cartoons to *Vanity Fair,* though that outlet ended when the magazine folded in 1936.

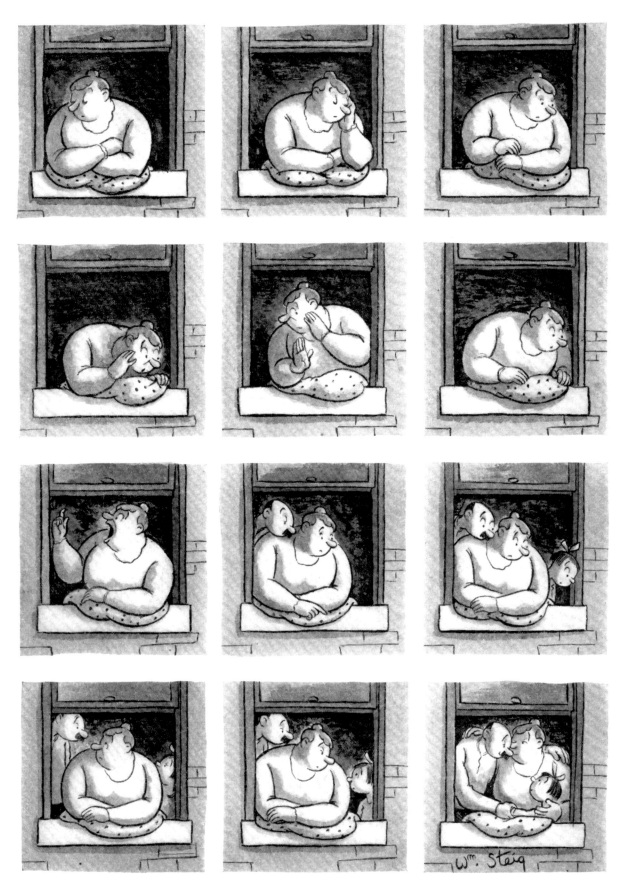

The Accident in the Street
Published in the *New Yorker,* May 26, 1934

Smoke
From "Small Fry: Snow" series, published in
Dreams of Glory and Other Drawings, 1953

Untitled drawing
Published in *Collier's*, May 21, 1940

In his book *The World of William Steig*, Lee Lorenz tells of the cartoon-ist's other beefs with the *New Yorker*. To begin with, they weren't buying enough of his "Small Fry" cartoons. These drawings, evocative of Steig's own childhood, were particularly precious to him, and he bristled when any were turned down. Then there was the indignity he felt working on "speculation." "I am continually asked to submit more idea drawings, more cover designs, more series ideas," he wrote to White, "much more material, in fact than you use. I consider this an unfair demand on my time and effort." The prickly char-acter evidenced in Steig's later years would appear to have been planted early.

Looking over the cartoons and dozens of covers the left-handed cartoonist produced in his first eight years at the *New Yorker*, one finds subtle changes. The heavily inked brush becomes drier and its line moves more freely. But these differences are nothing compared to the seismic changes we see in a small book he produced in 1939 called *About People*. It is a collection of esoteric images that at first seem little more than stream-of-consciousness doodles. But in their artistry and wit they represent a metamorphosis from cartoonist to artist.

Steig called these new pictures symbolic drawings. His brother, Arthur, who wrote the introduction to *About People*, heralded them as the "first exam-ples of work in a new art form," and went on to explain that "their reference is to the psychological integrity of the individual." Further evidence of the seriousness with which the artist took this new stage of his development, as Lorenz has written, were the many quotations from Johann Wolfgang Goethe,

William Steig and his youngest brother, Arthur
c. 1930s

Pablo Picasso, Paul Klee, William Blake, and Walt Whitman he unearthed for his preface.[1] Putting aside for a moment all claims for their intellectual profundity, one can see that these drawings are really a continuation of Steig's observation of the human condition, but done in a far more personal way than he had previously attempted.

The publication of *About People* had a surprising impact, in part because none of the work had previously appeared in magazines. No one was prepared, and some feared that they would never see more of his "Small Fry" cartoons. But having proved to the *New Yorker* and to the public that the depth of his creativity could exceed anything he had done in the magazine, he returned to doing the cartoons and drawings that had made him popular. A special favorite with *New Yorker* readers were his "Dreams of Glory" drawings, in which boys live out their movie-inspired fantasies. A few of these became covers, most notably one during World War II (from July 17, 1943), in which a boy imagines himself as a pilot shooting down several German planes at once.

In 1942 Steig published another small book, *The Lonely Ones,* similar to *About People* but more overtly comical; each image is captioned, leaving no doubt about what the drawing is meant to express. Some of them—"Mother loved me but she died"—entered the language almost immediately. Three years later his third book of experiments in line drawing, *Persistent Faces,* was published. In this collection of portraits, Picasso's influence is blatant. Steig used visual puns (drawing a fish for an eye in a profile, for example) and

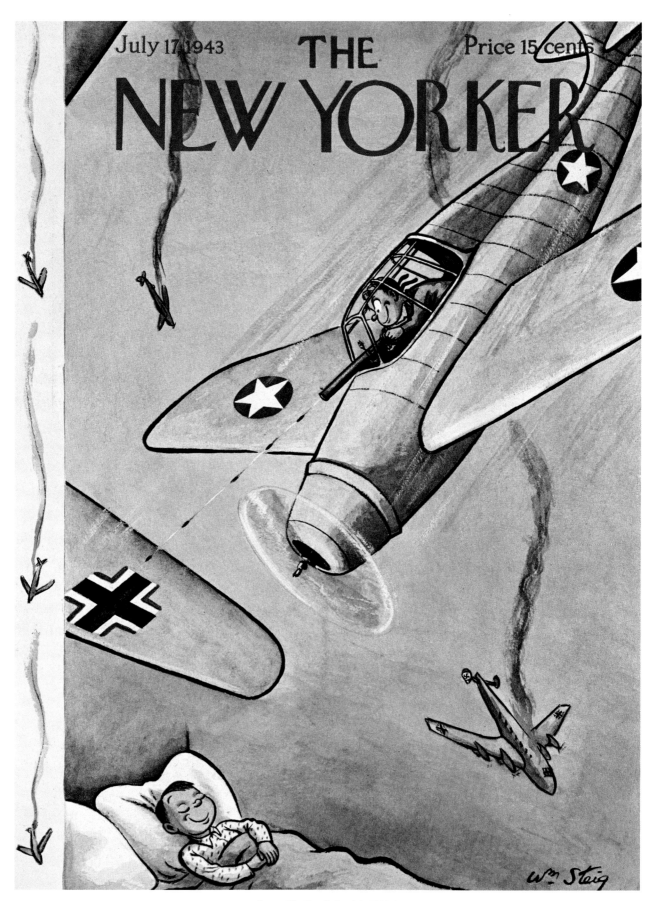

Cover of the *New Yorker,* July 17, 1943

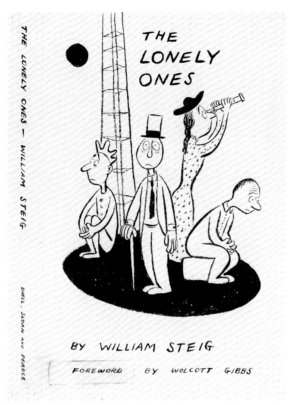

Final illustration for cover of
The Lonely Ones, 1942

Conformist
Final drawing for *Persistent Faces,* 1945

abstracted facial features in as many different ways as he could imagine. Artists and critics hailed his inventiveness, but others saw them as clever visual tricks substituting for insightfulness.

In later years Steig himself denigrated this collection, attributing his lapse to the meningitis he was suffering from at the time.[2] But with his recovery, which he credited to the unorthodox psychiatrist Wilhelm Reich and his orgone energy accumulator, Steig set forth on a new examination of the relationship between men and women. The resulting book, *Till Death Do Us Part* (1947), deals with courtship, marriage, and its discontents. Here Steig is at his wittiest and most spontaneous, and his line has never seemed more effortless.

The respect paid to him by critics assured him that he was now taken seriously as an artist, and he was allowed, in the words of Woody Allen, to "eat at the grown-ups' table." Steig was eager to have his symbolic drawings, which he regarded as his important work, considered apart from his cartoons. When he was urged to collect all his "Dreams of Glory" drawings into a book, he hesitated, fearing it would take attention away from his deeper work, such as *The Agony in the Kindergarten* (1950). He finally agreed to publish the "Dreams of Glory" cartoons in 1953, but not before redrawing a number of them, improving the body language and simplifying the backgrounds.

New World Champion
From "Dreams of Glory" series, published in
the *New Yorker*, April 8, 1950

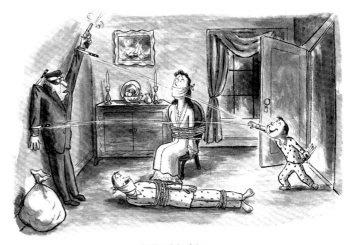

In the nick of time
From "Dreams of Glory" series, published in
the *New Yorker*, May 26, 1951

By this time Steig had just about given up doing gag cartoons, and his brushline was so free and spontaneous one can almost feel his joy in abandoning pencil sketches and all other guidelines. Now he himself would occasionally be surprised by what his hand had created, and "he loved that," his wife, Jeanne, has said. His experiments extended to color as well, as seen in his *New Yorker* covers for the next thirty years. These were his most stunning creations for the magazine, and the combination of colors he used he seemed never to repeat.

In the late 1960s several *New Yorker* cartoonists, including Steig, were invited to create their own children's books. His was a word game called *CDB!* (continued in the book *CDC?* in the 1980s), in which the accompanying picture supplies a clue to the letters' meaning. T-D-M, for example, becomes TEDIUM when combined with a picture of a father forced to listen to his son playing the violin. Though *CDB!* was a small black-and-white book, it was a commercial success. Did Steig ever begin an artistic enterprise that did not succeed? Apparently not. That same year, 1968, his second book for children, *Roland the Minstrel Pig*, became another popular and critical hit. The artist was sixty-one years old, and it's doubtful that he or the public had any inkling that, artistically, the best was yet to come.

Steig's third book, *The Bad Island* (1969), republished as *Rotten Island* in 1984, depicts a ghastly island inhabited by murderous beasts determined to devour each other. These fantastic monsters look deadly and amusing at the same time. Drawn with a boogie-woogie line and blaring color that occasionally makes you want to step back a bit, it became, and remained, one of the artist's

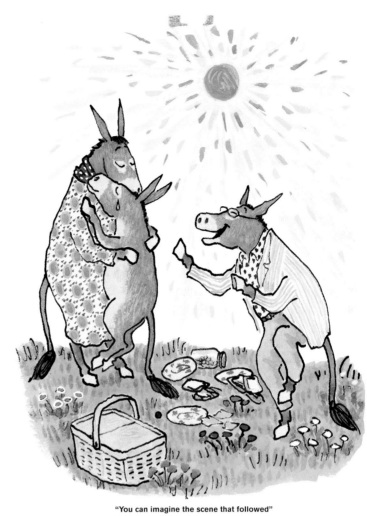

"You can imagine the scene that followed"
Final illustration for *Sylvester and the Magic Pebble*, 1969

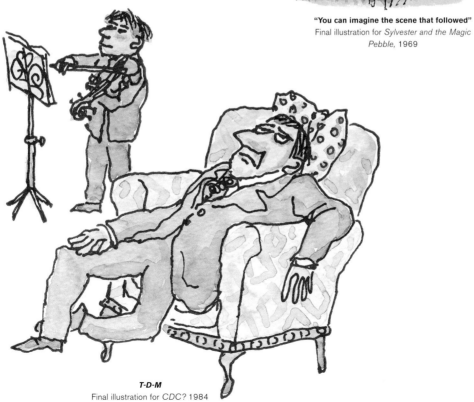

T-D-M
Final illustration for *CDC?* 1984

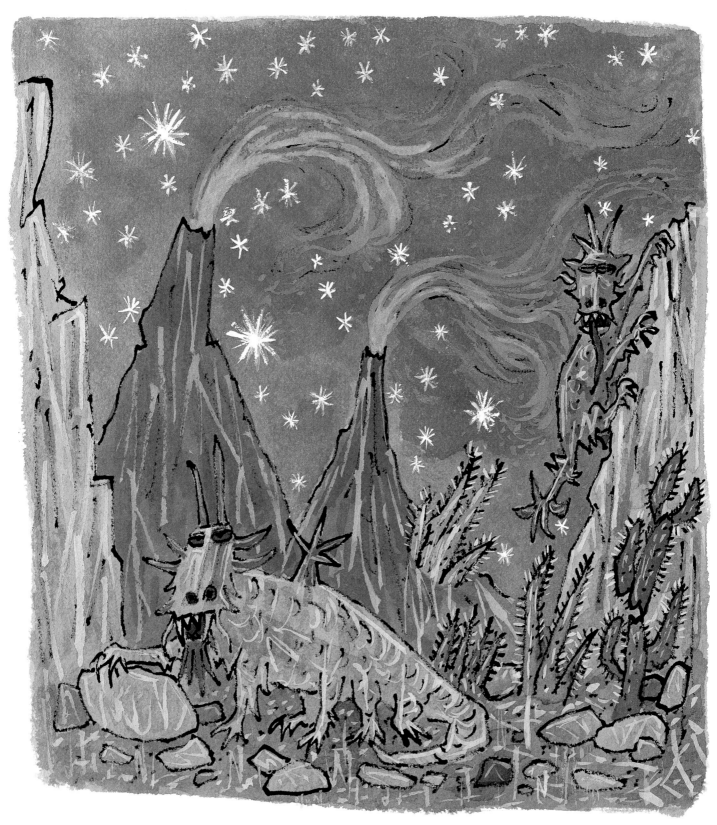

**"At night it froze: all living things stopped moving
and turned to ice"**
Preliminary illustration for *The Bad Island*, 1969
(republished as *Rotten Island*, 1984)

personal favorites. He had deliberately written a story without a protagonist so that he could draw freely and never have to duplicate a figure. Now he could simply draw without knowing exactly where he was going, and then be surprised with the result. Because of the book's spontaneity he seems to have seen it as on a higher artistic plane than some of his other books for children. What Steig refused to consider was that an artist's own enjoyment at creating art is not the only criterion for judging its value.

That same year he wrote and illustrated *Sylvester and the Magic Pebble*. It's unclear which book was done first, but they could not be more different. Where *The Bad Island* is raucous and rather plotless, the drawings in *Sylvester* are serene and carefully designed, and the tale builds to the happiest of climaxes. In the story, Sylvester, a young donkey, picks up a red pebble, which has the power to grant him any wish. When he encounters a lion on the way home, he saves himself by wishing to be turned into a rock. As the wish comes true, he now has no way to wish himself back to life. "Night followed day and day followed night over and over again. . . . He felt he would be a rock forever and he tried to get used to it." Some adults read the book as a parable about death, but the author saw it as being about a youth's relations with his parents.

Many consider *Sylvester and the Magic Pebble* Steig's masterpiece, but in truth, it's only one masterpiece among many. By the time he died in 2003 he had produced forty books specifically for children. But if we consider his entire oeuvre—his prolific output, the inventiveness of his stories (so often involving transformation), his precise and demanding language, and the sheer beauty of his pictures—then his legacy can only be described as unprecedented.

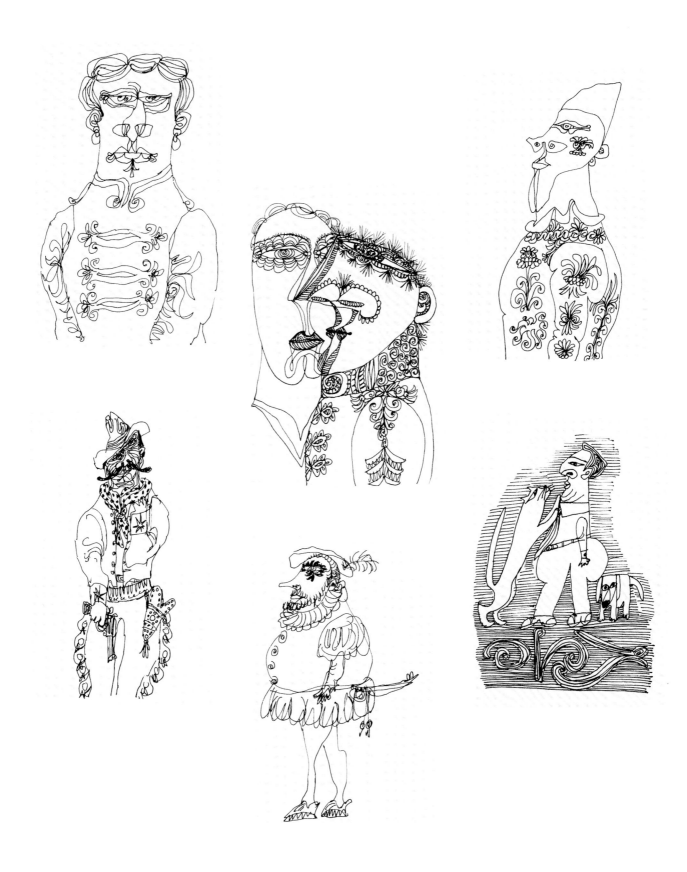

Doodles given by the artist to his daughter Maggie
1972–76

What Would You Rather Be?

Maggie Steig

My father's hair grew straight up out of his head. It had velocity. Sometimes, when he got out of bed in the morning, he would look like he had been shot out of a cannon backwards.

I loved everything about my father's person—his crazy hair, his square hands, the shirts he wore, the cadence and tone of his speech, and his beautiful blue eyes surrounded by smile crinkles. Being with him always made me feel good.

I was born when he was fifty-one, and when we were together he played with me constantly. He was a very good player. The repetition in children's games never bored him; he experienced every moment as being entirely different, even if the content appeared to be exactly the same. Sometimes grown-ups get complimented on their patience in playing with children. Bill wasn't being patient—he really enjoyed it, and whoever he was playing with knew it.

Children and animals always commanded his full attention. He could watch animals endlessly. He would always speculate about what they were thinking, and he liked to predict what they were going to do next. He felt it to the bone when an animal was in a bad predicament. He usually had a cat or a dog living with him, and his deep affection for these members of the family was evident. He empathized greatly with animals, people, and even things.

One favorite thinking game we played was called "What would you rather be?" (which was later turned into a book). To play, you ask questions like: What would you rather be, a tree or a flower? And why? Whatever you answered you had to explain—I'd rather be a tree because I'll live for a long time, I'll see the change of seasons for years, and birds will come and sit on me, and maybe some people will climb me too. Maybe they'll carve their initials in my bark to be seen by every passerby. Or—I'd rather be a flower because even if my life is short it will be exciting, I could be in a royal wedding bouquet, and afterward the princess will press me flat in her diary . . .

We would play this game on long subway rides. Most often he would pose

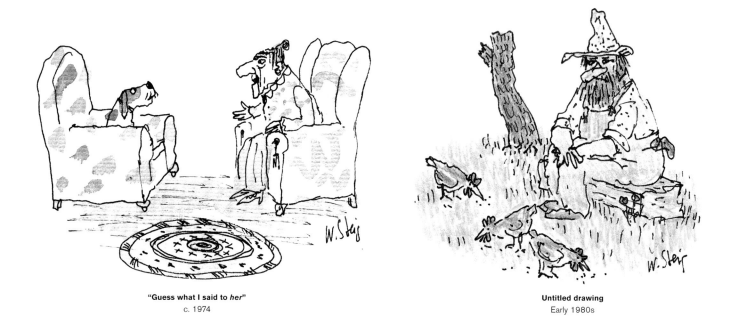

"Guess what I said to *her*"
c. 1974

Untitled drawing
Early 1980s

the questions — what would you rather be, a door or a window, a knee or an elbow? Following his example, I would think very hard about what it would actually be like to be those things. I would try to feel myself into the door or the window or whatever the object was. It was an unspoken rule that even if you found something unappealing, you had to try it on.

The game would inevitably, and gleefully, degenerate into choices between two very undesirable items. What would you rather be — a pinch of pus or a pile of puke, a scab or a wart? We dove into these imaginings. Really thinking about being a wart or a scab made me consider them a bit differently. Bill drew a lot of warty, scabrous characters, always with great affection. I think it's because he always felt himself inside the characters (and even the warts) he drew.

His drawing table always stood in the middle of his modest studios, unconstrained by contact with any walls. The first drawing table I remember was an adjustable wooden drafting table at his Washington Place apartment in Greenwich Village. He used an adjustable Luxo lamp clamped to the desk. The surface of the table was completely crowded. There were his rapidograph pens, his bamboo pens, various India inks, cotton rags with ink stains, stacks of good paper and doodle pads, stacks of drawings, a magnifying glass and a reducing glass, a coffee can filled with a variety of paint brushes, and a very large scissors.

The scissors fascinated me. They were huge and looked worn, but I never saw him use them. He always tore his paper to size, giving it a nice deckle-like edge. He showed me how to fold it back and forth many times so that it would weaken along the folded line and tear easily.

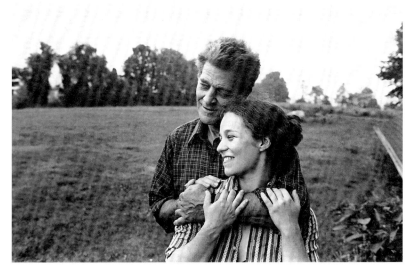

William and Maggie Steig, Kent, Connecticut, August 1979
Photograph by Sarah Benham

Ring made by Maggie Steig
for William Steig

When I was about six we developed a bedtime ritual with his painting brushes. After reading to me, he would bring in the can of brushes and let me choose one. He would then "paint" my face, outlining my features or detailing the shadows. The brushes had different textures, and I became fond of them all. My favorite was the scumble brush, with its arched, fan shape. After he brushed my eyelids shut it was always easy to sleep.

When he moved to Kent, Connecticut, in 1972, his drawing table increased in size. He was doing more kid's books and had started coloring more of his free drawings, so his desktop now accommodated colored pencils, watercolors, gouache, and colored inks (made by Bill's brother, Arthur). There was also an assortment of small talismans and a collection of gaudy rhinestone brooches. He liked to work with a little sparkle in his periphery. I had made him an enameled ring he said he liked to wear while he was drawing, but more often I saw him twirling it on the end of his nose, lost in thought.

He was partly deaf due to an episode of meningitis in his forties. Usually he wouldn't hear me when I came into his studio. I liked to watch him draw. He didn't mind having people around while he was working, but those moments when I saw him drawing before he knew I was there were special. He said a lot of his drawing was really unconscious, and that he enjoyed being surprised by what came out of his hand. It did look effortless except for when he was illustrating, which he regarded as a chore due to the repetition and continuity requirements. While watching him illustrate I would see him making all kinds of faces. He was making the faces he was drawing.

He saw faces everywhere, in the grain of a pine board, in the folds of a

Untitled drawing
Undated

"This is in the strictest confidence"
Undated

cushion, in the top of a muffin—everywhere! He loved to share the faces he saw and was always happy when other people saw them too. In the last decade of his life we used to play a drawing game called "Five Lines." One person would make five random lines on a piece of paper, and the other person would have to add to those lines and turn them into a face. At the age of ninety-four, when Bill decided he was not going to draw anymore, this game would tease him out again.

He couldn't keep a secret—they encumbered him in some way—and as soon as he had one he had to get rid of it. A friend named Barney Rooter once confided in Bill that he bet on horses and asked him not to tell anyone. As Bill described it, the sentence, "Barney Rooter bets on horses" played a loop in his head, getting louder and louder. He left the apartment and blurted out to the first person he knew, "Did you know Barney Rooter bets on horses?" and he was a free man again. We tried not to burden him with any information about which he needed to be discreet. In his nineties I remember him saying to me, "There's something I'm not supposed to tell you, but I can't remember what it is."

He remembered his childhood like it was yesterday. I loved to hear his stories. One favorite is about the time he fell down the fire escape. It was a broiling summer day in the Bronx, and he was going to pay a visit to his upstairs neighbor, Essie Hobberman. He climbed up the fire escape to call at the kitchen window. It was wide open. Mrs. Hobberman was washing the floors

Accident
From "Small Fry: Park Playground" series,
published in the *New Yorker*, April 18, 1953

"What a battle royal raged!"
Final illustration for *Dominic,* 1972

with her long skirt pulled up onto her back, her big, bare bottom in the air. Stumbling backwards, Bill fell some distance. The doctor was called for, and Bill, conscious but stunned, was examined and pronounced physically intact. However, he did not speak no matter how the doctor prodded him. The doctor announced that he would be mute, and then departed, whereupon Bill told his tearful mother, "It hurts, Ma."

He never forgot what it was like to be a kid—how little choice kids have, how unfairness feels. He hated injustice. Doing the right thing was very important to him. If a clerk gave him an extra dime in change, he would drive miles to return it. He was the most honest person I've ever known, and although he sometimes lacked a little in tact, you could count on getting the straight story from Bill.

Like a kid, Bill saw things in black and white—you were a good guy or a bad guy, and there was nothing in between. For the people that he considered to be the bad guys, his fantasies knew no end of punishments. The worst of the bad guys were the hateful politicians, the ones who lied and cheated (and surely you would agree with him about who they were—you were no friend of his if you didn't).

I N-V U
Final illustration for *CDB!* 2000

Besides politicians, there was one other group of which Bill was not too fond—scientists. I think he just didn't like anyone poking at the mysteries of the universe. He had a particular pet peeve about the big bang theory. Any visitor with a scientific bent was lured into discussing it. "Tell me about the big bang theory," Dad would begin. The discussion would always end with Bill dismissing the theory by saying something like, "You mean to tell me this couch, this rug, and this whole house fit into something the size of a baseball? That's ridiculous."

My dad loved sweets. I sometimes wondered if he was preserved in sugar. Every day there was jam in the morning, cookies after lunch, and an untold amount of the treats that everyone loved to give him. The sweets were kept in the kitchen pantry, which he would refer to regularly all day, every day. It was impossible for anyone—child or adult—to know him well and not enter into some form of candy conspiracy with him. It was just too much fun to enjoy his enjoyment, especially in the late afternoon hours before dinner when it might spoil one's appetite.

There was a decorative egg-shaped container on the table next to the chair where he always sat in the living room. When we visited, my daughter, Lily, would make many secret deliveries from the pantry to the egg, which he accepted with glee. My sister, Lucy, and her daughter, Melinda, were his halvah connection. His wife, Jeanne, gave Godiva. Holly, his editor, gave him ninety candy bars on his ninetieth birthday. I specialized in dark chocolate–covered orange peel. He would take the wrapped box as if he were going to faint and ask, "Is this what I think it is?"

His enjoyment of candy was like his enjoyment of many things—exuberant, unabashed, innocent, and extreme. If he was eating a good cookie, it immediately became the best cookie he'd ever tasted. When he liked something

he would demand that whoever was there come share the experience. "You have to come see the sky!" "Look at the Ryder moon!" "You've got to taste this!" His enthusiasm stopped the normal pace of life and helped us all enjoy the beauty at hand.

As his life was winding down I loved to just sit with him. He had such a warm, generous presence that it felt good to be near him. I think many people experienced that with him. We didn't have to say or do anything, we just enjoyed each other. His essential self was a great appreciator. When he looked at nature, when he looked at animals, when he looked at people he loved, his look always said, "You delight me." His delight is in all his art, and it is how I remember him.

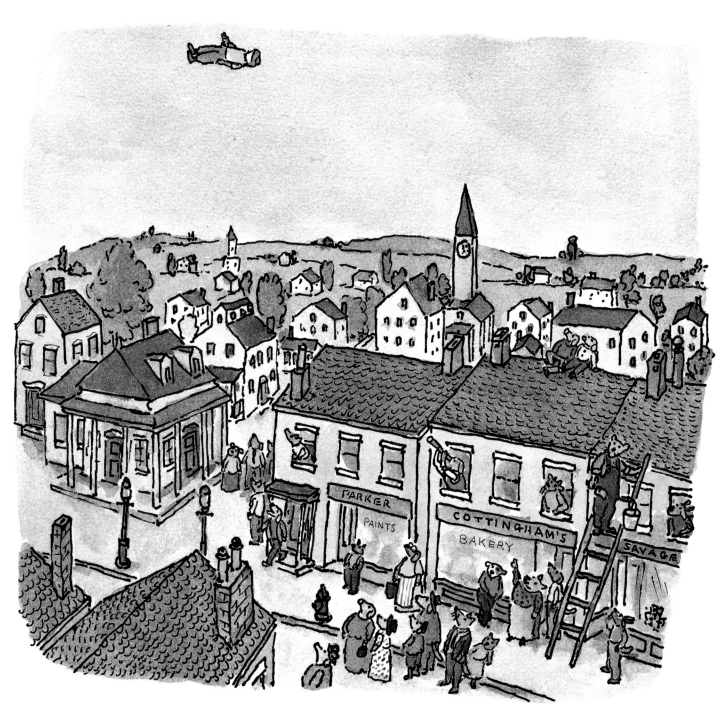

**"As Gorky passed over Pruneville, they were craning
their necks out of windows"**
Final illustration for *Gorky Rises,* 1980

One of a Kind

Robert Cottingham

Sometime around 1948, I entered my teenage years and became an avid follower of mass-media magazines. Looking back, it seems that they were everywhere, an unending flow of latest issues, each documenting our lives as mid-twentieth-century Americans. *Life*, *Look*, *Collier's*, *Esquire*, the *Saturday Evening Post*, and the *New Yorker* were at the top of my list. Their pictorial content fascinated me most. As a fledgling artist I took a keen interest in the illustrations and cartoons, as well as the photography, lettering, and graphic formats of these periodicals. I scoured the editorial material and the advertising pages. It was one big visual feast to me.

The *New Yorker* occupied a special place in this hierarchy. A veritable portfolio of art and literature, it was, and still is, a category unto itself, bringing together, in elegant presentation, some of the most creative talents of the time. I became familiar with the work of the *New Yorker*'s regular contributing artists. Their cartoons, executed in black and white and spread throughout the magazine, reflected their individual styles, each as distinctive as the signature attached to it. I had my favorites, of course, but even within this select group, one talent seemed to rise above the merely great. More visible, more prolific, and, it seemed to me, warmer and more knowing, was the extraordinary outpouring of visual ideas from the mind and hand of William Steig.

Here was an artist unique among the unique. Much of his cartoon work functioned beyond the accepted parameters of that genre. (The term "cartoon" never fully embraced the range of illustrations, doodles, and Picasso-inspired drawings Steig did throughout his life.) Often omitted from his work were the gags or punch lines of the more conventional cartoons, although he did his share of those as well. Many of his drawings would convey, through a character's body language, a psychological state or social predicament. Some of these appeared without titles or other verbal clues, occasionally leaving the reader mystified. Others might be titled with a single word or short phrase identifying a behavioral classification or a character's neurosis.

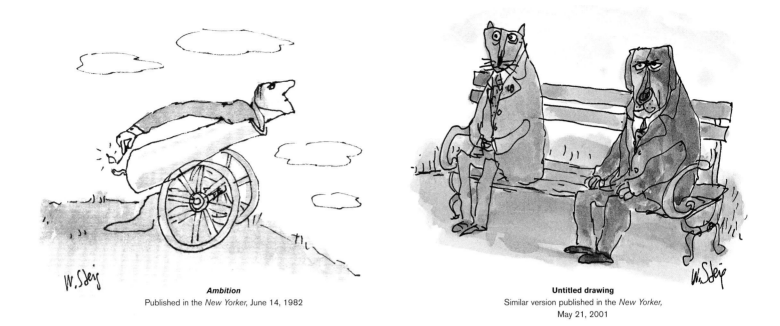

Ambition
Published in the *New Yorker*, June 14, 1982

Untitled drawing
Similar version published in the *New Yorker,*
May 21, 2001

Overall, these drawings spoke of the human condition, the messages delivered by a parade of immediately recognizable characters—Steig characters—that could also be read as stand-ins for ourselves. We could not avoid viewing these creations with understanding and a smile of acceptance. Even the most arrogant characters would somehow gain our sympathy because we understood that they carried the immense weight of being human.

The covers that Steig did for the *New Yorker* (one hundred twenty-three of them) expanded on the themes of his black-and-white drawings, the characters enlarged, their actions now played out in full color. The motifs usually referred to the current season or holiday. (He did nine Fourth of July covers—the most of any artist for the magazine.) Some might reflect the country's current climate or its collective mood, but always with that Steig twist, offering a viewpoint that wasn't quite available to us before.

As my wife, Jane, and I raised our family, we would save and frame *New Yorker* covers that resonated for us at that moment in our lives. The covers that produced that thrill of recognition were *always* the Steig covers. One of our favorites was the cover for the holiday issue of 1969 (the year our first daughter was born) depicting a little girl in party dress opening Christmas presents, surrounded by adoring relatives who clearly see her as *their* Christmas present.

Years later, living in Connecticut, we were invited to a dinner at the home of mutual friends. We drove north from Newtown, the Steigs drove south from Kent, and we met for the first time. Other dinners followed as Bill and Jeanne and Jane and I established a friendship that would continue for thirty years.

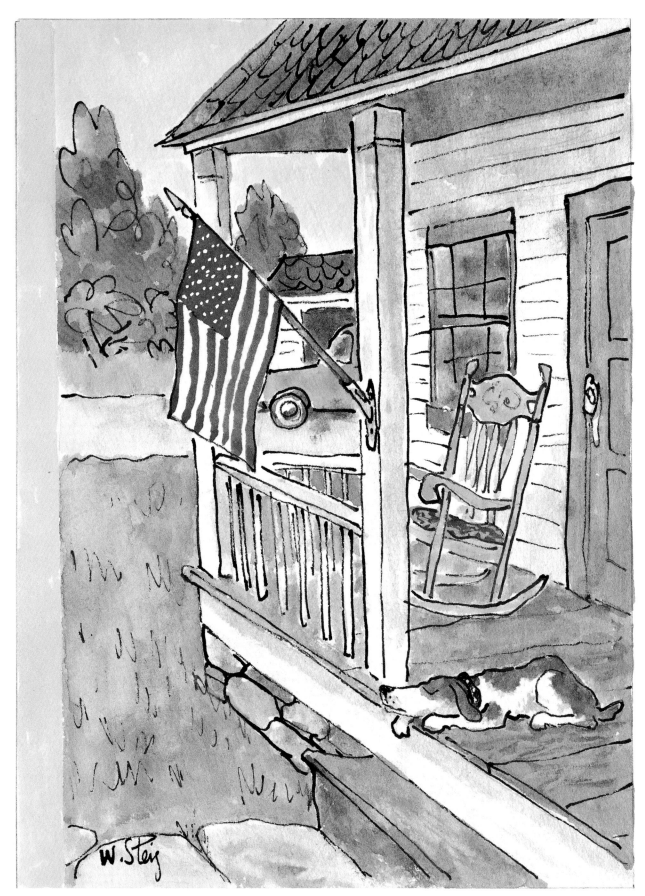

Final cover illustration for the *New Yorker,* July 6, 1968

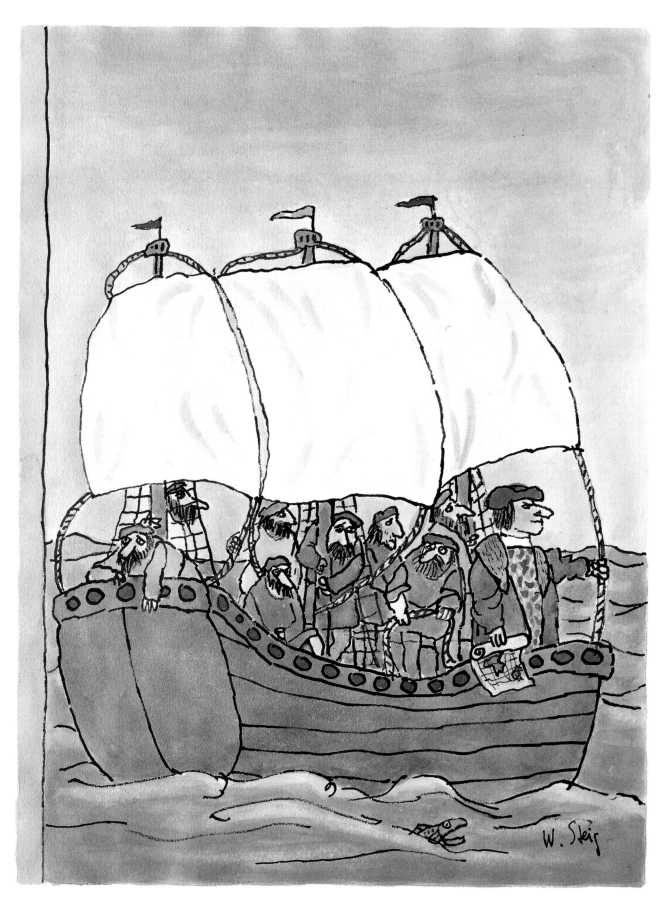

Final cover illustration for the *New Yorker,* October 9, 1989

Cover of the *New Yorker,* December 27, 1969

William and Jeanne Steig, 1997
Photograph by Nancy Crampton

Jeanne—sculptor, writer, collaborator, and life partner—was Bill's fourth wife, but that seemed only fair. Bill was Jeanne's fourth husband. It was the winning combination.

After a few of these evenings together, Bill and I were to have lunch together, just the two of us. This caused me some anxiety. Conversing at a small gathering was one thing, but sitting face to face over lunch, with no conversational support from our wives, was a very different matter. I'd known Bill for some time now, but he was still a hero to me, based on at least thirty years of admiration for his work. And besides his being an institution, he was born the same year as my father. Could we bridge the gap? What would I say to William Steig?

I needn't have worried. Bill took the lead and the conversation took off. We discussed art, money, children, women, film, history, publishing, and favorite candy bars. He spoke of his friend Stuart Davis, and his theories of color. He told of how his fellow *New Yorker* contributor Saul Steinberg would lecture him on the importance of career building and the necessity of self-promotion. (Bill would have none of it.) He told vivid tales of growing up in the Bronx, survival in the streets, and escapades on tenement stairs.

In his youth, Bill worked as a housepainter and a lifeguard. His great ambition had been to go to sea and travel the world. In fact, he had already received his papers to sail when the Great Depression ended his dream. Forced to support his family, he used the drawing abilities he learned from

his brother, Henry, and the art education he received at the National Academy of Design, to create cartoons. His first sale was to *Life*, a humor magazine that later sold its name to the more famous photographic newsweekly. He continued to sell to other publications, including *Collier's* and the *Saturday Evening Post*, before joining the *New Yorker*, where he remained a contributor for seven decades.

He would look forward to meeting days at the *New Yorker* when the artists personally delivered their newest work to the magazine's offices. This occasion inevitably meant a lunch with a group of his peers that might include Charles Saxon, Mischa Richter, Lee Lorenz, Charles Addams, Donald Reilly, Edward Koren, William Hamilton, Stan Hunt, Warren Miller, George Booth, and other luminaries.

"Steig is one of a kind," I heard from his friends and colleagues over the years. Yes, he was a true character, and a contradiction in many ways: insightful and wise, innocent and guileless. He was soft-spoken and reserved, yet always ready to initiate a conversation.

Bill could wrap up a topic pretty well, too. Once, over dinner, we discussed my compulsion to close cabinet doors, however slightly ajar they might be. "A closed door represents death," he said. "But what about an open door," I asked. "What does that mean?" "Also death," he said.

Bill enjoyed a good story and a good laugh, which he seemed almost to want to hide. There were no guffaws or outbursts of any kind. His was a silent chuckle, accompanied, if the laugh intensified, by watering eyes and a reddening face as he struggled for composure. Getting that reaction to one of my stories was to make my day.

He could give himself a good laugh too. His favorite joke—I witnessed its telling a number of times—was about the European immigrant who arrives in New York. Unable to speak English, he learns one phrase from a friend— "apple pie and coffee"—to be used in restaurants so that he won't go hungry. After days of eating nothing but apple pie and coffee he pleads with the friend for another phrase. The friend teaches him "ham sandwich." The first waiter he uses it on asks, "White or rye?" He panics and answers, "Apple pie and coffee." Bill would laugh at his own telling of this as though he'd just heard it for the first time.

In Connecticut we dined out or at each others' homes. There were weekend trips to Boston, the Hamptons, and Block Island. Eventually, the Steigs moved to Boston, but we continued to see each other. By that time Bill and Jeanne had become surrogate grandparents to our three daughters, who had only limited experience with their own. In their Back Bay apartment, Bill and

Cover of the *New Yorker*, November 30, 1998

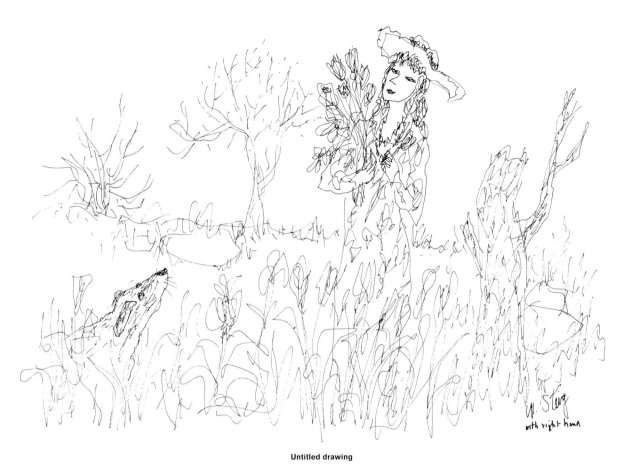

Untitled drawing
Undated
The left-handed Steig made this drawing with his right hand.

Jeanne created rooms of lush, seductive color. Walls of burnt reds and oranges, and velvety violets, became the backdrops for collections of toys, masks, paintings, and sculpture. Here, in this artistic, organic space, the couple had separate studios, where they worked daily.

At sixty, the age when others find themselves retiring, Bill began a new career writing children's books. He published forty of them, winning numerous awards and creating a treasury of classics. He was remarkably prolific and never without projects. The cartoons for the *New Yorker* were an ongoing affair. Cover assignments broke into that schedule periodically and the books, his favorite endeavor, developed at the rate of one or two a year.

Bill's drawing process was as direct and uncomplicated as his conversation. With image in mind, he would begin drawing with ink, usually starting with a character's head and expanding from there. He had no need for preliminary drawings or even thumbnail sketches. If the occasional drawing didn't work out to his satisfaction, he would simply do another.

His knowledge of the visual world was prodigious. Animals, landscapes, furniture, vehicles, and architecture were always drawn from memory. He

Final cover illustration for *Abel's Island,* 1976

would reluctantly resort to reference material only when confronted with a project requiring some degree of historical accuracy. He once grumbled at length when there arose the possibility of his illustrating a Shakespearean play. On his shelf he kept a book of historic costumes, and one of Wild West drawings, as emergency backup. His resistance to this type of research was warranted. His gift of invention was allowed free rein only when he drew from his head, relying on his own catalogue of memories and interpretations of the world.

Bill created his line drawings using an old-fashioned straight pen with a wooden shaft, cork grip, and interchangeable nibs. Dipping into his bottle of India ink, he would begin the contour of a particular shape. Often, as the line continued, his hand would leap ahead and place a tiny dot where he wanted the line to go. Each time the line caught up with the dot, his hand would again dart out to establish the destination for the next segment of line. Then again he might use a bamboo pen to obtain a delicately broken line. He loved to experiment with any new materials.

For magazine covers and children's book illustrations, he would add color to these drawings, using gouache, color dyes, or watercolors, with touches of opaque white. His brother, Arthur, also an accomplished artist, developed and manufactured the ink, dyes, and opaque white that Bill and many other artists considered the best on the market.

Bill claimed to enjoy writing his stories more than he did illustrating them. Many began with only a notion of plot or character, growing organically as he worked on them, each chapter determining the thrust of the one following. With this freewheeling approach, the outcome and moral of the tale sometimes remained unknown until its completion. Other stories, however, might begin with a single, powerful theme. In *The Real Thief* (1973), Bill set out to write a story of injustice, specifically the heartbreaking consequences of unjust accusation.

In many of his stories, the lead character embarks on a voyage of discovery, the reader gaining insights as the journey progresses. But in one surprising instance it was the author who gained the insight. Some time after Bill had finished writing his book *Dominic* (1972), he realized that his main character, Dominic the dog, was in fact a portrait of his own father.

These children's stories, requiring the fusion of Bill's two major talents—writing and drawing—provided him with ample reason to create new worlds on a daily basis for the rest of his life. "If you want to be a writer, it's important that you write every day," he would say. He obviously believed this to be true for artists as well. "He drew every day," Jeanne told me. "It was the thing he loved the most."

In his last years, his gait slowed to a shuffle and his diminished hearing made conversation difficult. But he continued to work and to take delight in the simple joys of his world.

In his book *Abel's Island* (1976), Bill drew Abel reclining on the limb of a tree beneath a starry sky. I view this gentle, loving illustration as a self-portrait. Abel *is* Bill, worldly, at peace, and enthralled as he contemplates his place—our place—in the vastness of the cosmos.

"King Kang" (**"Ken, the killer kangaroo . . ."**)

Final illustration for *Alpha Beta Chowder,* 1992

Clowning Around

Jeanne Steig

When I first met Bill he lived on Washington Place in Greenwich Village. His studio was a tiny room with a view of the seedy hotel across the street, a place diverting by virtue of almost-nightly drug busts, and even, once, a sniper on the rooftop. Bill would sit down to his desk like another man might hunker down at the movies; there was a little glass of booze beside him instead of popcorn. His drawings were smallish, partly because that made them easy to transport on Wednesdays to the *New Yorker*, partly because the space on his desk was consumed by teetering stacks of drawings—his filing system. The ceiling above him was tar-black from the four packs of cigarettes he went through daily. There was always music playing: blues, most often, jazz, Indian music, Beethoven's last quartets.

It was a purely functional apartment. The living room held a table, a huge and venerable overstuffed chair, and the daybed on which he slept. Burlap curtains of dubious color and age contributed style. Bill was not an acquisitive man. Pride of place was held by a large cow weathervane, the only proper bit of decoration, except for two Stuart Davis paintings given to him by the artist. There was a tiny kitchen, a small room reserved for visits from his young daughter, Maggie, and the studio, which housed the orgone energy accumulator in which he often sat reading, "recharging" his boundless energy and bolstering his excellent health. He claimed it had rescued his mother from cancer; his belief in it was absolute.

We met at a party in Brooklyn Heights, an upscale locale alien to both of us. Bill had asked a former girlfriend to take him someplace where he could meet girls; I came with a friend in want of a companion. As it was a costume party, she had dolled me up in dismaying cerise tights and an awful bonnet. The other guests were resplendent; we could have been at Versailles. I crept across the room in search of the bar and was stopped in my tracks by a good-looking, irritated fellow whose hair stood on end. He was wearing a serviceable sport jacket and a ratty knit tie and waving a couple of drinks in my direction. "I was bringing a vodka to that actress in feathers," he complained, "and

PRICE $3.50

NOV. 25, 2002

THE NEW YORKER

W. Steig

Cover of the *New Yorker*, November 25, 2002

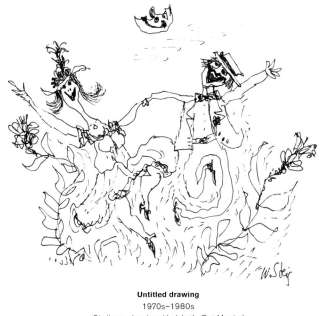

Untitled drawing
1970s–1980s
Similar to drawing titled *Let's Get Married*

somebody beat me to it." I relieved him of the drink, and we fell into conversation. The ex-girlfriend turned up and introduced us. I was staggered to find myself talking to William Steig, whose work I loved, and who, I had somehow assumed, was long dead. Bill was twenty-two years older than I was. It never showed. "You know my work?" he asked shyly.

"Everybody knows your work," said I. The girlfriend, seeing that she had done her duty, departed.

He quizzed me: "Who is your favorite artist? Picasso, right?" I was given no time to answer. "Who is your favorite writer? Melville, right?" Then, in a rush, "We have a lot in common." Favorite artists aside, we did. "Where do you live?" he asked.

"Fourteenth Street and Seventh Avenue," I said.

"I don't usually go that far uptown for girls," he said, "but maybe we could get together." "Sure," I said, "if you don't mind traveling." The next day I told my kids that I had met one of my heroes, and that he had asked me out.

"Go for it," they said.

"But he seems to be a little crazy," I added.

He was crazy, of course, in the best of all possible ways. He had something of the clown in him: he was goofy and often mysterious. You could sometimes predict what he was going to do; you hadn't the slightest idea why he was doing it. He was not, as he was moved to say of those who puzzled him, like the other boys and girls. Bill resembled a simple man, a role that pleased him, but when you looked at his work, you knew better. Bill's work was the living center of his life. There, he saw everything.

He was a neighborhood sort of guy; he didn't much care to travel. He was pleased to go out to dinner, once you managed to pry him from his desk, providing the food was good, the waiters were interesting, and the ambience was "not too fancy." In New York he liked to dine at the soda fountain in Bigelow's Pharmacy, where he indulged himself with a chocolate malted, his all-time favorite food. When we moved to Boston he admired the cafeteria at Massachusetts General Hospital, which turned out excellent BLTs. More sophisticated dining pleased him as well, assuming the maître d' didn't try to force him into a jacket.

Reading was essential. He read *Moby-Dick* once a year for many years before he decided he should catch up on contemporary fiction. He turned up his nose at the supernatural and at science fiction; the real world was juicy enough. A quick look at his bookshelf reveals Lewis Mumford, Alec Wilkinson, Robert Burns, Nicanor Parra, Krishnamurti, Edith Hamilton, Irish verse, W. H. Hudson, Machado de Assis, Elizabethan lyrics, Wislawa Szymborska, *Piers Plowman*, James Joyce, and Simenon's Maigret.

Because of his considerable hearing loss, Bill didn't always catch what was being said. The visual was what he was after, anyway. He loved television and particularly relished a Spanish talk show though he did not speak a word of Spanish. The excitement on the faces of the speakers, their intensity, captivated him. He drew hundreds of pages of faces; some were abstract, and some resembled portraits, though they never were.

Though Bill was wary of too much company, he talked enthusiastically to waiters and taxi drivers, with whom he might enjoy an intense conversation and no further obligations. He could be a curmudgeon when he felt pressed to be gregarious; he could also be the best possible company—which is why he so often felt pressed. He never postured and always said exactly what was on his mind. Bill navigated by his feelings; you were either with him or agin' him. He didn't allow for many shades of gray. When you first met, he would ask you about yourself; his questions were personal and direct, and he was utterly honest, always. You felt his energy on you, like a gift.

It was Bill who made a visual artist out of me. I went into a shut-down writer's block the moment we got together. "Well, you can't sit around writing all day," he said. "It isn't healthy." He had just begun writing children's books, and he never stopped drawing, so his advice wasn't worth much. "You have to do something with your hands," he said. "You ought to be making things." I protested my lack of skill and training, but the truth was that I had always wanted to make things, and he had somehow figured that out. So I gathered what was lying around my apartment and what turned up on New York streets

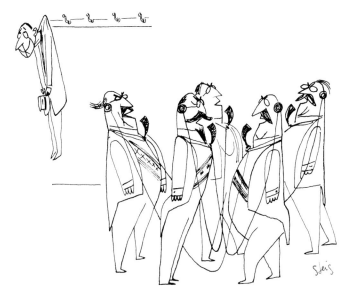

Throw out your politicians and diplomats
Final drawing for *Listen, Little Man!* 1948

and began what became a passion. My medium is still "trash," and my work is a kind of lyric comedy, whereas my poetry always tended toward sorrow. I was now, after all, outrageously happy.

It was lovely working with him. Or before him or after him. We didn't exactly work together. I wrote, then he illustrated, or vice versa, but I wasn't allowed to write a proper story; Bill hated to illustrate stories, including his own. He hated repetition; he really hated having to do anything he was told to do, even if he was telling himself. Two of our books, *A Handful of Beans* and *A Gift from Zeus,* were written from drawings he had done much earlier and had only to color. Even then, when I mentioned a white bull, he came up with a black one. "It's supposed to be white," I complained. "It's black," he said. "Now" was strongly implied.

I was always honored to make a book with him. I learned so much from him, above all that being a comic artist was a reasonable, serious profession. He taught me about craziness and that you had to go all the way with it or fall into the dreadful, damned state of cuteness. Craziness meant letting go, allowing the mysterious thing that needed to get said or shown find its own way. The bizarre articulations of the bodies he drew were descriptions of inner lives; an arm might emerge from a neck or a hip, for instance. These distortions seemed right; they told something about character, about spirit.

Bill drew with enormous pleasure; he got a kick out of what flowed from his pen much as a man at a movie theater might from a knockdown comedy. His drawings surprised him; he loved that. He loved working for the *New Yorker.* His cartoons are peopled with convicts and lovers, drunks, drifters,

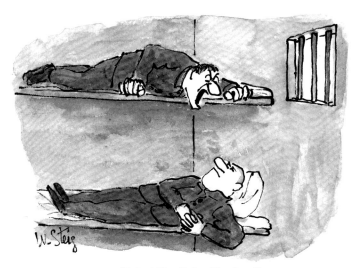

"You've told me that a million times!"
c. 1963

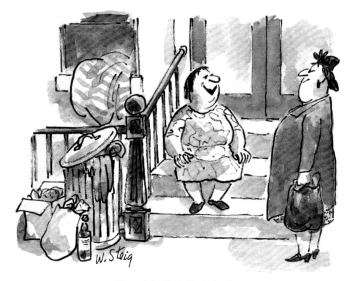

"A good day for falling in love!"
Delivered to *Look* magazine, May 8, 1957

philosophers, the absurdly rich, and couples engaged in bewildered attempts to understand each other. They are all drawn with sympathy, even the businessman, upon whom he ought to have frowned, having been raised a socialist. They were grown-up versions of the kids on the block in the Bronx; he felt himself among them.

He was endlessly playful; his work was serious play. He began writing children's books when he was sixty, and his *New Yorker* work warmed then as well; he allowed himself a tad more optimism. When we moved to the country, he swam, dived recklessly, gave up smoking, and, mostly, drinking, in favor of riding his lawn mower in large, meditative circles around the house. He liked to keep talismanic bits of gaudy jewelry in front of him on his desk to liven things up — a sort of costume party for art. And he invented a couple of crazy hats: one was a desperately awful green gaucho affair, with a rhinestone pin attached. He never worked in them; they were just for clowning around.

When he was eighty-five and neither of us could drive safely, we moved back to the city, Boston, this time — Bill said he couldn't run fast enough any more for New York. I had found our new building on my own; Bill insisted that if I liked it, he would, too. He hated it. Its two most glaring faults were that nobody sat on the stoop and that it featured a doorman, which was about as bourgeois as a building could get. The doorman later became one of Bill's preferred people, but Bill would invariably lead any guest to the window in order to point out that there was nothing outside. *Nothing.* He did like the park. He liked to sit watching couples pass by: would their relationship last? Most likely not. When he spotted a couple or group with a camera he volunteered to take

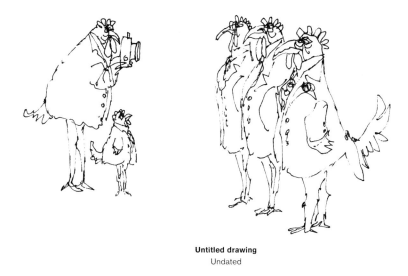

Untitled drawing
Undated

their picture, coached them into the proper positions, and offered them excellent advice.

Beyond everything, Bill hated pretension. He tended to dress as though he had gone into the closet and invited his clothes to fall upon him. This was not as arbitrary as it seemed because his clothes had already been chosen with the eye of A Simple Man of the People. His favorite outfit consisted of a classic blue work shirt, baggy pants, and squarish brown, unpolished loafers. When we got to Boston and he was forced to buy a few real shirts, he worried that he would be taken for bourgeois, a term he used to describe unpleasant people, Republicans, and, sometimes, me, when I suggested that he put on a tie for a dinner out. His ties were all dubious knitted affairs and were eventually abandoned entirely.

An otherwise modest man, he was proud of a couple of things: of being left-handed, for example, and of having saved a drowning woman when he was a lifeguard at summer camp in the Catskills — for which he was tipped a dollar. He was an All-American International Water Polo Champion, though I believe that America was then the only country that played water polo. It was a brutal game and had no rules to speak of. You could hold your opponent underwater and could kick him where it seemed it would do the most good. Bill remained athletic without ever putting much effort into it; it was how he thought of himself. At the age of eighty-five he dived backwards, fully clothed, into a swimming pool to celebrate the fact that we were moving to Boston. He was proud of his ability to fall and rise again unscathed. I saw him slip on an iced-over stone. His head bounced, he rested a moment, and was on his feet before I could catch my breath.

William Steig (front row, left) with his parents, Laura and
Joseph (back row, center and right), and his brothers,
Irwin (back row, left), Arthur (front row, center), and
Henry (front row, right), c. 1920

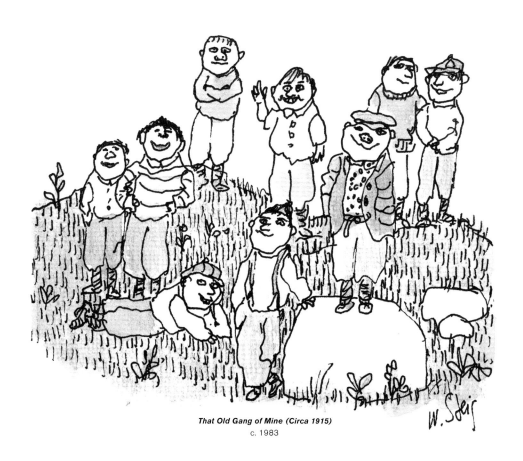

That Old Gang of Mine (Circa 1915)
c. 1983

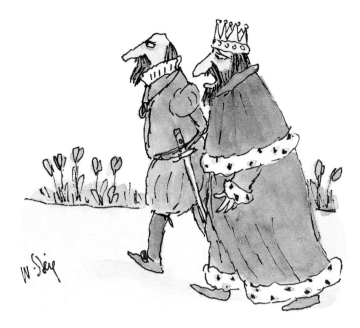

"But I don't feel like a king. I feel like a schmo."
Undated

The home of the Orion A.C.s, an athletic club made up of Bill's childhood pals from Brookfield Avenue, was Claremont Park in the Bronx. The area would have been considered a slum; Bill loved it. There was a sense of community and interdependence that was vital to him. He believed in an eventual just community, and his faith in the sovereignty of the workingman went deep; he was convinced that the world would come right during his lifetime. Meanwhile, a lot of it needed work, and he always went straight for the truth; one way or another he asked all the hard questions. He dealt with tough subjects even in his children's books, and, faithful to his socialist roots, he rejoiced at giving a smart poke at snobbery, inequity, injustice, and just plain rotten meanness. His work was never topical; it went deeper than that. His father liked to tell of a brilliant Polish-Jewish jester, a fabulous figure who impressed Bill mightily: the underdog who keeps the king in his place. His *New Yorker* drawings were often of highfalutin folks looking downright foolish. Come to think of it, everybody looked foolish. That's how a serious clown sees the world.

Bill drew clowns often: circus clowns sometimes, more frequently ordinary people, neighbors, cowboys and kings, strollers in the park, dogs and cats, all embellished with big red noses as they went earnestly about their business. People amused and delighted him. His drawings were always kind. Bill disliked caricature—he thought it a cruelty—and he never understood the concept of teasing. He didn't do it, and if he were teased, he took it literally and fretted.

Bill seldom said anything about the process of work; his ideas for children's books were often visual. *Roland the Minstrel Pig* evolved from a drawing he

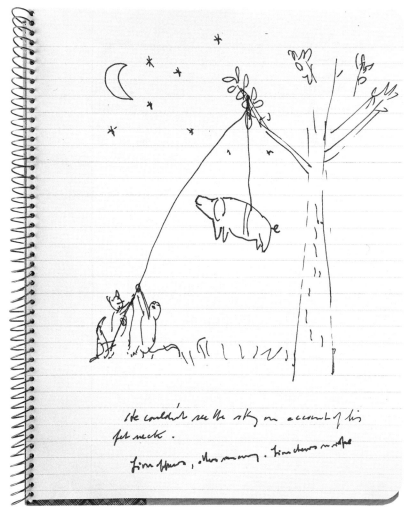

Preliminary illustration for *Roland the Minstrel Pig,* 1968

did of a hanging pig. Somebody once asked Bill why he wrote children's books. Bill said, "It's a good racket." That was a bit of flimflam. Children's books gave him the chance to deal with deep questions: loneliness, injustice, God, friendship, death, and, often, terrible isolation. They ended, so many of them, with the hero or heroine safe once more in the family's arms. They ended with kisses because they were written for children, and, Bill said, "Children must begin with hope."

His own parents appeared to have quarreled furiously. Bill's favorite was a dispute over the size of the moon. Joe, his optimist father, claimed it was big as a quarter; his mother Laura, a pessimist, insisted it was the size of a dime. It seems to have been a bit like a Punch and Judy show. Once, Joe, in a rage over a record Bill was playing, threw a teapot at him. Bill ducked, and it hit his mother. Joe took the rap. "You've killed me," Laura cried. "I've always known you would kill me someday."

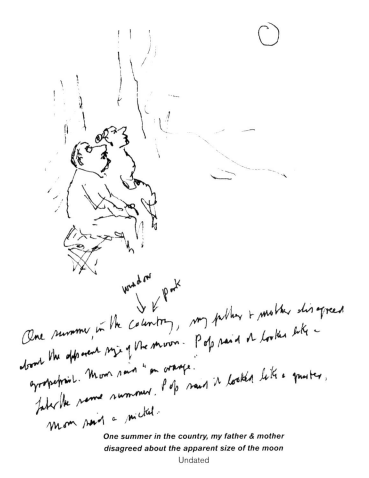

One summer in the country, my father & mother disagreed about the apparent size of the moon
Undated

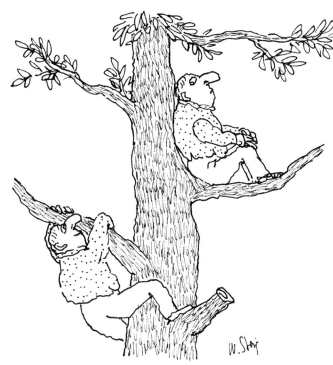

Somehow the Self Always Turns Up
Similar version published in *Strutters & Fretters*, 1992

Laura was a dressmaker, Joe was a housepainter, but there was no work for them during the Depression, and Bill was given to know that the support of the family was now up to him. He went straight to work as a cartoonist, starting with the cheapest humor magazines, rising quickly to the *New Yorker*. "I flew out of the nest with my parents on my back," he said. "But I always thought, 'You can have my body, but you can't have me.'"

One of Bill's early books, *Dreams of Glory and Other Drawings* (1953), considers the marvelous fantasies of children. They are shown winning the game, flying the plane, coming through at the last minute, heroes. I asked Bill what his own childhood dream had been. A pirate, I thought, or a rugged sea captain. "I would have saved my parents," he said. From what? He couldn't say. From their anger, perhaps. Leonard, the hero of Bill's children's book *The Zabajaba Jungle* (1987), is a latter-day figure from *Dreams of Glory*. He fights his way through a ferocious jungle and discovers his parents, trapped together in a bottle. Leonard breaks the bottle, frees them, and leads them home.

People in bottles were a fairly common theme in his drawings. In his children's books the protagonist is frequently trapped, or transformed into a nail, a rock, a dog, or confined in prison, or shrunk to the size of a thumb. The

isolation of The Self preoccupied Bill; he treated it, in its various guises, over and over, portraying the mostly defensive postures and emblems with which we define ourselves and present ourselves to the world. But his doodles were often interlocked figures, mouth to mouth, sometimes sharing a nose or an eye. Were they trapped with each other, or was the connection a comfort?

Bill's overriding questions were always, "What's it all about? What are we doing here? How should we be counted? Where will it end?" He walked with his head bent into the wind that he knew, committed worrier that he was, would come. He did have an endless supply of things to worry about, few of which made the least bit of sense to anyone. They were, in some loony way, like a comfort blanket — something you could always turn to when things felt unaccountably disagreeable. You could not soothe him; life was curious and full of possible grief, and it was important to be on guard. That said, he had a wonderful time of it, most of the time. He would have been one hundred years old on November 14, 2007. He'd have nixed a party but been grateful for any amount of candy. Neither cigarettes nor booze carried him off; at the age of ninety-six he gave out peacefully. The last thing he said was, "Blue skies."

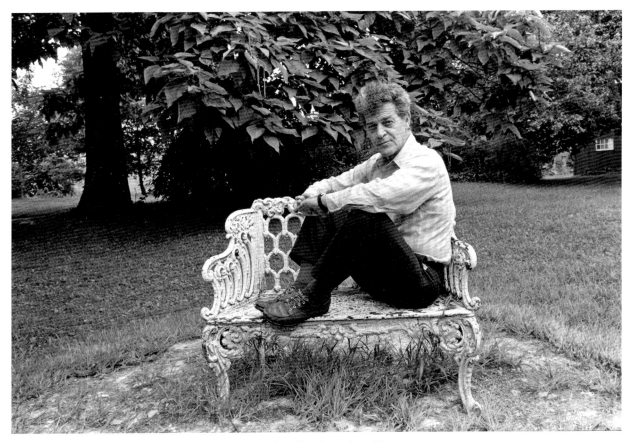

William Steig, Kent, Connecticut, 1973
Photograph by Nancy Crampton

The Art of
William Steig

Illustration for unpublished *New Yorker* cover
Undated

Wiseguy
From "Small Fry: Snow" series, published in
Dreams of Glory and Other Drawings, 1953

Zero Hour
From "Small Fry: Snow" series, published in the
New Yorker, March 7, 1953

Ammunition Dump
From "Small Fry: Snow" series, published in
Dreams of Glory and Other Drawings, 1953

Untitled drawing
From "Small Fry: Snow" series, published in
Dreams of Glory and Other Drawings, 1953

"How do you spell 'hate'?"
1960s

"You are not the center of the universe!"
Published in the *New Yorker*, March 14, 1964

"What did I do?"
Published in the *New Yorker*, June 30, 1962

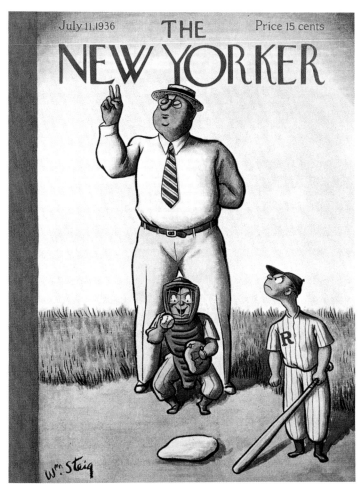

Cover of the *New Yorker,* July 11, 1936

Slugger
From "Small Fry: Sandlot Baseball" series,
published in the *New Yorker,* May 31, 1952

No-hitter going into the series finale
From "World Series Fever" series, published in
Holiday, October 1953

Greatest Comedian of His Time
From "Dreams of Glory" series, published in
the *New Yorker,* April 28, 1951

Thirty-eight days at sea
From "Dreams of Glory" series, published in
the *New Yorker,* October 28, 1950

Rescue
From "Dreams of Glory" series, published in
the *New Yorker,* August 5, 1950

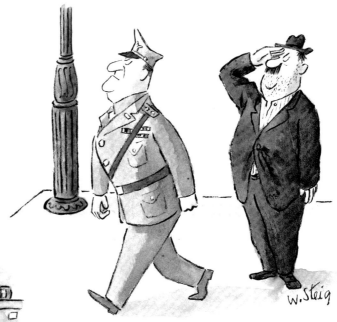

Untitled drawing
Received at *Collier's* magazine, January 20, 1956

**"You might be glad to know that your money
will not be squandered foolishly."**
Published in the *New Yorker,* May 15, 1954

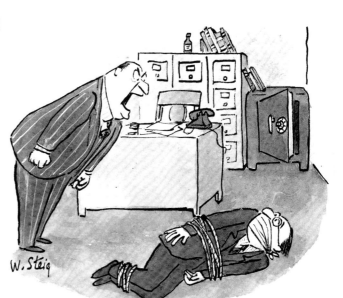

"You're fired!"
Published in the *New Yorker,*
December 26, 1953

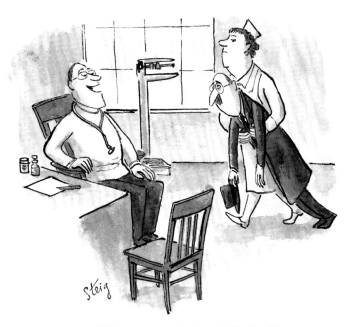

"Well, what seems to be the trouble, Mr. Sims?"
Published in the *New Yorker,* December 21, 1957

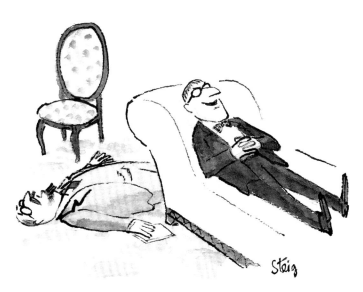

"Well– I guess nothing can shock you . . . "
c. 1960s

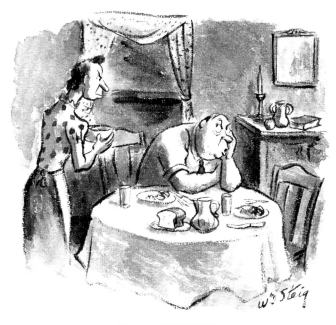

"You *know* I hate toinips!"
1940s–1950s

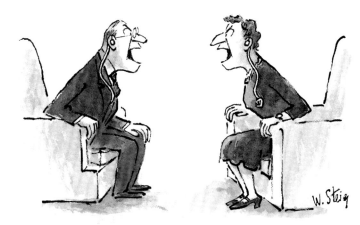

Untitled drawing
c. 1960s

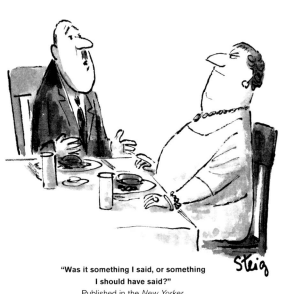

"Was it something I said, or something
I should have said?"
Published in the *New Yorker,*
September 15, 1962

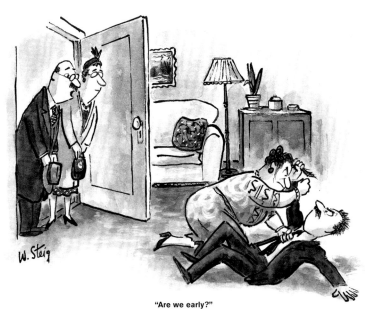

"Are we early?"
Delivered to *Look* magazine, May 17, 1956

1.

F.B.I. REPORTS JUVENILE CRIME ON INCREASE

2.

FARMER GOES BESERK, KILLS TWO IN-LAWS, SIX CHILDREN

3.

BERLIN THREAT GROWS

4.

TREASURY AGENTS TO CRACK DOWN

5.

FALLOUT SHELTERS CLAIMED VITAL TO SURVIVAL

6.

Published in the *New Yorker*, August 1, 1959

Memory of an incident which probably did not occur
Final drawing for *About People: A Book of Symbolic Drawings*, 1939

Loss of a memory
Final drawing for *About People: A Book of Symbolic Drawings*, 1939

Pleasant chap—but never a friend
Final drawing for *About People: A Book of Symbolic Drawings*, 1939

The coy one
Final drawing for *About People: A Book of Symbolic Drawings*, 1939

Melancholia
Final drawing for *About People: A Book of Symbolic Drawings*, 1939

I am at one with the universe
Final drawing for *The Lonely Ones*, 1942

I want your love but don't deserve it
Final drawing for *The Lonely Ones*, 1942

Why pretend?
Final drawing for *The Lonely Ones*, 1942

***This is one thing they'll never take
away from me***
Final drawing for *The Lonely Ones*, 1942

Cinderella
Final drawing for *Persistent Faces,* 1945

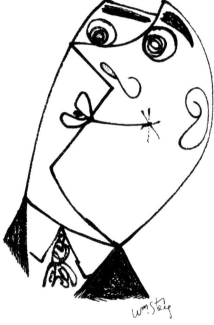

Kibitzer
Final drawing for *Persistent Faces,* 1945

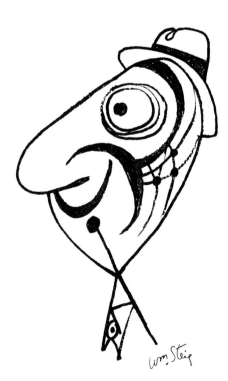

Optimist
Final drawing for *Persistent Faces,* 1945

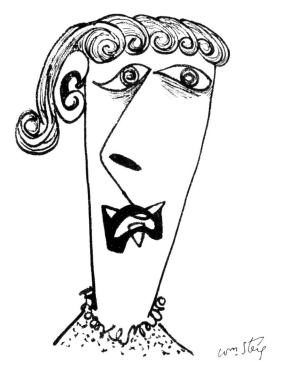

Dog's best friend
Final drawing for *Persistent Faces*, 1945

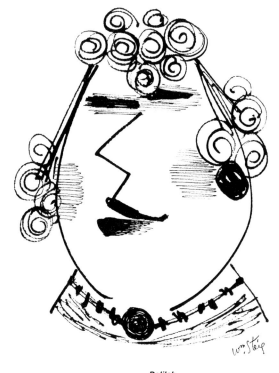

Delilah
Final drawing for *Persistent Faces*, 1945

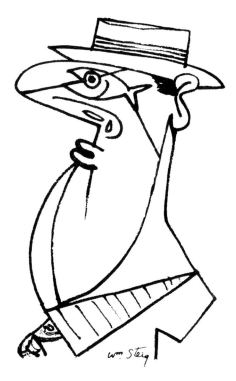

Stone wall
Final drawing for *Persistent Faces*, 1945

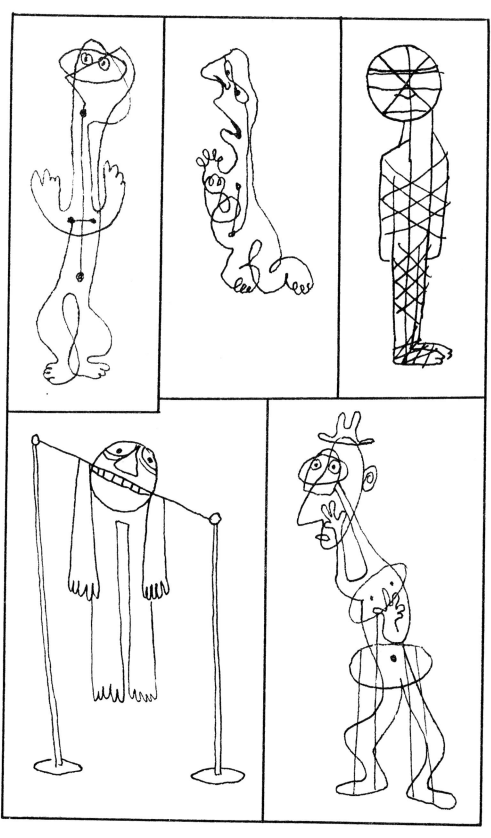

Some Kinesthetic Notes III
Final drawing for *All Embarrassed*, 1944

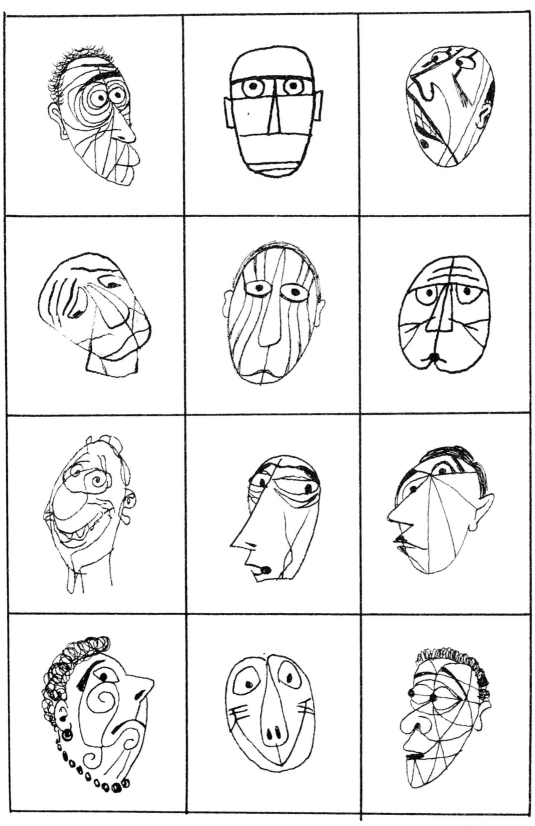

Untitled drawing
Final drawing for *All Embarrassed,* 1944

97

**From time to time you lift your head out of
the muck and shout Hurrah!**
Final drawing for Wilhelm Reich's *Listen, Little
Man!* 1948

Coney Island
Final drawing for Wilhelm Reich's *Listen, Little
Man!* 1948

Little big man
Final drawing for Wilhelm Reich's *Listen, Little
Man!* 1948

"Willie!"
Final drawing for *The Agony in the
Kindergarten*, 1950

God is watching
Final drawing for *The Agony in the
Kindergarten*, 1950

Are you sure you don't have to go?
Final drawing for *The Agony in the Kindergarten*, 1950

Are you sure you have to go?
Final drawing for *The Agony in the Kindergarten*, 1950

*He was **always** a quiet child*
Final drawing for *The Agony in the Kindergarten*, 1950

Come into my room—I want to have a talk with you
Final drawing for *The Agony in the Kindergarten*, 1950

Mama–don't leave me!
Final drawing for *The Rejected Lovers*, 1951

What a woman!
Final drawing for *The Rejected Lovers*, 1951

We were so right together
Final drawing for *The Rejected Lovers,* 1951

She was never loved the way I loved her
Final drawing for *The Rejected Lovers,* 1951

Ideal Woman
Final drawing for *Our Miserable Life,* 1990

Our marriage will be different
Final drawing for *Till Death Do Us Part,* 1947

News
Published in the *New Yorker,* June 21, 1982

Untitled drawing
Published in the *New Yorker*, August 7, 1971

Untitled drawing
c. 1969

Untitled drawing
c. 1960s

Déjeuner sur l'herbe
Similar version published in the *New Yorker*,
August 10, 1981

Preliminary cover illustration for the *New Yorker*
Final version published on April 29, 1991

Showdown (at the Hot Dawn)
Late 1970s or early 1980s

Untitled drawing
Similar version published in the *New Yorker*,
October 31, 1970

I'm the one who's being reasonable!
Final drawing for *Sick of Each Other*, 2001

"Relent!"
Final drawing for *Sick of Each Other*, 2001

They'd believe me . . . people drown all the time
Final drawing for *Sick of Each Other*, 2001

Tree That Has Witnessed Historical Events
Published in the *New Yorker*, October 31, 1977

Untitled drawing
Undated

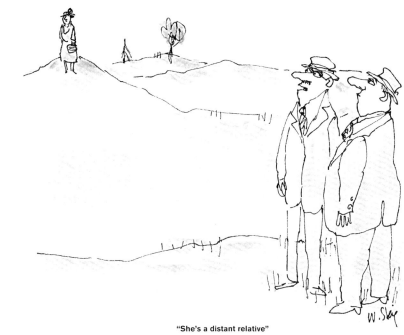

"She's a distant relative"
Undated

Untitled drawing
1993

"Let me show you the ropes."
Published in the *New Yorker,* September 10, 1990

The Long Story
1980s

Final cover illustration for the *New Yorker*,
August 14, 2000

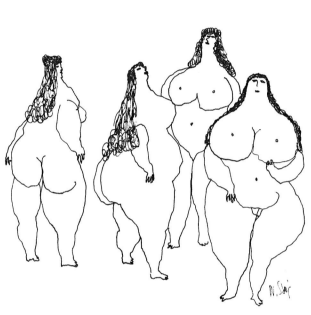

Paleolithic Venuses
Similar version published in *Drawings*, 1979

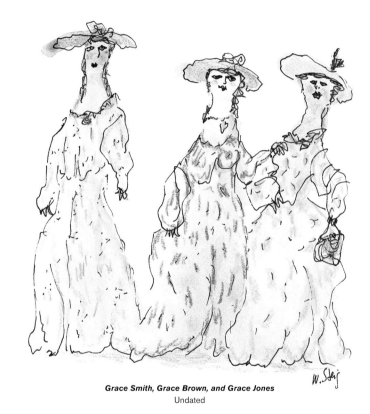

Grace Smith, Grace Brown, and Grace Jones
Undated

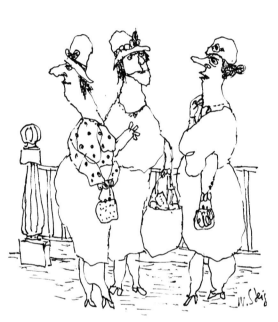

The Three Fates
Similar version published in the *New Yorker*,
April 13, 1981

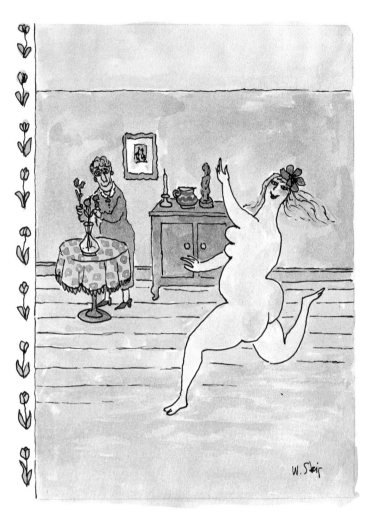

Preliminary cover illustration for the *New Yorker*
Final version published on May 24, 1993

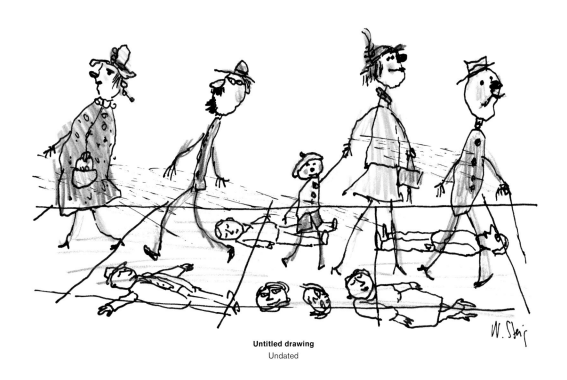

Untitled drawing
Undated

Untitled drawing
Undated

Movers and Shakers
Final version published in the *New Yorker*,
April 22, 1996

Saucissons Alfresco
From "Dining Out" series, published in the
New Yorker, January 18, 1999

Untitled drawing
Similar version published in *Drawings*, 1979

Untitled drawing
1970s

Life Is Passing Him By
From "Man and Beast" series, published in the
New Yorker, May 2, 1994

Hunting Accident
From "Man and Beast" series, published in the
New Yorker, May 2, 1994

Untitled drawing
Undated

Old Clown
Published in the *New Yorker,* July 7, 1986
Cover illustration for *Our Miserable Life,* 1990

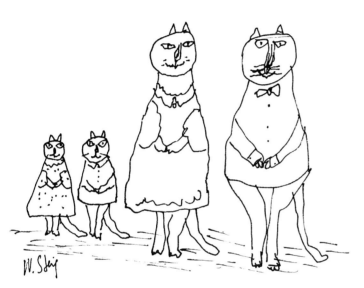

The Catses
c. 1980s

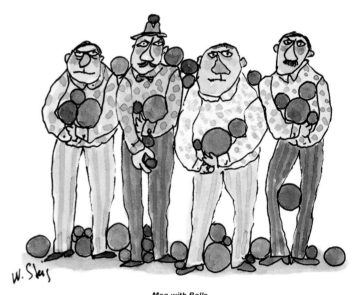

Men with Balls
Undated

Untitled drawing
Published in the *New Yorker,* October 7, 1985

A Fork in the Road
Published in the *New Yorker,* February 10, 1992

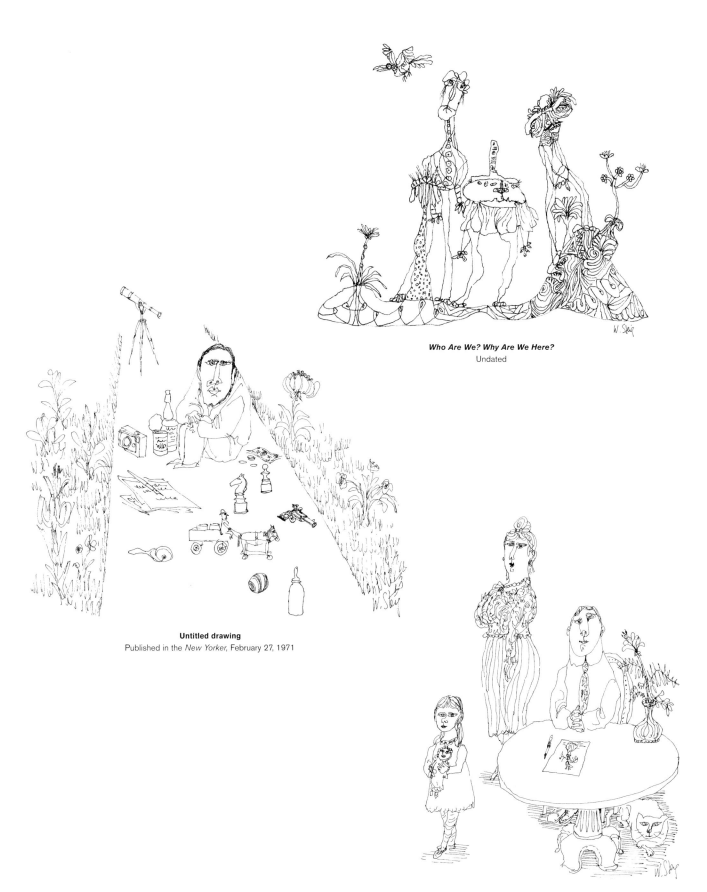

Who Are We? Why Are We Here?
Undated

Untitled drawing
Published in the *New Yorker*, February 27, 1971

Untitled drawing
Undated

The People in One's Life
Undated

Family Structure
c. 1980s

Self-Effacing Self
Similar version published in *Strutters & Fretters*, 1992

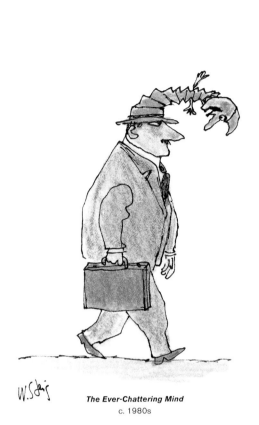

The Ever-Chattering Mind
c. 1980s

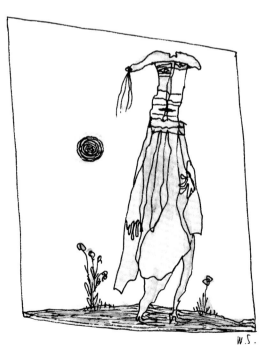

A Self in Love
Similar version published in the *New Yorker*,
March 9, 1992

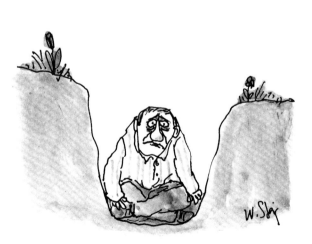

Man in a Deep Depression
Published in the *New Yorker*, June 8, 1992

One Has But a Moment on Life's Stage
Published in *Strutters & Fretters*, 1992

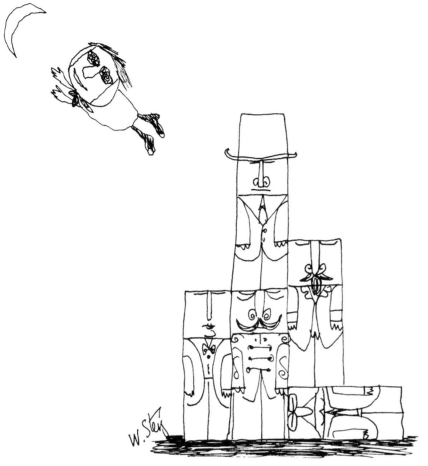

Untitled drawing
Similar version published in the *New Yorker*,
April 1, 1974

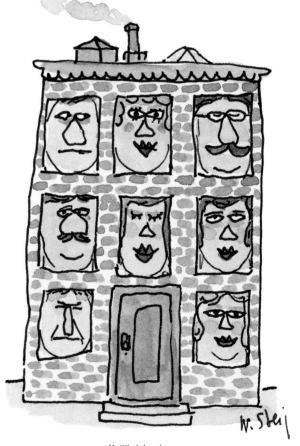

Untitled drawing
Undated

Aviary
c. 1980s

Fellow Inmates
Undated

Division of Property
Undated

127

Old Trysting Place
Published in the *New Yorker,* July 24, 1978

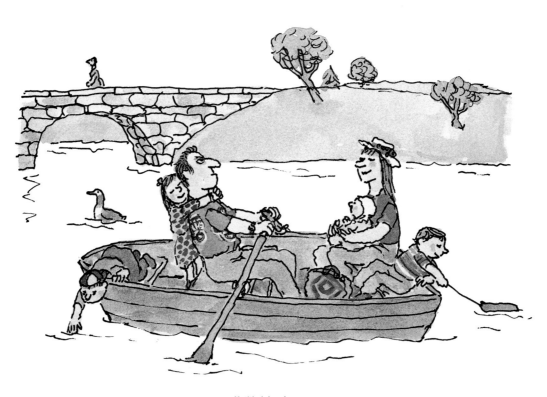

Untitled drawing
1980s–1990s

A Haven in the City
Similar version published in the *New Yorker*,
September 18, 1974

Untitled drawing
1980s–1990s

Preliminary cover illustration for the *New Yorker*
Final version published on May 8, 1965

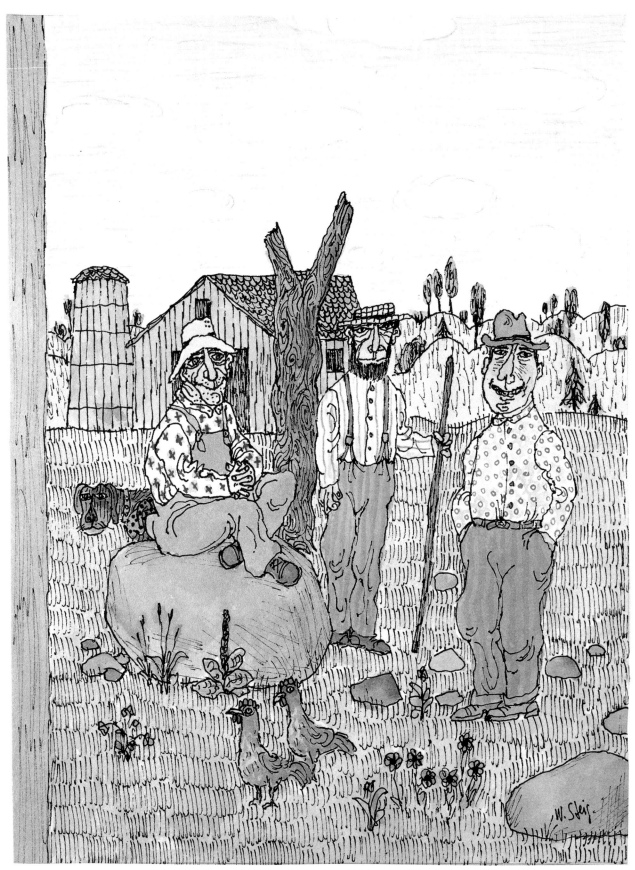

Illustration for unpublished *New Yorker* cover
1980s

Animal, Vegetable, Mineral
Similar version published in the *New Yorker*,
June 9, 1980

Mother Earth (Hugging Ground)
Undated

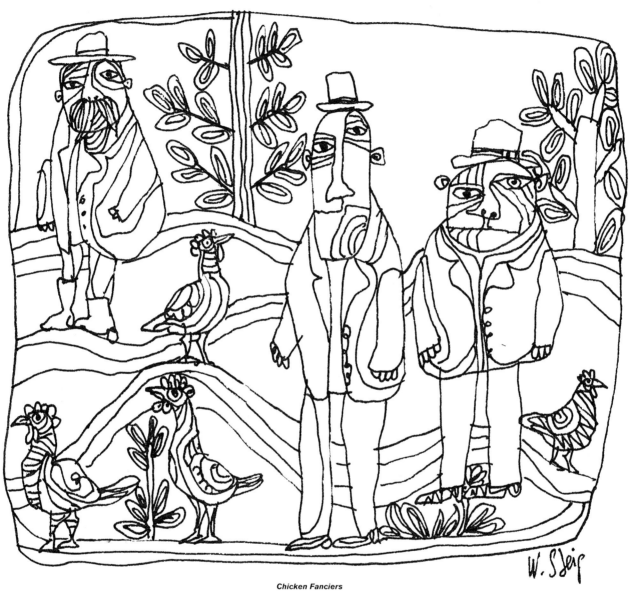

Chicken Fanciers
Similar version published in the *New Yorker*,
February 16, 1981

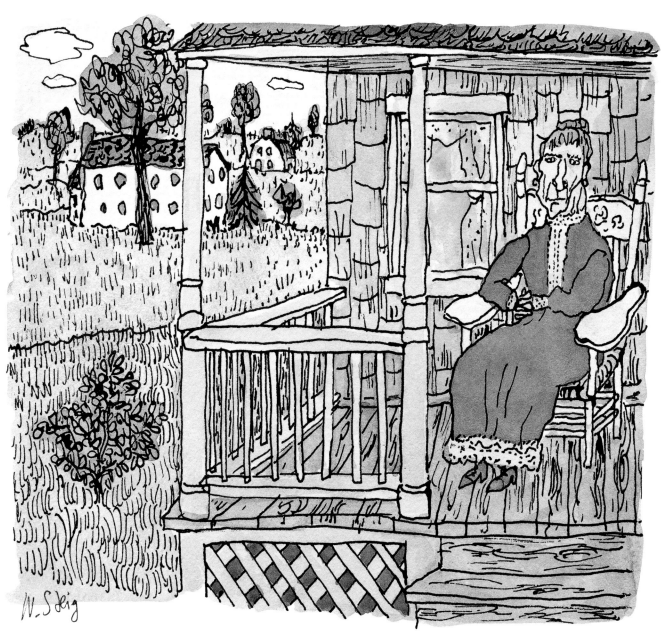

Untitled drawing
Undated

Ruminating
Published in the *New Yorker,* October 24, 1983

Poet, Painter, and Musician by the Sea
Undated

The Sculptor and His Marble
Published in the *New Yorker*, September 11, 1978

Untitled drawing
Similar version published in the *New Yorker*,
December 26, 1988

Impressionist Receiving Impressions
Published in the *New Yorker*, October 25, 1982

The Russian Blouse
Undated

Concert
Undated

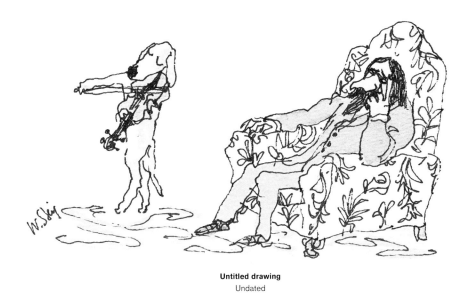

Untitled drawing
Undated

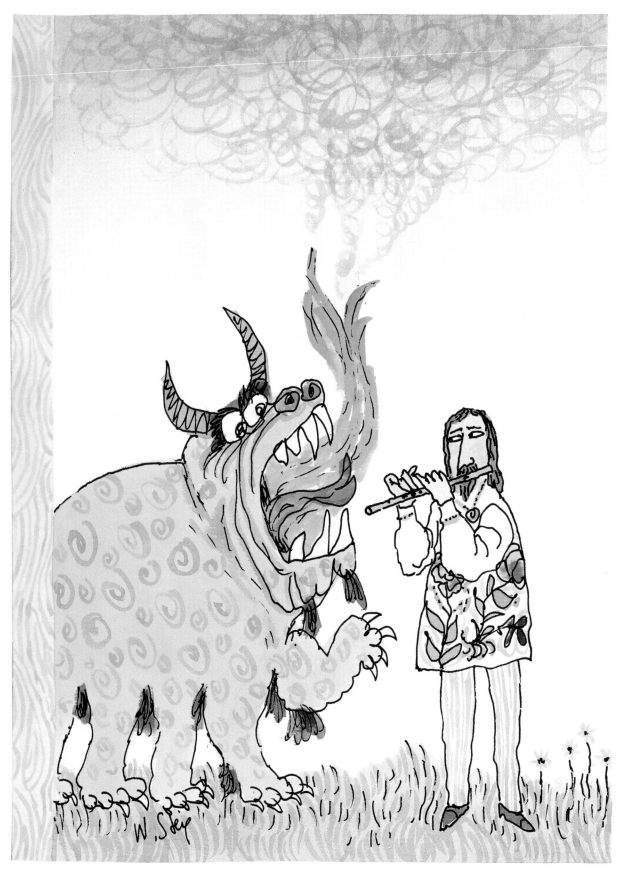

Illustration for unpublished *New Yorker* cover
Late 1970s

Untitled drawing
Published in the *New Yorker*, November 30, 1992

Preliminary cover illustration for the *New Yorker*
Final version published on September 23, 1985

Final cover illustration for the *New Yorker*,
December 24, 1979

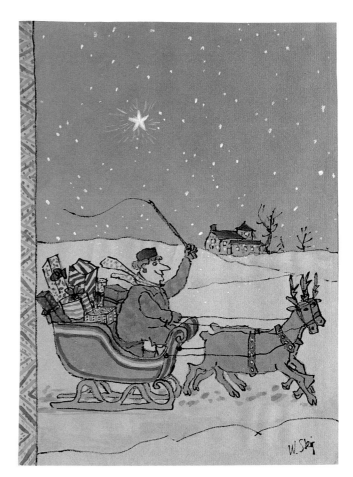

Illustration for unpublished *New Yorker* cover
Undated

R U C-P? S, I M. I M 2
Final illustration for *CDB!* 2000
Pen-and-ink version published in 1968

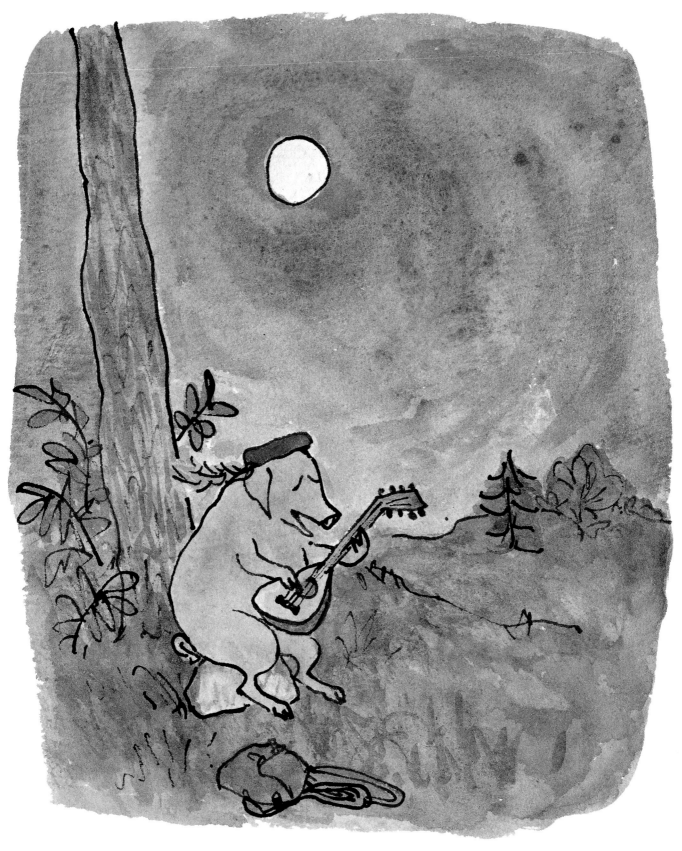

**"At night, before saying his prayers and going to
sleep, he sang this sad song"**

Preliminary illustration for *Roland the Minstrel Pig*, 1968

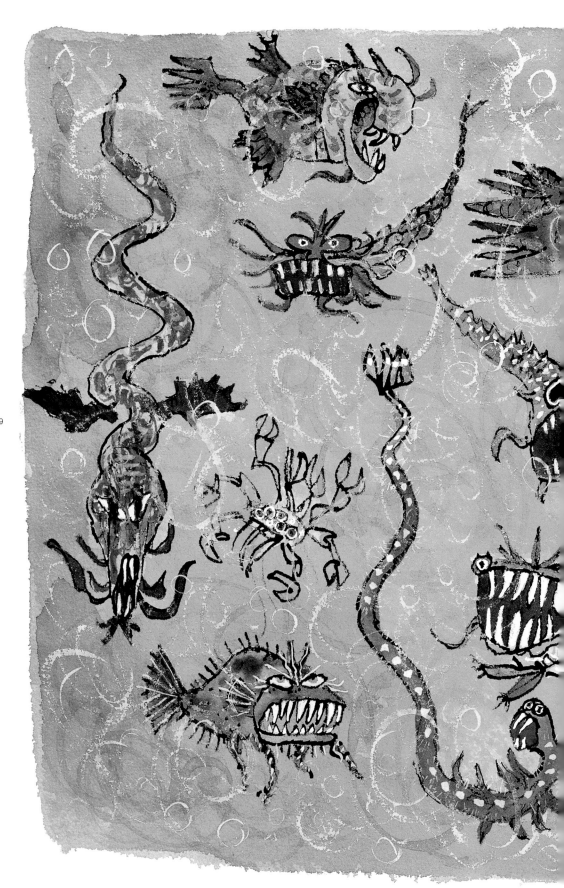

"The rotten, horrible island was set in a boiling sea seething with serpents"
Preliminary illustration for *The Bad Island,* 1969
(republished as *Rotten Island,* 1984)

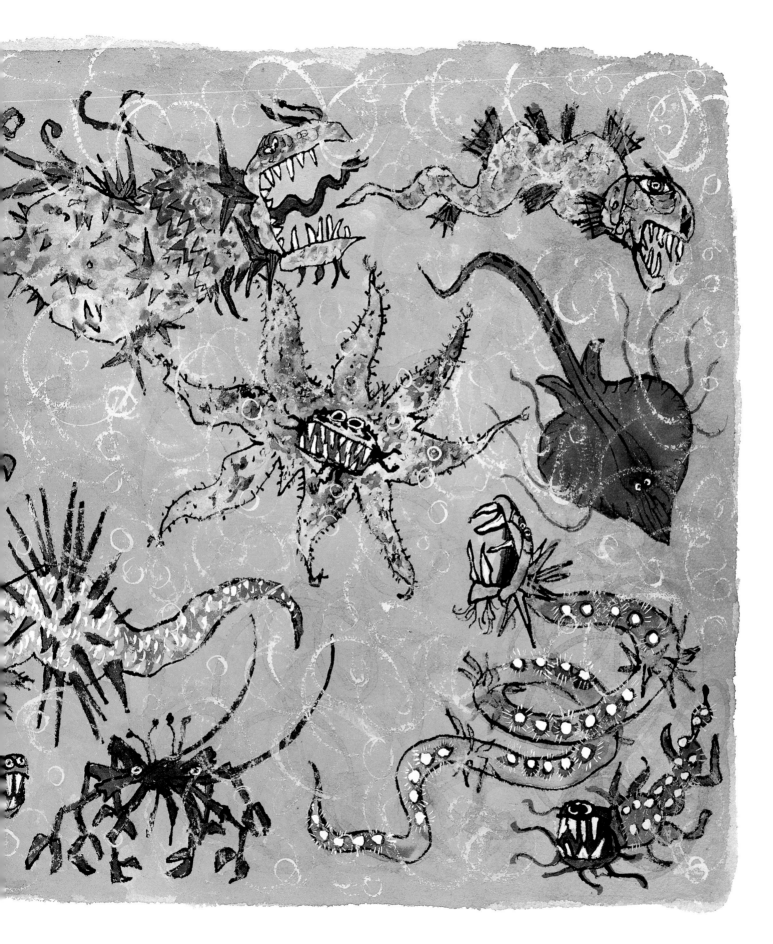

**"Sylvester Duncan lived with his mother and
father at Acorn Road in Oatsdale"**
Final illustration for *Sylvester and the Magic
Pebble*, 1969

**"On a rainy Saturday during vacation he found a
quite extraordinary one"**
Final illustration for *Sylvester and the Magic
Pebble*, 1969

**"'Oh, how I wish he were here with us on this
lovely May day,' said Mrs. Duncan"**
Preliminary illustration for *Sylvester and the
Magic Pebble*, 1969

Preliminary sketches for *Amos & Boris*, 1971

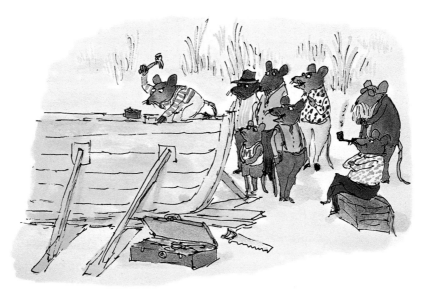

*Amos builds his boat in spite of
discouragement from his friends*
Preliminary illustration for *Amos & Boris*, 1971

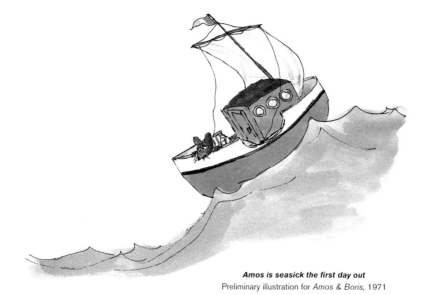

Amos is seasick the first day out
Preliminary illustration for *Amos & Boris,* 1971

Amos's family tries to keep Boris moist
Preliminary illustration for *Amos & Boris,* 1971

**"He saw a very old, very wrinkled pig, very
unpink and unwell-looking, lying in bed"**
Final illustration for *Dominic,* 1972

**"Dominic woke in the morning, a blissful
smile on his face"**
Final illustration for *Dominic,* 1972

**"Sitting with the doll in the rosy light of the
setting sun, he knew he would be pleased
with his future"**
Final illustration for *Dominic,* 1972

**"High up on a hickory not far ahead of him, he
was startled to see a goose hanging by the feet"**
Final illustration for *Dominic,* 1972

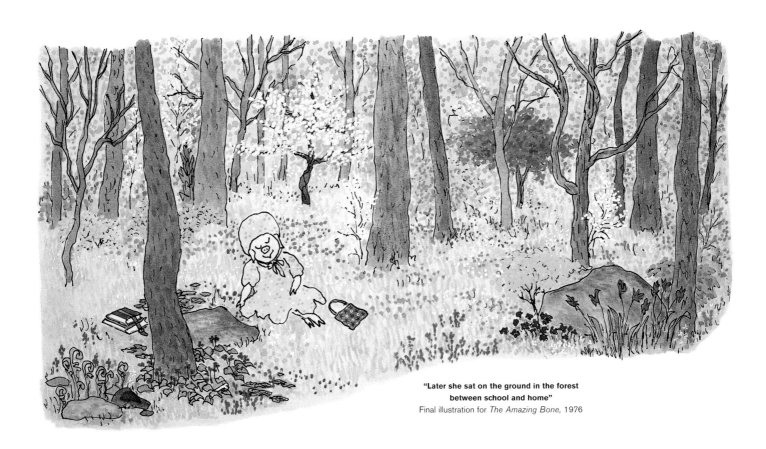

**"Later she sat on the ground in the forest
between school and home"**
Final illustration for *The Amazing Bone*, 1976

**"The bone made the sounds of a trumpet
calling soldiers to arms"**
Final illustration for *The Amazing Bone,* 1976

"The wily fox was not as easily duped as the robbers"
Final illustration for *The Amazing Bone,* 1976

"Drenched, cold, exhausted, he still held on to his nail"
Final illustration for *Abel's Island,* 1976

"If the owl was offended at Abel's insults, it didn't show that it was"
Final illustration for *Abel's Island,* 1976

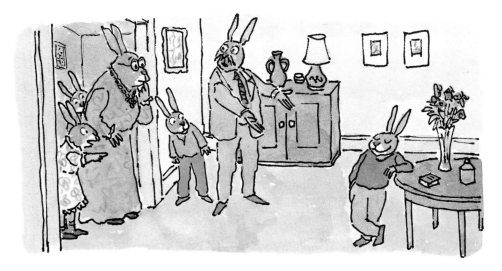

**"Then that tricky rascal would turn up out of
nowhere, looking smug and innocent"**
Final illustration for *Solomon the Rusty Nail,* 1985

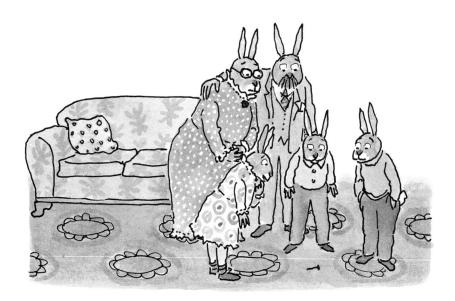

**"When things settled down, Solomon told them
his story and finally revealed his secret"**
Final illustration for *Solomon the Rusty Nail,* 1985

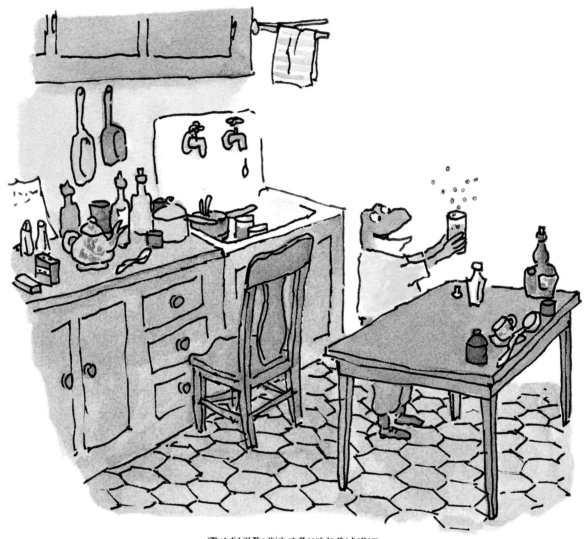

**"That did it! The thick stuff sank to the bottom
of the mixing glass and he had a reddish
golden liquid"**
Final illustration for *Gorky Rises,* 1980

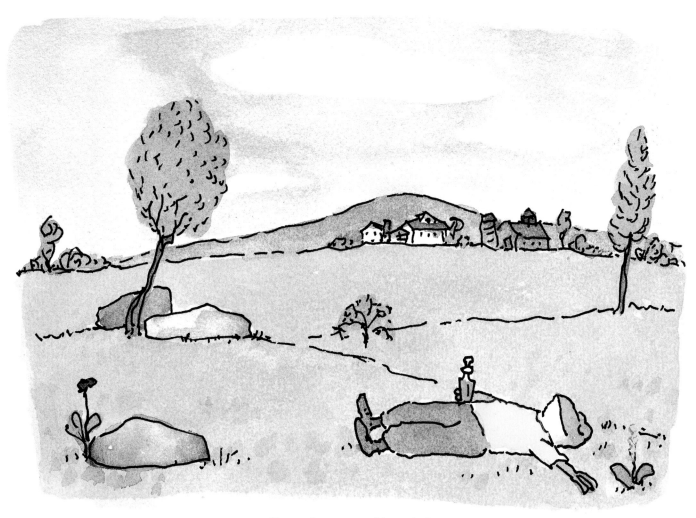

"It was early summer; everything was fresh and fair"
Final illustration for *Gorky Rises*, 1980

Final illustration for cover of *Gorky Rises,* 1980

following pages:
"For extra-large animals, he had a special room"
Final illustration for *Doctor De Soto,* 1982

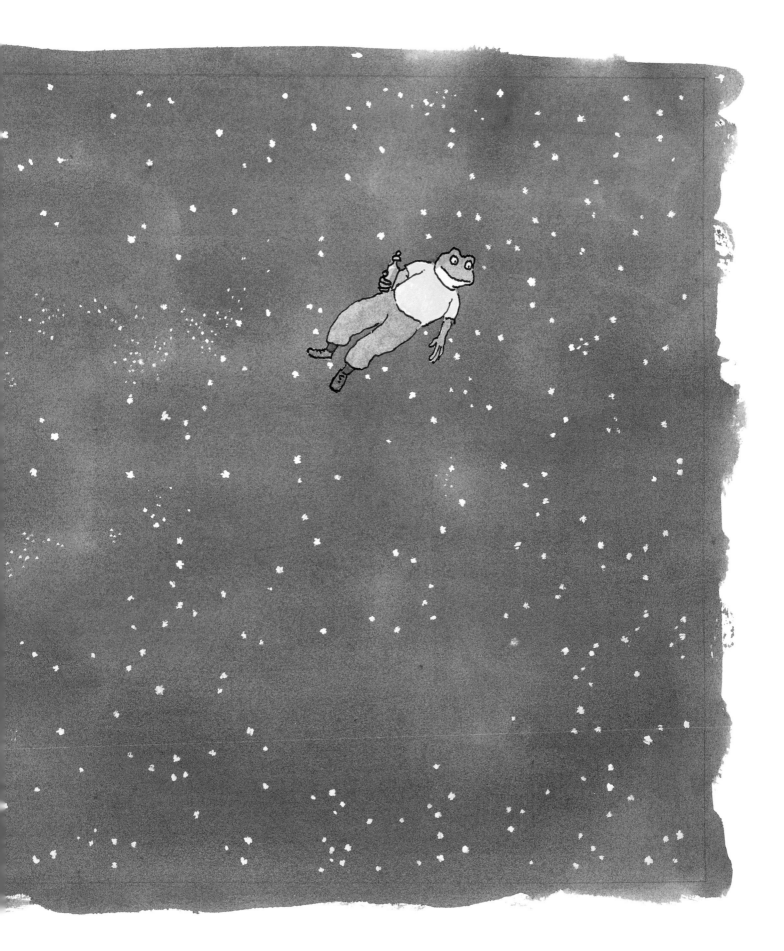

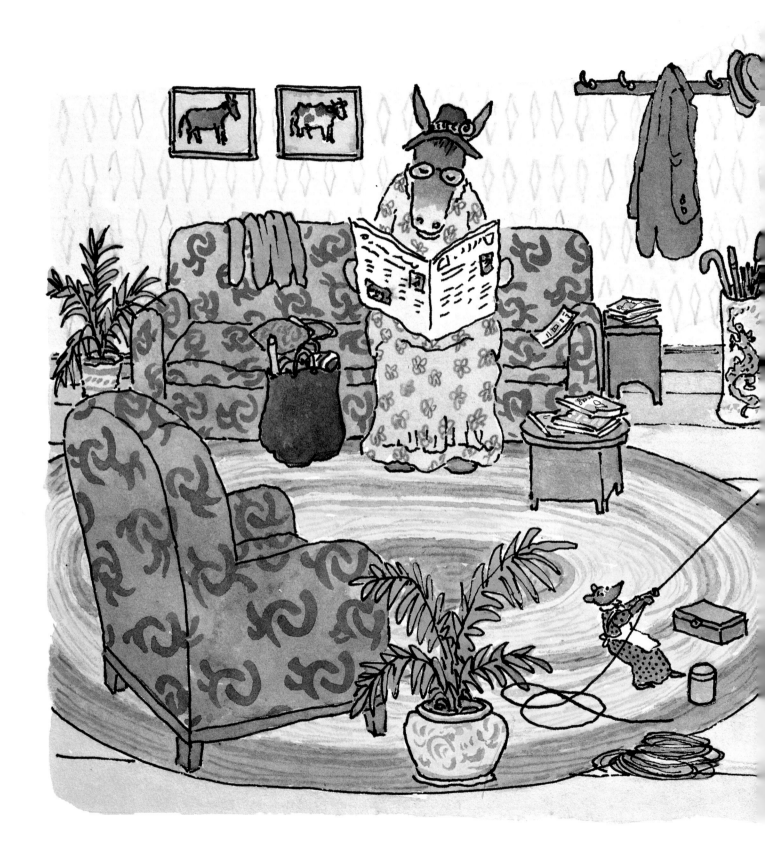

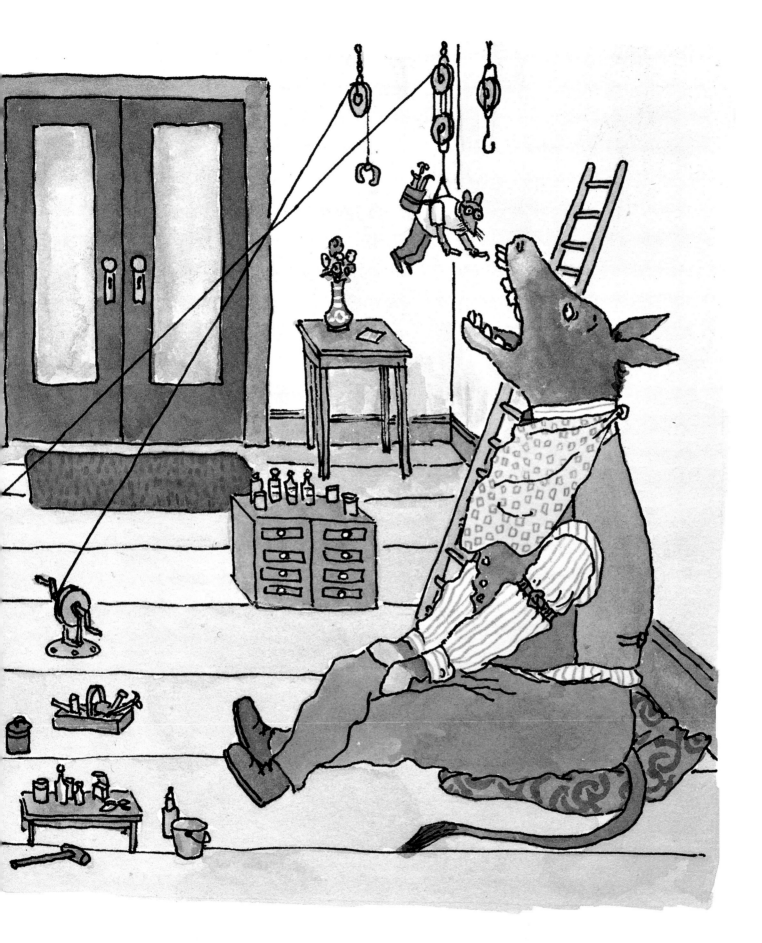

"'Please!' the fox wailed"
Final illustration for *Doctor De Soto*, 1982

"That night the De Sotos lay awake worrying"
Final illustration for *Doctor De Soto*, 1982

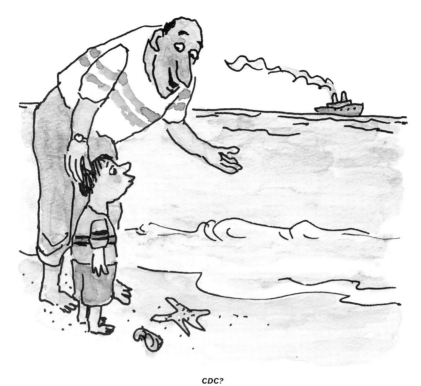

CDC?
Final cover illustration for *CDC?* 1984

A 2-R F D 4-M
Final illustration for *CDC?* 1984

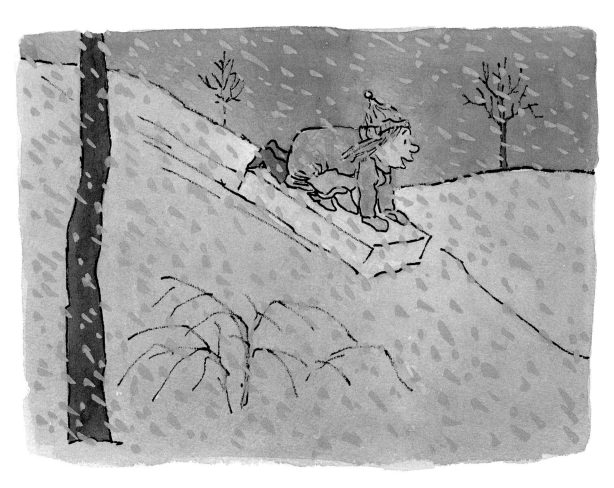

"She laid the box down and climbed aboard"
Final illustration for *Brave Irene*, 1986

"What a wonderful ball it was!"
Final illustration for *Brave Irene,* 1986

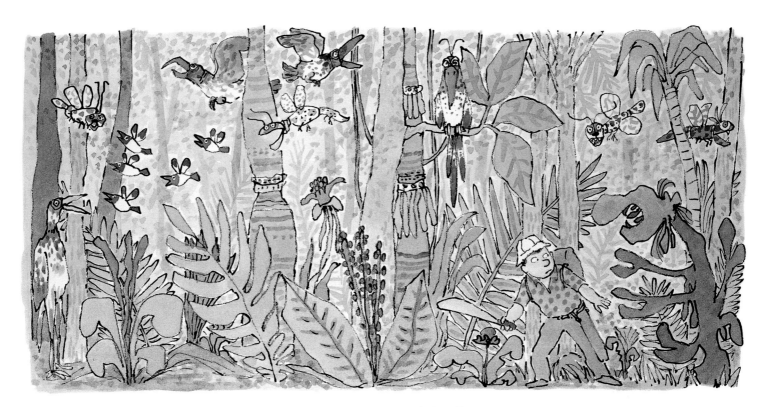

"One more whack and he breaks through"

Final illustration for *The Zabajaba Jungle,* 1987

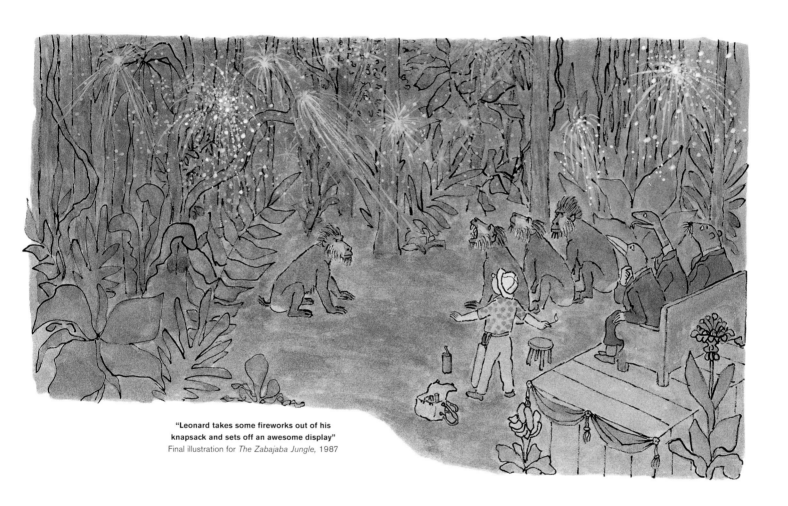

"Leonard takes some fireworks out of his knapsack and sets off an awesome display"
Final illustration for *The Zabajaba Jungle,* 1987

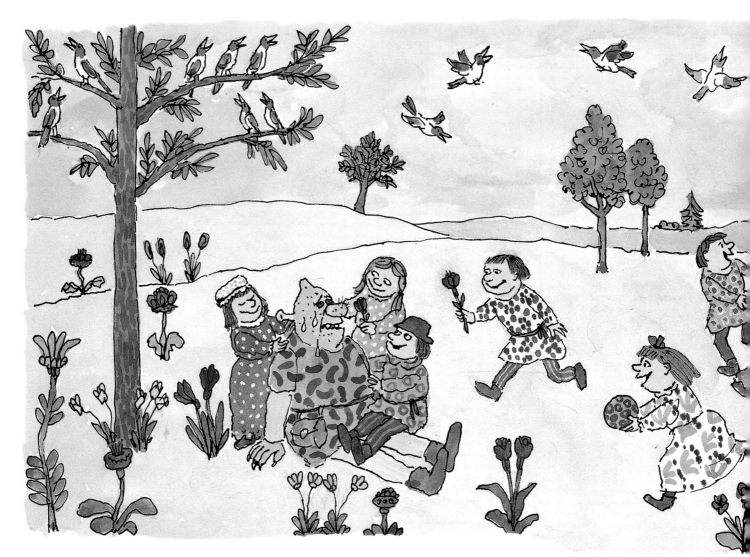

**"He dreamed he was in a field of flowers
where children frolicked and birds warbled"**
Final illustration for *Shrek!* 1990

**"His mother was ugly and his father was ugly,
but Shrek was uglier than the two of them put
together"**
Final illustration for *Shrek!* 1990

**"And sure enough, a little way into the woods,
a whopper of a dragon barred his path"**
Final illustration for *Shrek!* 1990

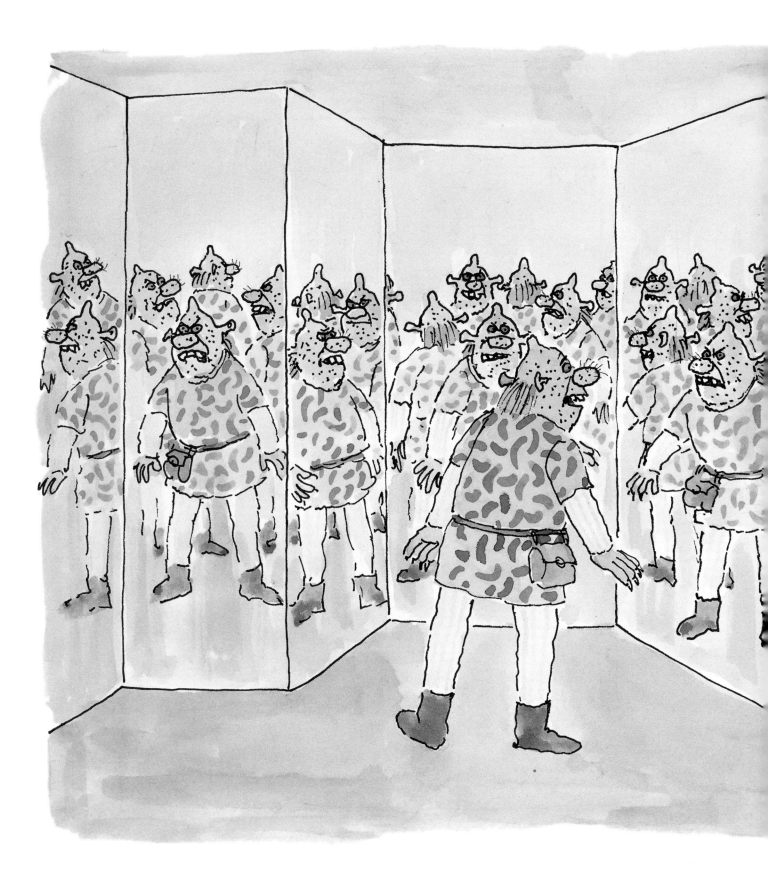

"All around him were hundreds of hideous creatures"
Final illustration for *Shrek!* 1990

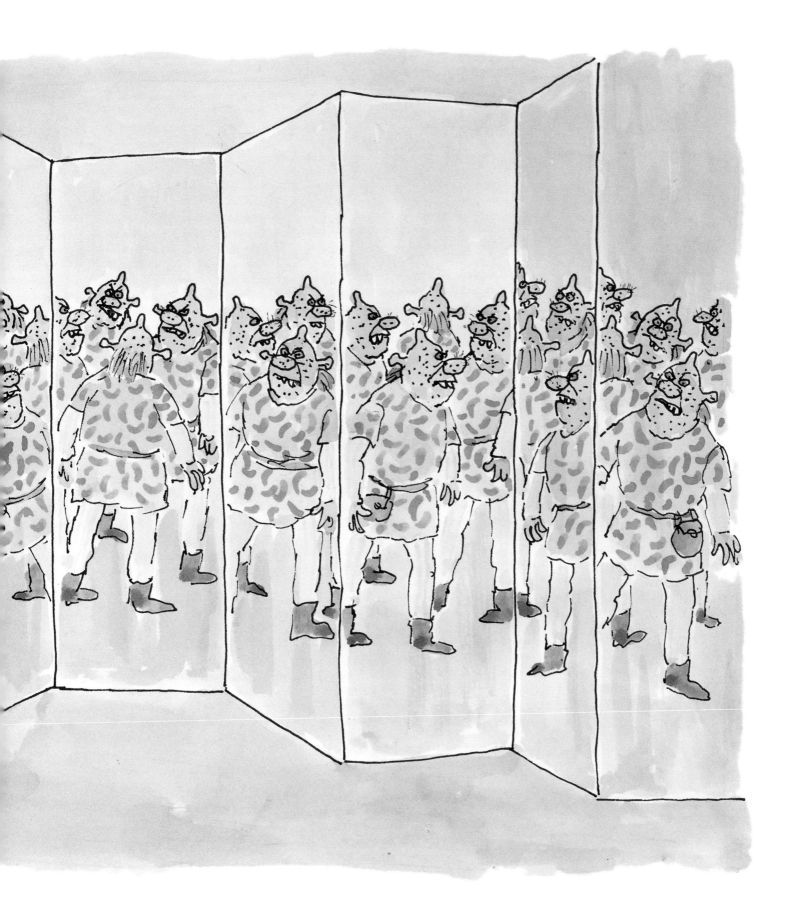

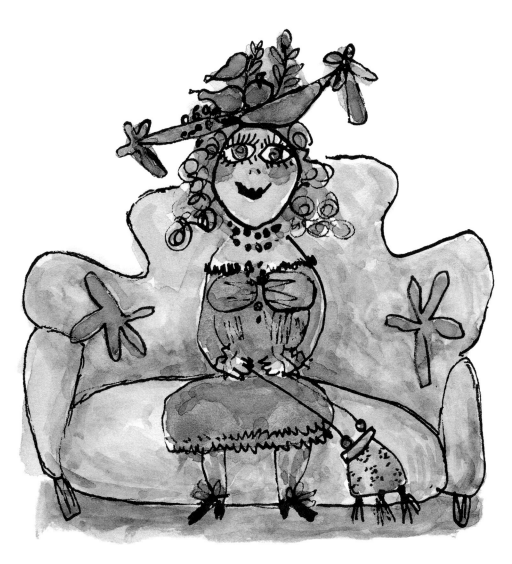

"This was Mom's best friend"
Final illustration for *When Everybody
Wore a Hat*, 2003

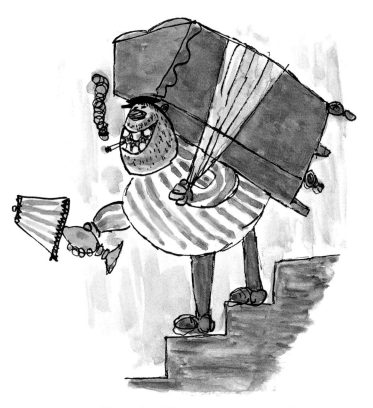

"We moved a lot. The moving men were very strong"
Final illustration for *When Everybody
Wore a Hat*, 2003

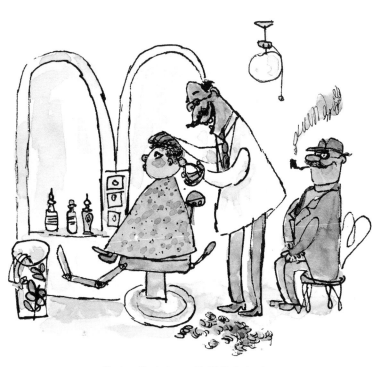

"I got my first haircut at Ditchick's Barbershop"
Final illustration for *When Everybody
Wore a Hat*, 2003

Notes

Introduction

1. Whitney Balliett, "On William Steig," in William Steig, *Ruminations* (New York: Farrar, Straus and Giroux, 1984), n.p.

2. Malcolm Jones, Jr., with Yahling Chang, "The King of Cartoons," *Newsweek*, May 15, 1995.

3. In 1945, the Steig family had a group exhibition at the New Art Circle in New York, and both Joseph and Laura Steig had solo exhibitions. See Henry Steig, "Papa's Conflict: Portrait of a Man with Two Strings to His Bow," *Commentary*, April 1946, 363. A number of works by members of the Steig family were published in Lee Lorenz, *The World of William Steig* (New York: Artisan, 1998), 26–27.

4. Although an atheist, Joseph Steig "remained a firm believer in freedom of worship, and he felt that Jews had as much right to hold religious services as the people of other faiths," according to his son Henry. The latter recounts how his father, on the way to America, made sure that Jewish passengers who were being prevented from holding religious services aboard the ship be allowed to do so. See Henry Steig, "Papa's Conflict," 369–70.

5. Joel Smith, *Saul Steinberg: Illuminations* (New Haven: Yale University Press, 2006), 37.

6. Joshua Hammer, "With Pen, Ink, and the Eye of an Innocent, a Brilliantly Off-Center Writer/Cartoonist Refuses to Surrender to Age," *People*, December 3, 1984.

7. Saul Steinberg was originally quoted in Robert Long, *De Kooning's Bicycle: Artists and Writers in the Hamptons* (New York: Farrar, Straus and Giroux, 2005), 198.

8. Lorenz, *The World of William Steig*, 87.

9. The artist was quoted by his wife, Jeanne Steig, in Roger Angell, "The Minstrel Steig," *New Yorker*, February 20–27, 1995.

10. William Steig, *Dominic* (New York: Farrar, Straus and Giroux, 1972), 82–83.

11. Steig was quoted in "Drawing on childhood fancies," *U.S. News and World Report*, March 17, 1997.

Kids Get to Do All the Driving

1. Iain Topliss, *The Comic Worlds of Peter Arno, William Steig, Charles Addams, and Saul Steinberg* (Baltimore: Johns Hopkins University Press, 2005), 75.

2. Lee Lorenz, *The World of William Steig* (New York: Artisan, 1998), 32–38.

3. Quoted in James E. Higgins, "William Steig: Champion for Romance," *Children's Literature in Education* 9, no. 1 (1978): 15.

4. Steig is quoted in "I created a monster . . . ," *Mail on Sunday* (London), June 6, 2004.

5. Diana Trilling, "Small Fry: Twenty Years Later," *New Republic*, January 25, 1943, 124.

6. Topliss, *Comic Worlds*, 86.

7. William Steig, *Dreams of Glory and Other Drawings* (New York: Knopf, 1953), viii.

8. Harold Ross is quoted by Lee Lorenz in Sarah Boxer's obituary of William Steig ("William Steig, 95, Dies; Tough Youths and Jealous Satyrs Scowled in His Cartoons," *New York Times*, October 5, 2003).

9. Quoted in Israel Shenker, "Steig, Surviving as He Nears 65, Finds a Peace in Being a Depressed Cartoonist," *New York Times*, November 14, 1972.

10. Lorenz, *World of William Steig*, 120.

11. Roger Angell, "The Minstrel Steig," *New Yorker*, February 20–27, 1995.

12. "William Steig at 80," *Publishers Weekly*, July 24, 1987.

13. Higgins, "William Steig," 6.

14. Angell, "Minstrel Steig."

15. Steig is cited in Karla Kuskin, ". . . and William Steig," *New York Times Book Review*, November 14, 1976.

16. From an unpublished dummy for *Solomon the Rusty Nail*, in the collection of the Estate of William Steig.

17. Higgins, "William Steig," 10.

18. William Steig, *Abel's Island* (New York: Farrar, Straus and Giroux, 1976), 106–7.

19. Higgins, "William Steig," 5.

20. Donald Phelps, "A Back Road of Genius: The Graphic Perception(s) of William Steig," *Comics Journal* 265 (January–February 2005): 102.

21. Higgins, "William Steig," 12. Jonathan Cott views Dominic as a true "Reichian" hero; see Cott, *Pipers at the Gates of Dawn: The Wisdom of Children's Literature* (New York: Random House, 1983), 96–107.

22. From Marcus's interview with Steig in Leonard S. Marcus, *Ways of Telling: Conversations on the Art of the Picture Book* (New York: Dutton, 2002), 190.

23. Higgins, "William Steig," 13.

24. Roni Natov, "Internal and External Journeys: The Child Hero in *The Zabajaba Jungle* and *Linnea in Monet's Garden*," *Children's Literature in Education* 20, no. 2 (1989): 95.

25. Quoted in Angell, "Minstrel Steig."

26. The fact that the drawings portray a family with three sons and a daughter–instead of four sons, as in the Steig household–has recently led Iain Topliss to question the extent of their autobiographical nature (see *Comic Worlds*, 126). Topliss, however, discusses the drawings only as part of the original 1959 spread published in the *New Yorker* and makes no mention of subsequent publication in *When Everybody Wore a Hat*, in which Steig himself establishes their connection to his own childhood. The artist also kept at least a couple of notebooks where he wrote down memories from his childhood, probably in preparation for the publication of the children's book. One journal, entitled "Memory Lane," includes such reminiscences as "Pop and Mom going to the opera," "The Polish Countess," and "First hair cut at Ditchik's." The last event made it into the children's book but was not included in the original 1959 spread. Both unpublished notebooks in the collection of the Estate of William Steig are undated.

27. Edward Sorel, "When Everybody Wore a Hat," *New York Times Book Review*, April 20, 2003.

28. Quoted in Boxer, "William Steig, 95, Dies."

29. William Steig, *Dreams of Glory*, viii.

30. Jeanne Steig, *A Gift from Zeus: Sixteen Favorite Myths*, with illustrations by William Steig (New York: HarperCollins, 2001), 6–9.

The Ever-Evolving Art of William Steig

1. Lee Lorenz, *The World of William Steig* (New York: Artisan, 1998), 65–66. I am indebted to this book for many of the facts in this essay.

2. Ibid., 74.

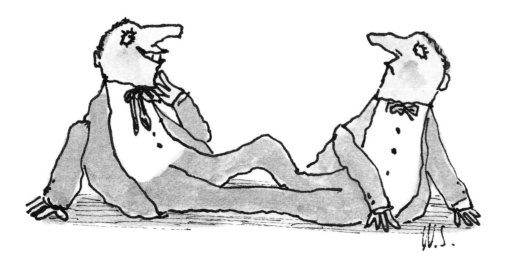

Bibliography

Books of Drawings by William Steig

Man About Town. New York: Ray Long & Richard R. Smith, 1932.

About People. New York: Random House, 1939.

The Lonely Ones. New York: Duell, Sloan and Pearce, 1942.

All Embarrassed. New York: Duell, Sloan and Pearce, 1944.

Small Fry. New York: Duell, Sloan and Pearce, 1944.

Persistent Faces. New York: Duell, Sloan and Pearce, 1945.

Till Death Do Us Part: Some Ballet Notes on Marriage. New York: Duell, Sloan and Pearce, 1947.

The Agony in the Kindergarten. New York: Duell, Sloan and Pearce, 1950.

The Rejected Lovers. New York: Dover, 1951.

Dreams of Glory and Other Drawings. New York: Knopf, 1953.

Continuous Performance. New York: Duell, Sloan and Pearce, 1961.

Male/Female. New York: Farrar, Straus and Giroux, 1971.

Drawings. New York: Farrar, Straus and Giroux, 1979.

Ruminations. New York: Farrar, Straus and Giroux, 1984.

Our Miserable Life. New York: Farrar, Straus and Giroux, 1990.

Strutters & Fretters: Or The Inescapable Self. New York: HarperCollins, 1992.

Made for Each Other. New York: HarperCollins, 2000.

Sick of Each Other. New York: HarperCollins, 2001.

Children's Books by William Steig

CDB! New York: Simon and Schuster, 1968.

Roland the Minstrel Pig. New York: Simon and Schuster, 1968.

The Bad Island. New York: Windmill, 1969.

Sylvester and the Magic Pebble. New York: Simon and Schuster, 1969.

The Bad Speller. New York: Simon and Schuster, 1970.

An Eye for Elephants. New York: Windmill, 1970.

Amos & Boris. New York: Farrar, Straus and Giroux, 1971.

Dominic. New York: Farrar, Straus and Giroux, 1972.

The Real Thief. New York: Farrar, Straus and Giroux, 1973.

Farmer Palmer's Wagon Ride. New York: Farrar, Straus and Giroux, 1974.

The Amazing Bone. New York: Farrar, Straus and Giroux, 1976.

Abel's Island. New York: Farrar, Straus and Giroux, 1976.

Caleb & Kate. New York: Farrar, Straus and Giroux, 1977.

Tiffky Doofky. New York: Farrar, Straus and Giroux, 1978.

Gorky Rises. New York: Farrar, Straus and Giroux, 1980.

Doctor De Soto. New York: Farrar, Straus and Giroux, 1982.

CDC? New York: Farrar, Straus and Giroux, 1984.

Yellow & Pink. New York: Farrar, Straus and Giroux, 1984.

Rotten Island. New Hampshire: David R. Godine, 1984 (original version published as *The Bad Island*).

Solomon the Rusty Nail. New York: Farrar, Straus and Giroux, 1985.

Brave Irene. New York: Farrar, Straus and Giroux, 1986.

The Zabajaba Jungle. New York: Farrar, Straus and Giroux, 1987.

Spinky Sulks. New York: Farrar, Straus and Giroux, 1988.

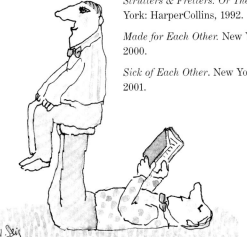

Shrek! New York: Farrar, Straus and Giroux, 1990.

Doctor De Soto Goes to Africa. New York: HarperCollins, 1992.

Zeke Pippin. New York: HarperCollins, 1994.

Grown-Ups Get to Do All the Driving. New York: HarperCollins, 1995.

The Toy Brother. New York: HarperCollins, 1996.

Pete's a Pizza. New York: HarperCollins, 1998.

When Everybody Wore a Hat. New York: HarperCollins, 2003.

Books by Jeanne and William Steig

Consider the Lemming. New York: Farrar, Straus and Giroux, 1988.

The Old Testament Made Easy. New York: Farrar, Straus and Giroux, 1990.

Alpha Beta Chowder. New York: HarperCollins, 1992.

A Handful of Beans: Six Fairy Tales. New York: HarperCollins, 1998.

A Gift from Zeus: Sixteen Favorite Myths. New York: HarperCollins, 2001.

Other Collaborative Books

Cuppy, Will. *The Decline and Fall of Practically Everybody.* Illustrations by William Steig. New York: Henry Holt, 1950.

——. *How to Become Extinct.* Illustrations by William Steig. New York: Farrar & Rinehart, 1941.

Fenner, Phyllis R. *Giggle Box: Funny Stories for Boys and Girls.* Illustrations by William Steig. New York: Knopf, 1950.

Hodgins, Eric. *Mr. Blandings Builds His Dream House.* Illustrations by William Steig. New York: Simon and Schuster, 1946.

Reich, Wilhelm. *Listen, Little Man!* Illustrations by William Steig. New York: Farrar, Straus and Giroux, 1948.

Steig, Irwin. *Common Sense in Poker.* Illustrations by William Steig. New York: Cornerstone, 1959.

——. *Poker for Fun and Profit.* Illustrations by William Steig. New York: Simon and Schuster, 1959.

Steig, William. *Potch and Polly.* Illustrations by Jon Agee. New York: Farrar, Straus and Giroux, 2002.

——. *Toby, What Are You?* Illustrations by Teryl Euvremer. New York: HarperCollins, 2001.

——. *Toby, Where Are You?* Illustrations by Teryl Euvremer. New York: HarperCollins, 1997.

——. *Toby, Who Are You?* Illustrations by Teryl Euvremer. New York: HarperCollins, 2004.

——. *Which Would You Rather Be?* Illustrations by Harry Bliss. New York: HarperCollins, 2002.

——. *Wizzil.* Illustrations by Quentin Blake. New York: Farrar, Straus and Giroux, 2000.

Yorinks, Arthur. *The Flying Latke.* Illustrations by William Steig. New York: Simon and Schuster, 1999.

Books on William Steig and the *New Yorker*

Cott, Jonathan. *Pipers at the Gates of Dawn: The Wisdom of Children's Literature.* New York: Random House, 1983.

Curley, Jane Bayard, ed. *Heart and Humor: The Picture Book Art of William Steig.* Amherst, Mass.: Eric Carle Museum of Picture Book Art, 2004.

Lorenz, Lee. *The Art of The New Yorker, 1925-1995.* New York: Knopf, 1995.

——. *The World of William Steig.* New York: Artisan, 1998.

Mankoff, Robert, ed. *The Complete Cartoons of The New Yorker.* New York: Black Dog & Leventhal, 2004.

Mouly, Françoise, and Lawrence Weschler. *Covering The New Yorker: Cutting-Edge Covers from a Literary Institution.* New York: Abbeville, 2000.

Topliss, Iain. *The Comic Worlds of Peter Arno, William Steig, Charles Addams, and Saul Steinberg.* Baltimore: Johns Hopkins University Press, 2005.

Yagoda, Ben. *About Town: The New Yorker and the World It Made.* New York: Da Capo, 2000.

Interviews with William Steig

Cotler, Joanna. "The Last Interview with Bill Steig." In Jane Bayard Curley, ed., *Heart and Humor: The Picture Book Art of William Steig.* Amherst, Mass.: Eric Carle Museum of Picture Book Art, 2004.

Higgins, James E. "William Steig: Champion for Romance." *Children's Literature in Education* 9, no. 1 (spring 1978): 3-16.

Marcus, Leonard S. *Ways of Telling: Conversations on the Art of the Picture Book.* New York: Dutton Children's Books, 2002.

General Articles on William Steig

"About William Steig (1907–2003)." Posted on http://www.williamsteig.com.

Angell, Roger. "The Minstrel Steig." *New Yorker*, February 20–27, 1995. Posted on http://www.williamsteig.com.

——. "William Steig." *New Yorker*, October 20, 2003, 69.

Bottner, Barbara. "William Steig: The Two Legacies." *Lion and the Unicorn* 2, no. 1 (spring 1978): 4–16.

Boxer, Sarah. "Wry Child of the Unconscious: William Steig, 90, on Art, Life, and the Mysterious Orgone." *New York Times*, November 29, 1997.

——. "William Steig, 95, Dies; Tough Youths and Jealous Satyrs Scowled in His Cartoons." *New York Times*, October 5, 2003.

Brodie, Carolyn S. "Amazing Cartoonist, Gifted Writer: William Steig." *School Library Media Activities Monthly* 21 (November 2004): 44ff.

Brown, Jennifer M. "Celebrating the Art of William Steig." *Publishers Weekly*, April 5, 2004, 25ff.

DeLuca, Geraldine, and Roni Natov. "The State of the Field in Contemporary Children's Fantasy: An Interview with George Woods." *Lion and the Unicorn* 1, no. 2 (fall 1977): 4–15.

Dellinger, Matt. "Bombs Bursting in Air." *New Yorker*, July 9, 2001.

Donovan, John. "American Dispatch." *Signal* 24 (September 1977): 111–16.

"Drawing on Childhood Fancies." *U.S. News and World Report*, March 17, 1997, 78.

Farber, Manny. "Chaim Gross, Milton Avery, and William Steig." *Magazine of Art* 36 (January 1943): 10–15.

Hammer, Joshua. "With Pen, Ink, and the Eye of an Innocent, a Brilliantly Off-Center Writer/ Cartoonist Refuses to Surrender to Age." *People*, December 3, 1984, 87–98.

Hawtree, Christopher. "William Steig: Prolific *New Yorker* Cartoonist and Children's Writer Whose Creations Included the Woodland Monster Shrek." *Guardian*, October 7, 2003.

Hearn, Michael Patrick. "Drawing Out William Steig." *Washington Post*, May 11, 1980.

Heppermann, Christine. "A Zest for Life Animates This Artist's Menagerie of Characters." *Riverbank Review* (summer 2002). Posted on http://www.williamsteig.com.

Higgins, James E. "William Steig: Champion for Romance." *Children's Literature in Education* 9, no. 1 (spring 1978): 3–10.

"I Created a Monster . . ." *Mail on Sunday* (London), June 6, 2004, 46–47.

"Illustrator and Children's Book Author William Steig Dies at 95." *U.S.A. Today*, October 4, 2003.

Kraus, Robert. "William Steig." *Horn Book Magazine* 46 (August 1970): 361–63.

Kroll, Stephen. "Steig: Nobody Is Grown-Up." *New York Times*, June 28, 1987.

Kuskin, Karla. ". . . and William Steig." *New York Times Book Review*, November, 14, 1976.

Lorenz, Lee. "William Steig, 1907–2003: A Tribute." *Comics Journal* 265 (January– February 2005): 70–95.

Lorraine, Walter. "Book Illustration: The State of the Art." In Lee Kingman, Grace Allen Hogarth, and Harriet Quimby, eds., *Illustrators of Children's Books, 1967–1976*, 2–19. Boston: Horn Book, 1978.

Luther, Claudia. "Children's Book Author Drew Many Covers for *The New Yorker*." *Los Angeles Times*, October 5, 2003.

"The Magical Creatures of William Steig." *Newsday*, May 1984. Posted on http://www.williamsteig.com.

"Obituary: William Steig, 1907–2003." *Comics Reporter*, November 30, 2003. (http://www.comicsreporter.com/index.php/resources/longbox/60/). Originally published in *Comics Journal*, no. 257 (December 2003).

Phelps, Donald. "A Back Road of Genius: The Graphic Perception(s) of William Steig." *Comics Journal* 265 (January–February 2005): 96–104.

Shenker, Israel. "Steig, Surviving as He Nears 65, Finds a Peace in Being a Depressed Cartoon- ist." *New York Times*, November 14, 1972.

Solomon, Charles. "Drawing from Experience: Four Grandmasters of Cartooning Look at the State of the Art." *Modern Maturity* 34, no. 5 (October 1991): 48ff.

Steig, Henry. "Papa's Conflict: Portrait of a Man with Two Strings to His Bow." *Commentary*, April 1946, 363–70.

Steig, Jeanne. "What My Husband Saw." *New York Times*, October 11, 2003.

Steig, William. "The Artist at Work (Illustra- tors)." *Horn Book Magazine* 69 (March 1993): 170.

Van Gelder, Lawrence. "William Steig Shapes His Doodles into Prize-Winning Children's Books." *New York Times*, November, 18, 1977.

"William Steig at 80." *Publishers Weekly*, July 24, 1987, 116–18. Posted on http://www.williamsteig.com.

"William Steig, 1907–2003." *St. Petersburg Times*, October 12, 2003.

Articles on William Steig's Books of Drawings

About People (1939)

Jenkins, John G. "*About People* by William Steig (review)." *American Journal of Psychology* 53, no. 3 (July 1940): 485.

Mallet, Isabelle. "The Inspired Geography of Lunacy." *New York Times*, June 18, 1944. Reviews of *About People* and *All Embarrassed*.

The Lonely Ones (1942)

Chamberlain, John. "Books of the Times." *New York Times*, December 10, 1942. Reviews of both *The Lonely Ones* and *About People*.

Greenberg, Clement. "Steig's Gallery: Review of *The Lonely Ones* by William Steig." *The Nation*, January 16, 1943. Reprinted in *Clement Greenberg: The Collected Essays and Criticism*, vol. 1: *Perceptions and Judgments 1939–1944*, ed. John O'Brian, 137–38. Chicago: University of Chicago Press, 1986.

Trilling, Diana. "Small Fry: Twenty Years Later." *New Republic*, January 25, 1943, 124.

All Embarrassed (1944)

Weigle, Edith. "Queer and Dippy People Depicted by William Steig." *Chicago Daily Tribune*, July 2, 1944.

Small Fry (1944)

Hutchens, John K. "Small Fry: Drawings by William Steig." *New York Times*, November 19, 1944.

Persistent Faces (1945)

"People Who Read and Write." *New York Times*, October 28, 1945.

Poore, Charles. "Books of the Times." *New York Times*, November 17, 1945.

Listen, Little Man! (1948) by Wilhelm Reich, with illustrations by William Steig

Sykes, Gerald. "What Is a 'Little Man' Made Of?" *New York Times*, October 31, 1948.

The Agony in the Kindergarten (1950)

Jackson, Joseph Henry. "Bookman's Notebook." *Los Angeles Times*, April 17, 1950.

"Look, I'm in Pictures." *New York Times*, March 19, 1950.

"'Small Fry's' Parents Get Real Training." *Los Angeles Times*, April 30, 1950.

The Rejected Lovers (1951)

Steig, William. Letter to the Editor. *New York Times*, December 2, 1951.

Vollmer, Hermann. "This Thing Called Love." *New York Times*, October 21, 1951.

Continuous Performance (1963)

Gingras, Angele de T. "Cartoons in Triplicate." *Washington Post*, August 18, 1963.

Drawings (1979)

Fern, Alan. "William Steig Drawings." *New York Times*, November 25, 1979.

"People." *Newsweek*, September 3, 1979.

Solomon, Charles. "The Offerings in Cartoon Books." *Los Angeles Times*, December 2, 1979.

Tanabe, K. Francis. "Laugh Lines." *Washington Post*, December 9, 1979.

Articles on William Steig's Children's Books

CDB! (1968)

Wimsatt, William. "In Search of Verbal Mimesis." *Yale French Studies*, no. 52 (1975): 232–233.

Woods, George A. Review of *CDB!* *New York Times*, November 24, 1968.

Roland the Minstrel Pig (1968)

Goodwin, Polly. "Roland the Minstrel Pig." *Chicago Tribune*, September 1, 1968.

Steig, William. "Also, Pigs Are Pink." *New York Times*, May 4, 1969.

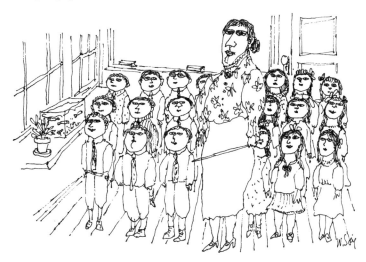

Woods, George A. "New Books for Young Readers." *New York Times*, April 21, 1968.

The Bad Island (1969)

Woods, George A. Review of *The Bad Island*. *New York Times*, October 19, 1969.

——. "The Best for Young Readers." *New York Times*, December 7, 1969.

Sylvester and the Magic Pebble (1969)

Cassidy, Claudia. "Sea Change." *Chicago Tribune*, May 2, 1971.

Fishbein, Ed. "Schools, Libraries Still Under Pressure to Censor Materials." *Los Angeles Times*, January 8, 1973.

"Girl Giggles, Deputy Fumes at Book." *Washington Post*, November 11, 1970.

Haviland, Virginia. Review of *Sylvester and the Magic Pebble*. *Chicago Tribune*, May 4, 1969.

King, Seth S. "Book's Two Pigs Stir Censorship Row." *New York Times*, February 20, 1971.

Lehmann-Haupt, Christopher. "Some Notable Children's Books." *New York Times*, December 8, 1969.

Leonard, Will. "Art and the Law." *Chicago Tribune*, March 13, 1971.

Marcus, Leonard S. "1970—*Sylvester and the Magic Pebble* by William Steig." In Marcus, ed., *A Caldecott Celebration: Six Artists and Their Paths to the Caldecott Medal*, 26–29. New York: Walker, 1998.

"Police Protest Storybook." *Chicago Tribune*, January 15, 1971, 3.

"Police Rebuffed in Bid to Quash 'Pig' Portrayal." *Washington Post*, November 25, 1970.

Raymont, Henry. "Fig Leafs for Children Irk Librarians." *New York Times*, June 27, 1972.

Steig, William. "Caldecott Award Acceptance Speech." Posted on http://www.williamsteig.com.

——. Letter to the Editor. *New York Times*, March 3, 1971.

Weitzman, Lenore J., Deborah Eifler, Elizabeth Hokada, and Catherine Ross. "Sex-Role Socialization in Picture Books for Preschool Children." *American Journal of Sociology* 77, no. 6 (May 1972): 1141–42.

Woods, George A. "Sylvester and the Magic Pebble." *New York Times*, February 16, 1969.

——. "The Best for Young Readers." *New York Times*, December 7, 1969.

Amos & Boris (1971)

Bandler, Michael J. "Tried and True." *Washington Post*, November 7, 1971.

"The Best of the Illustrated Books." *New York Times*, November 7, 1971.

Foote, Timothy. "Caboose Thoughts and Celebrities." *Newsweek*, December 27, 1971.

Lehmann-Haupt, Christopher. "Books of the Times: Some Children's Picture Books." *New York Times*, December 14, 1971.

Woods, George A. "For Young Readers." *New York Times*, October 17, 1971.

Dominic (1972)

Lanes, Selma G. "Afterwords." *Chicago Tribune*, May 7, 1972.

Lehmann-Haupt, Christopher. "Books of the Times: Children's Reading Books." *New York Times*, December 13, 1972.

Magid, Nora L. "Dominic." *New York Times*, July 9, 1972.

Moss, Anita. "The Spear and the Piccolo: Heroic and Pastoral Dimensions of William Steig's 'Dominic' and 'Abel's Island.'" *Children's Literature: Annual of the Modern Language Association Division on Children's Literature and the Children's Literature Association* 10 (1982): 124–40.

"Paperbacks of the Month: Young Readers." *New York Times*, February 10, 1974.

The Real Thief (1973)

Kuskin, Karla. "An Innocent Goose and an Evil Ring." *New York Times*, September 2, 1973.

Lehmann-Haupt, Christopher. "Books of the Times: Children's Books for Adults." *New York Times*, December 10, 1973.

"New in Paperback: Fiction." *New York Times*, November 10, 1974.

Abel's Island (1976)

Egoff, Sheila A. "The New Fantasy." In Egoff, *Thursday's Child: Trends and Patterns in Contemporary Children's Literature*, 80–129. Chicago: American Library Association, 1981.

Fisher, Margery. Review of *Abel's Island*. *Growing Point* 16, no. 9 (April 1978): 3291–92.

Hearne, Betsy. "Children's Books: Best of the Breed." *Los Angeles Times*, March 2, 1977. Reviews of *The Amazing Bone* and *Abel's Island*.

Hobbs, M. Review of *Abel's Island*. *Junior Bookshelf* 42, no. 1 (February 1978): 49–50.

"Outstanding Books of the Year." *New York Times*, November 14, 1976.

Spirt, Diana L. "Developing Values: William Steig, 'Abel's Island.'" In Spirt, *Introducing More Books: A Guide for the Middle Grades*, 66–69. New York: R. R. Bowker, 1978.

Wells, Rosemary. "A Good Mouse Is Hard to Find." *Washington Post*, July 11, 1976.

Whedon, Julia. "Abel's Island." *New York Times*, July 18, 1976.

Wolf, Virginia L. "Paradise Lost? The Displacement of Myth in Children's Novels Set on Islands." *Studies in the Literary Imagination* 18, no. 2 (fall 1985): 47–63.

Woods, George A. "Books of the Times: For Teens and Pre-Teens." *New York Times*, December 21, 1976.

The Amazing Bone (1976)

Eisenman, Alvin. Review of *The Amazing Bone*. In Barbara Bader, Betty Binns, and Alvin Eisenman, eds., *Children's Book Showcase 1977*, 6. New York: Children's Book Council, 1977.

Lehmann-Haupt, Christopher. "Books of the Times." *New York Times*, December 20, 1976.

Peterson, Linda Kauffman. "The Caldecott Medal and Honor Books, 1938–1981: 'The Amazing Bone.'" In Linda Kauffman Peterson and Marilyn Leuthers, *Newberry and Caldecott Medal and Honor Books: An Annotated Bibliography*, 365–66. Boston: G. K. Hall, 1982.

Quindlen, Anna. "Don't Read This." *New York Times*, October 1, 1994.

Review of *The Amazing Bone*. *Publishers Weekly*, December 6, 1976.

Review of *The Amazing Bone*. *Washington Post*, November 7, 1976.

Caleb & Kate (1977)

Haskell, Ann S. "Picture Books: The Eyes Have It." *Washington Post*, November 13, 1977.

Heins, Ethel L. Review of *Caleb & Kate*. *Horn Book Magazine* 54, no. 1 (February 1978): 38–39.

Howard, Maureen. "Daddy in the Dog House." *New York Times Book Review*, November 13, 1977.

Kanfer, Stefan. "A Cornucopia of Children's Books." *Newsweek*, November 21, 1977.

Pollack, Pamela D. Review of *Caleb & Kate*. *School Library Journal* 24, no. 5 (January 1978): 82.

Wilms, Denise M. Review of *Caleb & Kate*. *Booklist*, January 15, 1978.

Tiffky Doofky (1978)

Burns, Mary M. Review of *Tiffky Doofky*. *Horn Book Magazine* 55, no. 1 (February 1979): 54–55.

Kanfer, Stefan. "A Rainbow of Colorful Reading." *Newsweek*, December 4, 1978.

Lanes, Selma G. "When Showing Really Tells." *Washington Post*, November 12, 1978.

Lehmann-Haupt, Christopher. "Books of the Times." *New York Times*, December 12, 1978.

Lewis, Marjorie. Review of *Tiffky Doofky*. *School Library Journal* 25, no. 5 (January 1979): 48.

Review of *Tiffky Doofky*. *Kirkus Reviews*, December 15, 1978.

Review of *Tiffky Doofky*. *Publishers Weekly*, November 6, 1978.

Rice, Harold C. K. "Good Looking." *New York Times*, December 10, 1978.

Gorky Rises (1980)

Karlin, Barbara. "To Grow On." *Los Angeles Times*, November 16, 1980.

Lehmann-Haupt, Christopher. "Books of the Times." *New York Times*, December 5, 1980.

Review of *Gorky Rises*. *Kirkus Reviews*, January 1, 1981.

Rice, Harold C. K. "A Potpourri of Picture Books." *New York Times Book Review*, November 9, 1980.

Slung, Michele. "The Artful Menagerie." *Washington Post*, November 9, 1980.

Sutherland, Zena. Review of *Gorky Rises*. *Bulletin of the Center for Children's Books* 34, no. 6 (February 1981): 121.

Wilms, Denise M. Review of *Gorky Rises*. *Booklist*, December 15, 1980.

"The Year's Best Illustrated Books." *New York Times*, November 9, 1980.

Doctor De Soto (1982)

Bennett, Jill. Review of *Doctor De Soto*. *School Librarian* 32, no. 1 (March 1984): 53–54.

Flanagan, Kate M. Review of *Doctor De Soto*. *Horn Book Magazine* 59, no. 2 (April 1983): 162.

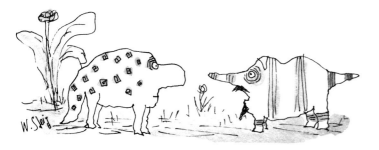

Hammill, Elizabeth. "Picture Books and Illustrated Stories 6 to 9: 'Doctor De Soto.'" *Signal Review of Children's Books* 2 (1984): 12.

Kanfer, Stefan. "A Short Shelf of Tall Tales." *Newsweek*, December 20, 1982.

Karlin, Barbara. "Children's Books: Mice, Men, Masterpieces." *Los Angeles Times*, December 5, 1982.

Lehmann-Haupt, Christopher. "Books of the Times." *New York Times*, November 29, 1982.

Review of *Doctor De Soto*. *Kirkus Reviews*, November 1, 1982.

Slung, Michele. "Picture Palettes." *Washington Post*, November 7, 1982.

Woods, George A. "Children's Books: Doctor De Soto." *New York Times*, December 12, 1982.

CDC? (1984)

Burns, Mary M. Review of *CDC? Horn Book Magazine* 61, no. 1 (January–February 1985): 56.

David, Martin A. Review of *CDC? Los Angeles Times*, November 25, 1984.

Hanley, Karen Stang. Review of *CDC? Booklist*, January 15, 1985.

Kanfer, Stefan. "Small Wonders for the Young." *Newsweek*, December 17, 1984.

Salvadore, Maria. Review of *CDC? School Library Journal* 31, no. 6 (February 1985): 87.

Rotten Island (1984)

Dirda, Michael. "Young Bookshelf: *Rotten Island*." *Washington Post*, July 8, 1984.

MacCann, Donnarae, and Olga Richard. "Picture Books for Children." *Wilson Library Bulletin* 59, no. 2 (October 1984): 128–29.

Martin, Sandra. "Children's Books: An Adult Appreciation." *Globe and Mail*, September 22, 1984.

Review of *Rotten Island. Publishers Weekly*, June 22, 1984.

Warwick, Ellen D. Review of *Rotten Island. School Library Journal* 31, no. 2 (October 1984): 152.

Yellow & Pink (1984)

Fisher, Margery. Review of *Yellow & Pink. Growing Point* 25, no. 4 (November 1986): 4703.

Gerhardt, Lillian N. Review of *Yellow & Pink. School Library Journal* 30, no. 10 (August 1984): 66.

Karlin, Barbara. "To Grow On." *Los Angeles Times*, November 25, 1984.

Marcus, Leonard S. "Steig and Gorey: Illustrious Illustrators." *Washington Post*, July 8, 1984.

Milford, Nancy. "Children's Books: *Yellow & Pink*." *New York Times Book Review*, August 12, 1984.

Review of *Yellow & Pink. Publishers Weekly*, May 18, 1984.

Sutherland, Zena. "Kids Introduced to Junk Tycoons, Space Wanderers." *Chicago Tribune*, January 6, 1985.

Solomon the Rusty Nail (1985)

Beavin, Kristi Thomas. Review of *Solomon the Rusty Nail. School Library Journal* 32, no. 6 (February 1986): 78–79.

Dirda, Michael. "Of Time Travel, Poetry, Cossacks and Boats." *Washington Post*, January 12, 1986.

Flowers, Ann A. Review of *Solomon the Rusty Nail. Horn Book Magazine* 62, no. 2 (March–April 1986): 197–98.

Kanfer, Stefan. "A Shelf of Small Wonders." *Newsweek*, December 23, 1985.

Lehmann-Haupt, Christopher. "Books of the Times." *New York Times*, December 2, 1985.

Review of *Solomon the Rusty Nail. Kirkus Reviews*, December 15, 1985.

Review of *Solomon the Rusty Nail. Publishers Weekly*, November 22, 1985.

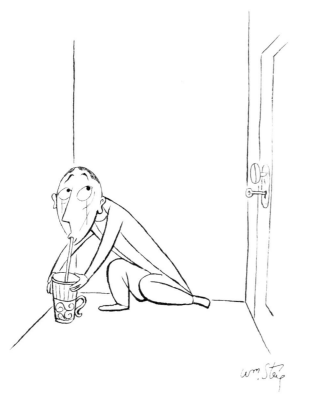

Wilms, Denise M. Review of *Solomon the Rusty Nail*. *Booklist*, January 1, 1986.

Brave Irene (1986)

Flowers, Ann A. Review of *Brave Irene*. *Horn Book Magazine* 62, no. 6 (November–December 1986): 740–41.

Gould, Lois. "Junior Ms., Tough and Smart." *New York Times Book Review*, November 9, 1986.

Kanfer, Stefan. "Enchantments For." *Newsweek*, January 5, 1987.

Lehmann-Haupt, Christopher. "Books of the Times." *New York Times*, December 4, 1986.

Review of *Brave Irene*. *Kirkus Reviews*, October 15, 1986.

Review of *Brave Irene*. *Publishers Weekly*, September 26, 1986.

"The Year's Best Illustrated Books." *New York Times*, November 9, 1986.

The Zabajaba Jungle (1987)

Kanfer, Stefan. "Liberating Youthful Spirits." *Newsweek*, December 14, 1987.

Natov, Roni. "Internal and External Journeys: The Child Hero in *The Zabajaba Jungle* and *Linnea in Monet's Garden*." *Children's Literature in Education* 20, no. 2 (1989): 91–101.

Review of *The Zabajaba Jungle*. *Publishers Weekly*, October 11, 1991.

Yolen, Jane. "The Trials of Chinless Leonard." *New York Times*, November 8, 1987.

Consider the Lemming (1988) by Jeanne and William Steig

Review of *Consider the Lemming*. *Publishers Weekly*, July 29, 1988.

Spinky Sulks (1988)

Barry, Dave. "Silence is the Best Revenge." *New York Times*, November 13, 1988.

Kanfer, Stefan. "A Child's Garden of Lore and Laughter." *Newsweek*, December 12, 1988.

Lehmann-Haupt, Christopher. "For Junior Bibliophiles, 10 Favorites of the Year." *New York Times*, December 5, 1988.

Noah, Timothy. "The Art of Sulk: William Steig's Greatest Contribution." *Slate*, October 6, 2003. Posted on http://www.slate.com/id/2089405/.

Review of *Spinky Sulks*. *Publishers Weekly*, December 23, 1988.

The Old Testament Made Easy (1990) by Jeanne and William Steig

Review of *The Old Testament Made Easy*. *Publishers Weekly*, September 21, 1990.

Shrek! (1990)

"A Child's Shelf of Delight." *Newsweek*, December 17, 1990.

Dirda, Michael. "Young Bookshelf: *Shrek!*" *Washington Post*, October 14, 1990.

Eccleshare, Julia. "Where Did the Hairy Nose Go?" *Guardian*, June 22, 2001.

Lehmann-Haupt, Christopher. "Presents of Words, Pictures, and Imagination." *New York Times*, December 3, 1990.

Review of *Shrek! Publishers Weekly*, September 14, 1990, 124.

Alpha Beta Chowder (1992) by Jeanne and William Steig

Review of *Alpha Beta Chowder*. *Publishers Weekly*, December 10, 1992.

Doctor De Soto Goes to Africa (1992)

Review of *Doctor De Soto Goes to Africa*. *Publishers Weekly*, June 22, 1992.

Zeke Pippin (1994)

Lehmann-Haupt, Christopher. "Illustrated for Children: Small Yield, Vintage Year." *New York Times*, December 1, 1994.

Review of *Zeke Pippin*. *Publishers Weekly*, November 21, 1994.

Grown-Ups Get to Do All the Driving (1995)

Jones, Malcolm Jr.. Review of *Grown-Ups Get to Do All the Driving*. *Newsweek*, May 15, 1995, 61–62.

Review of *Grown-Ups Get to Do All the Driving*. *Publishers Weekly*, February 20, 1995, 204.

The Toy Brother (1996)

Review of *The Toy Brother*. *Publishers Weekly*, January 15, 1996, 461.

Salvadore, Maria B. "The Toy Brother." *Horn Book Magazine* 72 (May–June 1996): 329ff.

Spitz, Ellen Handler. Review of *The Toy Brother*. *New York Times*, June 30, 1996.

Toby, Where Are You? (1997) by William Steig and Teryl Euvremer (illustrator)

Review of *Toby, Where Are You? Publishers Weekly*, February 12, 1996.

A Handful of Beans (1998) by Jeanne and William Steig

"Best Illustrated Books 1998." *New York Times*, November 15, 1998.

Review of *A Handful of Beans. Publishers Weekly*, October 5, 1998, 88.

Pete's a Pizza (1998)

Burns, Mary M. "Pete's a Pizza," *Horn Book Magazine* 74, no. 5 (September–October 1998): 602.

Lehmann-Haupt, Christopher. "Adventuring from a Child's Imagination to the Arctic." *New York Times*, December 7, 1998.

Review of *Pete's a Pizza. Publishers Weekly*, July 6, 1998, 58.

Wilkinson, Signe. "Some Pepperoni on Your Little Boy?" *New York Times*, November 15, 1998. Reviews of *Pete's a Pizza* and *A Handful of Beans.*

Wizzil (2000) by William Steig and Quentin Blake (illustrator)

Parravano, Martha V. "*Wizzil.*" *Horn Book Magazine* 76 (July–August 2000): 446ff.

Review of *Wizzil. Publishers Weekly*, July 3, 2000, 70.

A Gift from Zeus: Sixteen Favorite Myths (2001) by Jeanne and William Steig

Doniger, Wendy. "An Olympian Undertaking." *New York Times Book Review*, May 20, 2001.

Long, Joanna Rudge. "A Gift from Zeus." *Horn Book Magazine* 77, no. 3 (May–June 2001): 300ff.

Review of *A Gift from Zeus. Publishers Weekly*, June 25, 2001, 73.

Toby, What Are You? (2001) by William Steig and Teryl Euvremer (illustrator)

Review of *Toby, What Are You? Publishers Weekly*, May 14, 2001.

Potch and Polly (2002) by William Steig and Jon Agee (illustrator)

Review of *Potch and Polly. Publishers Weekly*, June 24, 2002, 56.

Which Would You Rather Be? (2002) by William Steig and Harry Bliss (illustrator)

Review of *Which Would You Rather Be? Publishers Weekly*, May 20, 2002, 64.

Ward, Doug. "Children's Books: These Are the Questions." *New York Times*, May 19, 2002.

When Everybody Wore a Hat (2003)

"Best Illustrated Books." *New York Times*, November 16, 2003.

Cotler, Joanna. "William Steig at 95." *Publishers Weekly*, April 21, 2003.

Review of *When Everybody Wore a Hat. Publishers Weekly*, February 10, 2003.

Sorel, Edward. "Children's Books: *When Everybody Wore a Hat.*" *New York Times Book Review*, April 20, 2003.

"*When Everybody Wore a Hat.*" *Horn Book Magazine* 79, no. 3 (May–June 2003).

Toby, Who Are You? (2004) by William Steig and Teryl Euvremer (illustrator)

Review of *Toby, Who Are You? Kirkus Reviews*, May 15, 2004.

Contributors

Claudia Nahson is associate curator at The Jewish Museum and the curator of the William Steig exhibition. She also curated *Wild Things: The Art of Maurice Sendak* (2005) and oversaw the reinstallation of The Jewish Museum's permanent exhibition *Culture and Continuity: The Jewish Journey* in 2003. She has been the museum's coordinating curator for many exhibitions, including *Focus on the Soul: The Photographs of Lotte Jacobi* (2004), *Facing West: Jews of Central Asia and the Caucasus* (1999), *Ikat: Splendid Silks of Central Asia from the Guido Goldman Collection* (1999), and *Women Photographers of the Weimar Republic* (1995). She is the author of *Ketubbot: Marriage Contracts from The Jewish Museum* (1998) and a contributor to *Masterworks of The Jewish Museum* (2004).

Robert Cottingham is an eminent photo-realist painter whose work has been widely exhibited and is represented in the collections of the Art Institute of Chicago, the Solomon R. Guggenheim Museum, the Hirshhorn Museum and Sculpture Garden, the Metropolitan Museum of Art, the Museum of Modern Art, the Whitney Museum of American Art, and other museums. Born in Brooklyn and educated at the Pratt Institute in New York, he has had solo exhibitions at many museums and galleries, including the Herbert F. Johnson Museum of Art at Cornell University, the Davison Art Center at Wesleyan University, the Springfield Art Museum in Missouri, and the Madison Art Center in Wisconsin.

Maurice Sendak is a visionary figure in children's literature, the winner of the 1964 Caldecott Medal for *Where the Wild Things Are* and the only American illustrator to win the international Hans Christian Andersen Award (in 1970, for his body of work). In 1956, with *Kenny's Window*, he began to create his own texts as well as illustrations. Also a distinguished set and costume designer for opera and ballet, he has designed many productions, including Mozart's *Magic Flute*, Tchaikovsky's *Nutcracker*, and Oliver Knussen's operas based on his *Where the Wild Things Are* and *Higglety Pigglety Pop!* In 1983, Mr. Sendak received the Laura Ingalls Wilder Award from the American Library Association; in 1996 he received a National Medal of Arts; and in 2003 he received the first Astrid Lindgren Memorial Award.

Edward Sorel is a caricaturist whose comic art has appeared on over forty-five covers of the *New Yorker*. His cartoons and essays have also appeared in the *Atlantic, the Nation, Time, Esquire, Vanity Fair, Fortune, Forbes,* and *American Heritage*. He is the illustrator of a dozen books for children, including *The Saturday Kid*, which he wrote. Collections of his work have appeared in *Unauthorized Portraits* (1997), *Literary Lives* (2006), and the forthcoming *Just When You Thought Things Couldn't Get Worse* (2007). He is the recipient of the Augustus Saint-Gaudens Medal from the Cooper Union, the George Polk Award for Satiric Drawing, and Den Karikaturpreis der Deutschen Anwaltschaft in Berlin.

Jeanne Steig was married to William Steig from 1973 until his death in 2003. She is an artist and the author of *Consider the Lemming* (1990), *The Old Testament Made Easy* (1990), *Alpha Beta Chowder* (1994), *A Handful of Beans: Six Fairy Tales Retold* (1998), *A Gift from Zeus* (2001), all illustrated by William Steig, as well as *Tales from Gizzard's Grill* (2004) and the forthcoming *Fleas*.

Maggie Steig is William Steig's daughter. She graduated summa cum laude in metalsmithing from Boston University, where she won the Royal Society of Arts medal. She acted with the Performer's Ensemble and cofounded the improvisational comedy group Guilty Children in Boston. She is creative director of FM&A Events and is a consultant for the Ariel Group.

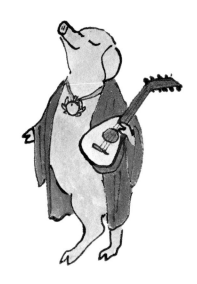

Illustration Credits

Unless otherwise noted, all works by William Steig are copyright © William Steig. All rights reserved.

Unless otherwise noted, all works are in the Collection of the William Steig Estate.

All photographs of William Steig's works were taken by Richard Goodbody except, as indicated below, for images provided by the Cartoon Bank, Condé Nast Publications, and the Eric Carle Museum of Picture Book Art, Amherst, Massachusetts.

Front cover: Untitled drawing (page of faces), undated. Pen and ink and watercolor on paper, 10¼ x 11⅛ in. (26 x 28.3 cm).

Endpaper, left: *Cast of Characters*, undated. Pen and ink on paper, 10 x 13 in. (25.4 x 33 cm). Collection of Lucy Steig.

Endpaper, right: Untitled drawing (seven figures in two rows), 1980s. Pen and ink on paper, 7⅞ x 11 in. (20 x 27.9 cm). Collection of Maggie Steig.

Back cover: Preliminary illustration for *Sylvester and the Magic Pebble*, 1969 ("'Oh, how I wish he were here with us on this lovely May day,' said Mrs. Duncan"). Pen and ink and watercolor on paper, 10¾ x 8 in. (27.3 x 20.3 cm). Collection of Lucy Steig. © 1969 William Steig, renewed 1997.

Page i: Final illustration for *Solomon the Rusty Nail* (New York: Farrar, Straus and Giroux, 1985) ("With the cats out of sight, Solomon resumed his natural form"). Pen and ink and watercolor on paper, 12 x 9 in. (30.5 x 22.9 cm). Collection of Melinda Franceschini. © 1985 William Steig.

Pages ii–iii: Untitled drawing (stick figures walking on sidewalk drawings), undated. Pen and ink and colored pencil on paper, 7 x 11½ in. (17.8 x 29.2 cm).

Page iv: Untitled drawing. From "Small Fry: Snow" series, published in *Dreams of Glory and Other Drawings* (New York: Knopf, 1953). Pen and ink on paper, 4⅞ x 4¼ in. (12.4 x 10.8 cm). Collection of Lucy Steig. © 1953 William Steig, renewed 1981.

Page v: Final cover illustration of *Caleb & Kate* (New York: Farrar, Straus and Giroux, 1977). Pen and ink and watercolor on paper, 9¼ x 12½ in. (23.5 x 31.8 cm). © 1977 William Steig, renewed 2005.

Page vi: Untitled drawing (circus performers taking a bow), undated. Pen and ink on paper, 9⅞ x 12¾ in. (25.1 x 32.4 cm).

Page x: Untitled drawing (boys on stilts), early 1950s. Pen and ink and wash on paper, 12 x 8½ in. (30.5 x 21.6 cm). Collection of Maggie Steig.

Page xii: Untitled drawing (family portrait), c. 1981. Pen and ink and watercolor on paper, 8½ x 8¾ in. (21.6 x 22.2 cm).

Page 3, top left: William Steig, c. 1970. Photograph by Henry Humphrey. Courtesy of Maggie Steig.

Page 3, bottom left: Joseph Steig, undated. Collection of Maggie Steig.

Page 3, right: Joseph and Laura Steig, 1912. From Lee Lorenz, *The World of William Steig* (New York: Artisan, 1998), 13.

Page 4, top: Untitled drawing (Sunday painter), undated. Pen and ink on paper, 4⅝ x 6⅜ in. (11.8 x 16.2 cm).

Page 4, middle: Final illustration for title page of *Brave Irene* (New York: Farrar, Straus and Giroux, 1986). Pen and ink and watercolor on paper, 7½ x 11⅛ in. (19.1 x 28.1 cm). © 1986 William Steig.

Page 4, bottom: Final illustration for *When Everybody Wore a Hat* (New York: HarperCollins, 2003; "There were times when sad news would come from the Old Country"). Pen and ink and watercolor on paper, 9½ x 11¼ in. (24.1 x 28.6 cm). Originally published as a pen-and-ink-and-wash drawing in the *New Yorker*, September 26, 1959. © 2003 William Steig.

Page 5, top: *A bid for immortality.* Final drawing for *About People: A Book of Symbolic Drawings* (New York: Random House, 1939). Pen and ink and wash on paper, 4½ x 6¾ in. (11.4 x 17.2 cm). © 1939 William Steig, renewed 1967, 1995.

Page 5, bottom: Saul Steinberg (American, b. Romania, 1914–1999), Artist's statement for *Fourteen Americans* exhibition at the Museum of Modern Art, New York, 1946 (earliest extant "false handwriting" drawing by Steinberg). Ink on paper, 3¾ x 7⅞ in. (9.5 x 20 cm). Private collection, formerly collection of Dorothy C. Miller. © The Saul Steinberg Foundation/Artists Rights Society (ARS), New York.

Page 6, left: "To life!" Published in the *New Yorker*, January 18, 1964. © The New Yorker Collection 1964 William Steig from cartoonbank.com. All rights reserved.

Page 6, right: "Gevalt!" Published in the *New Yorker*, April 20, 1992. © The New Yorker Collection 1992 William Steig from cartoonbank.com. All rights reserved.

Page 7: Preliminary illustration for "Lovey Dovey" in *Alpha Beta Chowder* (New York: HarperCollins, 1992; "A lunatic living in Lvov . . ."). Pen and ink and watercolor on paper, 11½ x 9¼ in. (29.2 x 23.5 cm). Collection of Lucy Steig. © 1992 William Steig.

Page 8: Final background illustration for *The Flying Latke* (New York: Simon and Schuster, 1999; "'Izzy,' my mother said as she brought in her prized platter of latkes"). Pen and ink and watercolor on paper, 11½ x 18 in. (29.2 x 45.7 cm). © 1999 William Steig.

Page 10: *Grown-ups like to sleep late.* Final illustration for *Grown-Ups Get to Do All the Driving* (New York: HarperCollins, 1995). Pen and ink and watercolor on paper, 4¾ x 10 in. (12.1 x 25.4 cm). © 1995 William Steig.

Page 12, top left: "I call your bluff!" Published in *Small Fry* (New York: Duell, Sloan and Pearce, 1944). Pen and ink and wash on paper. © 1944 William Steig, renewed 1972, 2000.

Page 12, top right: *Grown-ups always want to be kissed.* Final illustration for *Grown-Ups Get to Do All the Driving* (New York: HarperCollins, 1995). Pen and ink and watercolor on paper, 7⅞ x 8¼ in. (20 x 21 cm). © 1995 William Steig.

Page 12, bottom: "Pardon me, young man, are you a member of this Study Group?" Drawing by Helen E. Hokinson (1893–1949) and William Steig. Published in the *New Yorker*, January 26, 1935. Pen and ink, wash, and collage on paper, 14 x 12 in. (35.6 x 30.5 cm). Collection of Lakeview Museum of Arts and Sciences, Peoria, Illinois (1964.10.69). © The New Yorker Collection 1935 Helen E. Hokinson from cartoonbank.com. All rights reserved.

Page 13, left: "What a beautiful morning!" Published in *Collier's*, January 7, 1950. Pen and ink and wash on paper, 11 x 10 in. (27.9 x 25.4 cm). © 1950 William Steig, renewed 1978, 2006.

Page 13, right: "Yes, but my George has broader shoulders." Published in the *New Yorker*, January 23, 1932. © The New Yorker Collection 1932 William Steig from cartoonbank.com. All rights reserved.

Page 14, left: *The Round Table.* Similar version published in "King Arthur and His Knights" series in the *New Yorker*, December 21, 1968. Pen and ink and wash on paper, 10⅞ x 16¼ in. (27.3 x 41.3 cm). Collection of Maggie Steig. © 1968 William Steig, renewed 1996.

Page 14, right: *Posse.* From "The Wild West" series. Similar version published in the *New Yorker*, February 24, 1992. Pen and ink and

watercolor on paper, 7¾ x 11⅛ in. (19.7 x 28.3 cm). © 1992 William Steig.

Page 15, left: Final illustration for title page of *Shrek!* (New York: Farrar, Straus and Giroux, 1990). Pen and ink and watercolor on paper, 11¼ x 9¾ in. (28.6 x 24.8 cm). © 1990 William Steig.

Page 15, right: Final illustration for *Shrek!* 1990 ("Shrek snapped at her nose. She nipped at his ear. They clawed their way into each other's arms"). Pen and ink and watercolor on paper, 11¼ x 11⅛ in. (28.6 x 28.3 cm). © 1990 William Steig.

Page 16, top left: *Big Sister.* From "Small Fry: Park Playground" series, published in the *New Yorker*, April 18, 1953. Pen and ink and wash on paper, 9½ x 10 in. (24.1 x 25.4 cm). Collection of Maggie Steig. © 1953 William Steig, renewed 1981.

Page 16, top right: Cover of the *New Yorker*, July 13, 1957. Photograph copyright © 1957 Condé Nast Publications, Inc.

Page 16, bottom left: Cover of the *New Yorker*, July 21, 1956. Photograph copyright © 1956 Condé Nast Publications, Inc.

Page 16, bottom right: Untitled drawing (sideshow), c. 1956. Pen and ink and wash on paper, 9¼ x 11 in. (23.5 x 27.9 cm). Collection of Lucy Steig.

Page 17: Untitled drawing (Small Fry as cowboy confronting Hitler at gunpoint). From "Dreams of Glory" series, published in the *New Yorker*, February 19, 1944. © The New Yorker Collection 1944 William Steig from cartoonbank.com. All rights reserved.

Page 19, top: *Your slave driver is yourself!* Final drawing for Wilhelm Reich's *Listen, Little Man!* (New York: Farrar, Straus and Giroux, 1948). Pen and ink on paper, 6¼ x 9⅜ in. (15.9 x 23.9 cm). Copyright © information from Wilhelm Reich Trust to come.

Page 19, bottom left: *Mother's got an awful headache today.* Preliminary drawing for *The Agony in the Kindergarten* (New York: Duell, Sloan and Pearce, 1950). Pen and ink on paper, 9½ x 8 in. (24.1 x 20.3 cm). Collection of Maggie Steig. © 1950 William Steig, renewed 1978, 2006.

Page 19, bottom right: *Grown-ups get headaches.* Final illustration for *Grown-Ups Get to Do All the Driving* (New York: HarperCollins, 1995). Pen and ink and watercolor on paper, 7⅜ x 10⅛ in. (18.7 x 25.7 cm). © 1995 William Steig.

Page 20, top: *Family Reunion*, 1978–80. Pen and ink and wash on paper, 6½ x 9⅞ in. (16.5 x 25.1 cm).

Page 20, bottom: Final illustration for *Zeke Pippin* (New York: HarperCollins, 1994; "Zeke Pippin was drifting down the Hinkaholly River"). Pen and ink and watercolor on paper. Collection of Holly McGhee. Photograph courtesy of the Eric Carle Museum of Picture Book

Art, Amherst, Massachusetts. © 1994 William Steig.

Page 21: Final illustration for *Doctor De Soto* (New York: Farrar, Straus and Giroux, 1982; "Doctor De Soto stepped into the fox's mouth"). Pen and ink and watercolor on paper, 12 x 8⅞ in. (30.5 x 22.5 cm). Collection of Melinda Franceschini. © 1982 William Steig.

Page 23, top: Final illustration for *Solomon the Rusty Nail* (New York: Farrar, Straus and Giroux, 1985; "They decided to take turns keeping an eye on the cage"). Pen and ink and watercolor on paper, 12 x 9 in. (30.5 x 22.9 cm). Collection of Melinda Franceschini. © 1985 William Steig.

Page 23, bottom: Final illustration for *Solomon the Rusty Nail*, 1985 ("Ambrose and Clorinda watched and waited"). Pen and ink and watercolor on paper, 12 x 9 in. (30.5 x 22.9 cm). Collection of Melinda Franceschini. © 1985 William Steig.

Page 24, left: Final illustration for *Abel's Island* (New York: Farrar, Straus and Giroux, 1976; "The feeling that he could visit Amanda in dreams haunted Abel"). Pen and ink and wash on paper, 11 x⅛ x 7½ in. (28.3 x 19.1 cm). © 1976 Willliam Steig, renewed 2003.

Page 24, right: William and Jeanne Steig, Kent, Connecticut, 1973. Photograph by Nancy Crampton. Copyright © Nancy Crampton.

Page 25: Final illustration for *Dominic* (New York: Farrar, Straus and Giroux, 1972; "Dominic was inspired to take out his piccolo and play"). Pen and ink on paper, 6¼ x 9½ in. (15.9 x 24.1 cm). © 1972 William Steig, renewed 2000.

Page 26, left: Final illustration for *Spinky Sulks* (New York: Farrar, Straus and Giroux, 1988; "Then she covered him with a blanket and kissed him again"). Pen and ink and watercolor on paper, 11 x 10 in (27.9 x 25.4 cm). © 1988 William Steig.

Page 26, right: *A Dream of Chicken Soup.* Published in the *New Yorker*, June 28, 1982. Pen and ink and wash on paper, 9⅝ x 12½ in. (24.5 x 31.8 cm). © 1982 William Steig.

Page 27, top: *Getting the serum through.* From "Dreams of Glory" series, published in the *New Yorker*, March 15, 1952. Pen and ink and wash on paper, 9¼ x 11 in. (23.5 x 27.9 cm). Collection of Maggie Steig. © 1952 William Steig, renewed 1980.

Page 27, bottom: Final illustration for *Brave Irene* (New York: Farrar, Straus and Giroux, 1986; "She pounced and took hold, but the ill-tempered wind ripped the box open"). Pen and ink and watercolor on paper, 10⅞ x 19 in. (27.6 x 48.3 cm). © 1986 William Steig.

Page 28, left: Untitled drawing (kissing couple in bottles), c. 1968. Pen and ink on paper, 7½ x 7¼ in. (19.1 x 18.4 cm). Collection of Maggie Steig.

Page 28, right: Final illustration for *The Zabajaba Jungle* (New York: Farrar, Straus and Giroux, 1987; "He finds a rock and smashes a hole in the bottle"). Pen and ink and watercolor on paper, 11 x 10 in. (27.9 x 25.4 cm). © 1987 William Steig.

Page 29: Final illustration for *Solomon the Rusty Nail* (New York: Farrar, Straus and Giroux, 1985; "It was almost too much for them when Solomon, as alive as possible, came bursting into the house"). Pen and ink and watercolor on paper, 12 x 9 in. (30.5 x 22.9 cm). Collection of Melinda Franceschini. © 1985 William Steig.

Page 30: Sketches and notes for *When Everybody Wore a Hat* (2003), undated. Pen and ink on paper, 9½ x 8⁵⁄₁₆ in. (24.1 x 21.1 cm).

Page 31, top: Final illustration for *Caleb & Kate* (New York: Farrar, Straus and Giroux, 1977; "During one of those crazy quarrels"). Pen and ink and watercolor on paper, 11⅛ x 17½ in. (28.3 x 44.5 cm). © 1977 William Steig, renewed 2005.

Page 31, bottom: Final illustration for *When Everybody Wore a Hat* (New York: HarperCollins, 2003; "Sometimes Mom and Pop quarreled"). Pen and ink and watercolor on paper, 10¾ x 8½ in. (27.3 x 21.6 cm). Originally published as a pen-and-ink-and-wash drawing in the *New Yorker*, September 26, 1959. © 2003 William Steig.

Page 32: *Pandora's Box.* Final illustration for *A Gift from Zeus: Sixteen Favorite Myths* (New York: HarperCollins, 2001). Pen and ink and watercolor on paper, 10⅞ x 9⅝ in. (27.6 x 24.5 cm). Originally published as a pen-and-ink-and-wash drawing in the *New Yorker*, November 14, 1964. Collection of Jeanne Steig. © 2001 William Steig

Page 34: Untitled drawing (still life with figures). Published in *Ruminations* (New York: Farrar, Straus and Giroux, 1984). Pen and ink on paper, 10⅛ x 10¾ in. (25.7 x 27.3 cm). © 1984 William Steig.

Page 36: "Are you carrying a cane tonight?" "No. I'm going to rough it." Drawing by Peter Arno (American, 1904–1968). Published in the

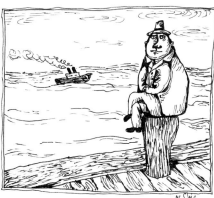

New Yorker, October 22, 1927. © The New Yorker Collection 1927 Peter Arno from cartoonbank.com. All rights reserved.

Page 37: *The Accident in the Street.* Published in the *New Yorker*, May 26, 1934. Pen and ink and wash on paper. © The New Yorker Collection 1934 William Steig from cartoonbank.com. All rights reserved.

Page 38, left: *Smoke.* From "Small Fry: Snow" series, published in *Dreams of Glory and Other Drawings* (New York: Knopf, 1953). Pen and ink and wash on paper, 10 x 10 in. (25.4 x 25.4 cm). Collection of Maggie Steig. © 1953 William Steig, renewed 1981.

Page 38, right: Untitled drawing (boy with gun behind woman on street). Published in *Collier's*, May 21, 1940. Pen and ink and wash on paper, 9⅝ x 10 in. (24.5 x 25.4 cm). Collection of Lucy Steig. © 1940 William Steig, renewed 1968, 1996.

Page 39: William Steig and his youngest brother, Arthur, c. 1930s. Collection of Maggie Steig.

Page 40: Cover of the *New Yorker*, July 17, 1943. Photograph copyright © 1943 Condé Nast Publications, Inc.

Page 41, left: Final illustration for cover of *The Lonely Ones* (New York: Duell, Sloan and Pearce, 1942). Pen and ink and collage on paper, 9 x 10⅛ in. (22.9 x 25.7 cm). Collection of Maggie Steig. © 1942 William Steig, renewed 1970, 1998.

Page 41, right: *Conformist.* Final drawing for *Persistent Faces* (New York: Duell, Sloan and Pearce, 1945). Pen and ink on paper, 9¾ x 8¼ in. (24.8 x 21 cm). © 1945 William Steig, renewed 1973, 2001.

Page 42, left: *New World Champion.* From "Dreams of Glory" series published in the *New Yorker*, April 8, 1950. Pen and ink and wash on paper, 10 x 11⅛ in (25.4 x 28.3 cm). © 1950 William Steig, renewed 1978, 2006.

Page 42, right: *In the nick of time.* From "Dreams of Glory" series, published in the *New Yorker*, May 26, 1951. Pen and ink and wash on paper, 10 x 12 in. (25.4 x 30.5 cm). © 1951 William Steig, renewed 1979, 2007.

Page 43, top: Final illustration for *Sylvester and the Magic Pebble* (New York: Simon and Schuster, 1969; "You can imagine the scene that followed"). Pen and ink and watercolor on paper. Photograph courtesy of the Eric Carle Museum of Picture Book Art, Amherst, Massachusetts. © 1969 William Steig, renewed 1997.

Page 43, bottom: *T-D-M.* Final illustration for *CDC?* (New York: Farrar, Straus and Giroux, 1984). Pen and ink and watercolor on paper, 10 x 13 in. (25.4 x 33 cm). © 1984 William Steig.

Page 44: Preliminary illustration for *The Bad Island*, 1969 (republished as *Rotten Island* [Boston: Godine, 1984]; "At night it froze: all living things stopped moving and turned to ice"). Pen and ink and watercolor on paper, 11⅛ x 9⅟₁₆ in. (28.3 x 23 cm). Collection of Lucy Steig. © 1969, 1984 William Steig, renewed 1997.

Page 46: Untitled doodles, 1972–76. Pen and ink on paper, each sheet 6 x 4 in. (15.2 x 10.2 cm). Collection of Maggie Steig.

Page 48, left: "Guess what I said to *her*," c. 1974. Pen and ink and wash on paper, 7¹⁵⁄₁₆ x 8⅜ in. (20.2 x 21.3 cm).

Page 48, right: Untitled drawing (farmer and three chickens), early 1980s. Pen and ink and watercolor on paper, 8½ x 10¾ in. (21.6 x 27.3 cm). Collection of Lucy Steig.

Page 49, left: William and Maggie Steig, Kent, Connecticut, August 1979. Photograph by Sarah Benham. Collection of Maggie Steig.

Page 49, right: Ring made by Maggie Steig for William Steig. Collection of Maggie Steig.

Page 50, left: Untitled drawing (interior with faces), undated. Pen and ink on paper, 10 x 13 in. (25.4 x 33 cm).

Page 50, right: "This is in the strictest confidence," undated. Pen and ink and wash on paper, 7⅞ x 11 in. (20 x 27.9 cm).

Page 51, top: *Accident.* From "Small Fry: Park Playground" series published in the *New Yorker*, April 18, 1953. Pen and ink and wash on paper, 9½ x 10 in. (24.1 x 25.4 cm). Collection of Maggie Steig. © 1953 William Steig, renewed 1981.

Page 51, bottom: Final illustration for *Dominic* (New York: Farrar, Straus and Giroux, 1972; "What a battle royal raged!"). Pen and ink on paper, 9½ x 14½ in. (24.1 x 36.8 cm). © 1972 William Steig, renewed 2000.

Page 52: *I N-V U.* Final illustration for *CDB!* (revised edition, New York: Aladdin, 2000). Pen and ink and watercolor on paper, 6¼ x 7⅞ in. (15.9 x 19.7 cm). Original pen-and-ink version

published in 1968. © 1968 William Steig, renewed 1996.

Page 54: Final illustration for *Gorky Rises* (New York: Farrar, Straus and Giroux, 1980; "As Gorky passed over Pruneville, they were craning their necks out of windows"). Pen and ink and watercolor on paper, 10 x 10⅛ in. (25.4 x 25.7 cm). © 1980 William Steig.

Page 56, left: *Ambition.* Published in the *New Yorker*, June 14, 1982. Pen and ink and wash on paper, 7¾ x 10¼ in. (19.7 x 26 cm). © 1982 William Steig.

Page 56, right: Untitled drawing (cat and dog on park bench). Similar version published in the *New Yorker*, May 21, 2001. Pen and ink and watercolor on paper, 7⅛ x 8⅝ in. (18.1 x 22 cm). © 2001 William Steig.

Page 57: Final cover illustration for the *New Yorker*, July 6, 1968 (dog sleeping on porch with American flag). Pen and ink and watercolor on paper, 13⅝ x 10¾ in. (34.6 x 27.3 cm). © 1968 William Steig, renewed 1996.

Page 58: Final cover illustration for the *New Yorker*, October 9, 1989 (Columbus on ship with crew). Pen and ink and watercolor on paper, 12¾ x 9¾ in. (32.4 x 24.8 cm). © 1989 William Steig.

Page 59: Cover of the *New Yorker*, December 27, 1969. Photograph copyright © 1969 Condé Nast Publications, Inc.

Page 60: William and Jeanne Steig, 1997. Photograph by Nancy Crampton. Copyright © Nancy Crampton.

Page 62: Cover of the *New Yorker*, November 30, 1998. Photograph copyright © 1998 Condé Nast Publications, Inc.

Page 63: Untitled drawing (woman in field of flowers with dog), undated. Pen and ink on paper, 9 x 12 in. (22.9 x 30.5 cm). Collection of Lucy Steig.

Page 64: Final cover illustration for *Abel's Island* (New York: Farrar, Straus and Giroux, 1976). Pen and ink and watercolor on paper, 7¼ x 6 in. (18.4 x 15.2 cm). Photograph courtesy of the Eric Carle Museum of Picture Book Art, Amherst, Massachusetts. © 1976 Willliam Steig, renewed 2004.

Page 66: Final illustration for "King Kang" in *Alpha Beta Chowder* (New York: HarperCollins, 1992; "Ken, the killer kangaroo . . . "). Pen and ink and watercolor on paper, 11⅝ x 16½ in. (29.5 x 41.9 cm). Collection of Jeanne Steig. Photograph courtesy of the Eric Carle Museum of Picture Book Art, Amherst, Massachusetts. © 1992 William Steig.

Page 68: Cover of the *New Yorker*, November 25, 2002. Photograph copyright © 2002 Condé Nast Publications, Inc.

Page 69: Untitled drawing, 1970s–1980s. Similar to drawing titled *Let's Get Married.* Pen and ink on paper, 10 x 10¾ in. (25.4 x 27.3 cm).

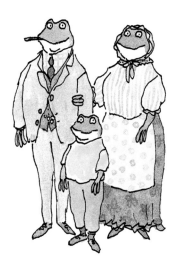

Page 71: *Throw out your politicians and diplomats.* Final drawing for *Listen, Little Man!* (New York: Farrar, Straus and Giroux, 1948). Pen and ink on paper, 7¼ x 8¾ in. (18.4 x 22.2 cm). Copyright © Wilhelm Reich Infant Trust.

Page 72, left: "You've told me that a million times!" c. 1963. Pen and ink and wash on paper, 8¾ x 11 in. (22.2 x 27.9 cm).

Page 72, right: "A good day for falling in love!" Delivered to *Look* magazine, May 8, 1957. Pen and ink and wash on paper, 10 x 9¼ in. (25.4 x 23.5 cm). © 1957 William Steig, renewed 1985.

Page 73: Untitled drawing (rooster photographer), undated. Pen and ink on paper, 9½ x 12½ in. (24.1 x 31.8 cm).

Page 74, top: William Steig with his parents, Laura and Joseph, and his brothers, Irwin, Arthur, and Henry, c. 1920. Collection of Maggie Steig.

Page 74, bottom: *That Old Gang of Mine (Circa 1915),* c. 1983. Pen and ink and watercolor on paper, 7¼ x 8¾ in. (18.4 x 22.2 cm).

Page 75: "But I don't feel like a king. I feel like a schmo," undated. Pen and ink and watercolor on paper, 8 x 9½ in. (20.3 x 24.1 cm).

Page 76: Preliminary illustration for *Roland the Minstrel Pig* (New York: Simon and Schuster, 1968). Pen and ink on paper, 10 x 8 in. (25.4 x 20.3 cm). © 1968 William Steig, renewed 1996.

Page 77, left: *One summer in the country, my father & mother disagreed about the apparent size of the moon,* undated. Pen and ink on paper, 9½ x 8¼ in. (24.1 x 21.0 cm).

Page 77, right: *Somehow the Self Always Turns Up.* Similar version published in *Strutters & Fretters: Or the Inescapable Self* (New York: HarperCollins, 1992). Pen and ink on paper, 7¼ x 7⅜ in. (18.4 x 18.7 cm). © 1992 William Steig.

Page 78: William Steig, Kent, Connecticut, 1973. Photograph by Nancy Crampton. Copyright © Nancy Crampton.

Page 79: Final illustration for title page of *The Amazing Bone* (New York: Farrar, Straus and Giroux, 1976). Pen and ink and watercolor on paper, 11⅟₁₆ x 10⅟₁₆ in. (28.1 x 25.6 cm). Collection of Maggie Steig. © 1976 William Steig, renewed 2004.

Page 81: Illustration for unpublished *New Yorker* cover (boy in woods), undated. Pen and ink and watercolor on paper, 12¼ x 8⁵⁄₁₆ in. (31.1 x 22.7 cm).

Page 82, top: *Wiseguy.* From "Small Fry: Snow" series, published in *Dreams of Glory and Other Drawings* (New York: Knopf, 1953). Pen and ink and wash on paper, 10 x 10 in. (25.4 x 25.4 cm). Collection of Maggie Steig. © 1953 William Steig, renewed 1981.

Page 82, bottom: *Zero Hour.* From "Small Fry: Snow" series, published in the *New Yorker,* March 7, 1953. Pen and ink and wash on paper, 6⅞ x 10 in. (17.5 x 25.4 cm). Collection of Lucy Steig. © 1953 William Steig, renewed 1981.

Page 83, top: *Ammunition Dump.* From "Small Fry: Snow" series, published in *Dreams of Glory and Other Drawings* (New York: Knopf, 1953). Pen and ink and wash on paper, 8 x 10 in. (20.3 x 25.4 cm). Collection of Lucy Steig. © 1953 William Steig, renewed 1981.

Page 83, bottom: Untitled drawing (two boys with snowballs and one boy with briefcase). From "Small Fry: Snow" series, published in *Dreams of Glory and Other Drawings,* 1953. Pen and ink and wash on paper, 10 x 10 in. (25.4 x 25.4 cm). Collection of Maggie Steig. © 1953 William Steig, renewed 1981.

Page 84, top: "How do you spell 'hate'?" 1960s. Pen and ink and wash on paper, 9 x 10 in. (22.9 x 25.4 cm).

Page 84, bottom left: "You are not the center of the universe!" Published in the *New Yorker,* March 14, 1964. Pen and ink and wash on paper, 9⅛ x 7¼ in. (23.2 x 18.4 cm). Collection of Maggie Steig. © 1964 William Steig, renewed 1992.

Page 84, bottom right: "What did I do?" Published in the *New Yorker,* June 30, 1962. Pen and ink and wash on paper, 9⅛ x 8 (23.2 x 20.3 cm). Collection of Maggie Steig. © 1962 William Steig, renewed 1990.

Page 85, top: Cover of the *New Yorker,* July 11, 1936. Photograph copyright © 1936 Condé Nast Publications, Inc.

Page 85, bottom left: *No-hitter going into the series finale.* From "World Series Fever" series, published in *Holiday,* October 1953. Pen and ink and wash on paper, 10 x 10 in. (25.4 x 25.4 cm). © 1953 William Steig, renewed 1981.

Page 85, bottom right: *Slugger.* From "Small Fry: Sandlot Baseball" series, published in the *New Yorker,* May 31, 1952. Pen and ink and wash on paper, 8½ x 10 in. (21.6 x 25.4 cm). Collection of Maggie Steig. © 1952 William Steig, renewed 1980.

Page 86, top: *Greatest Comedian of His Time.* From "Dreams of Glory" series, published in the *New Yorker,* April 28, 1951. Pen and ink and wash on paper, 10⅛ x 10¼ in. (25.7 x 26 cm). © 1951 William Steig, renewed 1979.

Page 86, bottom: *Thirty-eight days at sea.* From "Dreams of Glory" series, published in the *New Yorker,* October 28, 1950. Pen and ink and wash on paper, 10⅛ x 11¼ in. (25.7 x 28.6 cm). © 1950 William Steig, renewed 1978, 2006.

Page 87: *Rescue.* From "Dreams of Glory" series, published in the *New Yorker,* August 5, 1950. Pen and ink and wash on paper, 11¼ x 10 in. (28.6 x 25.4 cm). © 1950 William Steig, renewed 1978, 2006.

Page 88, top: Untitled drawing (bum saluting police officer). Received at *Collier's* magazine, January 20, 1956. Pen and ink and wash on paper, 9⅞ x 8½ in. (25.1 x 21.6 cm). © 1956 William Steig, renewed 1984.

Page 88, middle: "You might be glad to know that your money will not be squandered foolishly." Published in the *New Yorker,* May 15, 1954. Pen and ink and wash on paper, 8⅝ x 9¼ in. (22 x 23.5 cm). © 1954 William Steig, renewed 1982.

Page 88, bottom: "You're fired!" Published in the *New Yorker,* December 26, 1953. Pen and ink and wash on paper, 8½ x 9½ in. (21.6 x 24.1 cm). © 1953 William Steig, renewed 1981.

Page 89, top: "Well, what seems to be the trouble, Mr. Sims?" Published in the *New Yorker,* December 21, 1957. Pen and ink and wash on paper, 8¼ x 8¾ in. (21 x 22.2 cm). © 1957 William Steig, renewed 1985.

Page 89, bottom: "Well—I guess nothing can shock you . . . ," c. 1960s. Pen and ink and wash on paper, 7½ x 9⅞ in. (19.1 x 25.1 cm).

Page 90, top left: "You *know* I hate toinips!" 1940s–1950s. Pen and ink and wash on paper, 8¼ x 9⅛ in. (21 x 23.2 cm).

Page 90, top right: Untitled drawing (old couple with hearing aids), c. 1960s. Pen and ink and wash on paper, 7⅛ x 11 in. (18.1 x 27.9 cm).

Page 90, bottom left: "Was it something I said, or something I should have said?" Published in the *New Yorker,* September 15, 1962. Pen and ink and wash on paper, 10 x 7½ in. (25.4 x 19.1 cm). © 1962 William Steig, renewed 1990.

Page 90, bottom right: "Are we early?" Delivered to *Look* magazine, May 17, 1956. Pen and ink and wash on paper, 10 x 9¼ in. (25.4 x 23.5 cm). © 1956 William Steig, renewed 1984.

Page 91: *F.B.I. REPORTS JUVENILE CRIME ON INCREASE . . .* Published in the *New Yorker,* August 1, 1959. Pen and ink and wash on paper, 9⅛ x 12⅞ in. (23.2 x 32.7 cm). © 1959 William Steig, renewed 1987.

Page 92, top left: *Memory of an incident which probably did not occur.* Final drawing for *About People: A Book of Symbolic Drawings* (New York: Random House, 1939). Pen and ink and wash on paper, 7⅝ x 7½ in. (19.4 x 19.1 cm). © 1939 William Steig, renewed 1967, 1995.

Page 92, top right: *Pleasant chap—but never a friend.* Final drawing for *About People: A Book of Symbolic Drawings,* 1939. Pen and ink and wash on paper, 7⅜ x 5¾ in. (18.7 x 14.6 cm). © 1939 William Steig, renewed 1967, 1995.

Page 92, middle: *Loss of a memory.* Final drawing for *About People: A Book of Symbolic Drawings,* 1939. Pen and ink and wash on paper, 9¼ x 5⅛ in. (23.5 x 13 cm). © 1939 William Steig, renewed 1967, 1995.

Page 92, bottom left: *The coy one.* Final drawing for *About People: A Book of Symbolic Drawings,* 1939. Pen and ink and wash on paper, 7½ x 6⅛ in. (19.1 x 15.6 cm). © 1939 William Steig, renewed 1967, 1995.

Page 92, bottom right: *Melancholia.* Final drawing for *About People: A Book of Symbolic Drawings*, 1939. Pen and ink and wash on paper, 5½ x 6½ in. (14 x 16.5 cm). © 1939 William Steig, renewed 1967, 1995.

Page 93, top left: *I am at one with the universe.* Final drawing for *The Lonely Ones* (New York: Duell, Sloan and Pearce, 1942). Pen and ink on paper, 5½ x 5 in. (14 x 12.7 cm). © 1942 William Steig, renewed 1970, 1998.

Page 93, top right: *I want your love but don't deserve it.* Final drawing for *The Lonely Ones*, 1942. Pen and ink on paper, 5½ x 5 in. (14 x 12.7 cm). © 1942 William Steig, renewed 1970, 1998.

Page 93, bottom left: *Why pretend?* Final drawing for *The Lonely Ones*, 1942. Pen and ink on paper, 5½ x 5 in. (14 x 12.7 cm). © 1942 William Steig, renewed 1970, 1998.

Page 93, bottom right: *This is one thing they'll never take away from me.* Final drawing for *The Lonely Ones*, 1942. Pen and ink on paper, 5½ x 5 in. (14 x 12.7 cm). © 1942 William Steig, renewed 1970, 1998.

Page 94, top: *Cinderella.* Final drawing for *Persistent Faces* (New York: Duell, Sloan and Pearce, 1945). Pen and ink on paper, 9⅜ x 8¼ in. (23.9 x 21 cm). © 1945 William Steig, renewed 1973, 2001.

Page 94, middle: *Kibitzer.* Final drawing for *Persistent Faces*, 1945. Pen and ink on paper, 9⅜ x 8¼ in. (23.9 x 21 cm). © 1945 William Steig, renewed 1973, 2001.

Page 94, bottom: *Optimist.* Final drawing for *Persistent Faces*, 1945. Pen and ink on paper, 9⅜ x 8¼ in. (23.9 x 21 cm). © 1945 William Steig, renewed 1973, 2001.

Page 95, top: *Dog's best friend.* Final drawing for *Persistent Faces*, 1945. Pen and ink on paper, 9⅜ x 8¼ in. (23.9 x 21 cm). © 1945 William Steig, renewed 1973, 2001.

Page 95, middle: *Delilah.* Final drawing for *Persistent Faces*, 1945. Pen and ink on paper, 9⅜ x 8¼ in. (23.9 x 21 cm). © 1945 William Steig, renewed 1973, 2001.

Page 95, bottom: *Stone wall.* Final drawing for *Persistent Faces*, 1945. Pen and ink on paper, 9⅜ x 8¼ in. (23.9 x 21 cm). © 1945 William Steig, renewed 1973, 2001.

Page 96: *Some Kinesthetic Notes III.* Final drawing for *All Embarrassed* (New York: Duell, Sloan and Pearce, 1944). Pen and ink on paper, 11 x 9 in. (27.9 x 22.9 cm). © 1944 William Steig, renewed 1972, 2000.

Page 97: Untitled drawing (twelve faces in a grid). Final drawing for *All Embarrassed*, 1944. Pen and ink on paper, 11 x 9 in. (27.9 x 22.9 cm). © 1944 William Steig, renewed 1972, 2000.

Page 98, top: *From time to time you lift your head out of the muck and shout Hurrah!* Final drawing for Wilhelm Reich's *Listen, Little Man!* (New York: Farrar, Straus and Giroux, 1948). Pen and ink on paper, 6¹⁵⁄₁₆ x 6⅝ in. (17.6 x 16.8 cm). Copyright © Wilhelm Reich Infant Trust.

Page 98, middle: *Coney Island.* Final drawing for Wilhelm Reich's *Listen, Little Man!* 1948. Pen and ink on paper, 4¾ x 4½ in. (12.1 x 11.4 cm). Copyright © Wilhelm Reich Infant Trust.

Page 98, bottom: *Little big man.* Final drawing for Wilhelm Reich's *Listen, Little Man!* 1948. Pen and ink on paper, 10¾ x 7½ in. (27.3 x 19.1 cm). Copyright © Wilhelm Reich Infant Trust.

Page 99, left: *"Willie!"* Final drawing for *The Agony in the Kindergarten* (New York: Duell, Sloan and Pearce, 1950). Pen and ink on paper, 9¾ x 8⅛ in. (24.8 x 20.6 cm). © 1950 William Steig, renewed 1978, 2006.

Page 99, right: *God is watching.* Final drawing for *The Agony in the Kindergarten*, 1950. Pen and ink on paper, 9½ x 7¹⁵⁄₁₆ in. (24.1 x 20.2 cm). © 1950 William Steig, renewed 1978, 2006.

Page 100, left: *Are you sure you don't have to go?* Final drawing for *The Agony in the Kindergarten*, 1950. Pen and ink on paper, 11 x 8½ in. (27.9 x 21.6 cm). © 1950 William Steig, renewed 1978, 2006.

Page 100, right: *Are you sure you have to go?* Final drawing for *The Agony in the Kindergarten*, 1950. Pen and ink on paper, 9¾ x 8¾ in. (24.8 x 22.2 cm). © 1950 William Steig, renewed 1978, 2006.

Page 101, left: *He was always a quiet child.* Final drawing for *The Agony in the Kindergarten*, 1950. Pen and ink on paper, 9½ x 8½ (24.1 x 21.6 cm). © 1950 William Steig, renewed 1978, 2006.

Page 101, right: *Come into my room—I want to have a talk with you.* Final drawing for *The Agony in the Kindergarten*, 1950. Pen and ink and collage on paper, 10⅛ x 7¾ in. (25.7 x 19.7 cm). © 1950 William Steig, renewed 1978, 2006.

Page 102, left: *Mama—don't leave me!* Final drawing for *The Rejected Lovers* (New York: Dover, 1951). Pen and ink on paper, 11 x 8½ in. (27.9 x 21.6 cm). © 1951 William Steig, renewed 1979, 2007.

Page 102, right: *What a woman!* Final drawing for *The Rejected Lovers*, 1951. Pen and ink on paper, 9¹⁵⁄₁₆ x 7⁵⁄₁₆ in. (25.2 x 18.6 cm). © 1951 William Steig, renewed 1979, 2007.

Page 103, top: *We were so right together.* Final drawing for *The Rejected Lovers*, 1951. Pen and ink on paper, 11 x 8⅜ in. (27.9 x 21.3 cm). © 1951 William Steig, renewed 1979, 2007.

Page 103, bottom: *She was never loved the way I loved her.* Final drawing for *The Rejected Lovers*, 1951. Pen and ink on paper, 11 x 8½ (27.9 x 21.6 cm). © 1951 William Steig, renewed 1979, 2007.

Page 104, top: *Ideal Woman.* Final drawing for *Our Miserable Life* (New York: Farrar, Straus and Giroux, 1990). Pen and ink and wash on paper, 9⅞ x 10¹⁵⁄₁₆ in. (25.1 x 27.8 cm). © 1990 William Steig.

Page 104, bottom left: *Our marriage will be different.* Final drawing for *Till Death Do Us Part: Some Ballet Notes on Marriage* (New York: Duell, Sloan and Pearce, 1947). Pen and ink on paper, 9¾ x 6⅜ in. (24.8 x 16.2 cm). © 1947 William Steig, renewed 1975, 2003.

Page 104, bottom right: *News.* Published in the *New Yorker*, June 21, 1982. Pen and ink and watercolor on paper, 9⅜ x 13 in. (23.9 x 33 cm). Originally published as a pen-and-ink-and-wash drawing. © 1982 William Steig.

Page 105: Untitled drawing (couple locked in tiny house). Published in the *New Yorker*, August 7, 1971. Pen and ink on paper, 9 x 11¾ in. (22.9 x 29.9 cm). © 1971 William Steig, renewed 1999.

Page 106, left: Untitled drawing (two bottles with head stoppers, male and female), c. 1969. Pen and ink on paper, 7½ x 7½ in. (19.1 x 19.1 cm).

Page 106, right: Untitled drawing (sleeping couple tied into bed), c. 1960s. Pen and ink on paper, 8¼ x 11 in. (21 x 27.9 cm).

Page 107, top: *Déjeuner sur l'herbe.* Similar version published in the *New Yorker*, August 10, 1981. Pen and ink on paper, 9½ x 10⅜ in. (24.1 x 26.4 cm). © 1981 William Steig.

Page 107, bottom: Preliminary cover illustration for the *New Yorker* (husband and wife as Don Quixote and Sancho Panza). Final version published on April 29, 1991. Pen and ink on paper, 9⅜ x 10¼ in. (23.9 x 26 cm). © 1991 William Steig.

Page 108, top: *Showdown (at the Hot Dawn),* late 1970s or early 1980s. Pen and ink and watercolor on paper, 9¾ x 12¾ in. (24.8 x 32.4 cm). Collection of Maggie Steig.

Page 108, bottom: Untitled drawing (damsel protected from knight by monster). Similar version published in the *New Yorker*, October 31, 1970. Pen and ink and watercolor on paper, 10 x 13¾ in. (25.4 x 34.9 cm). © 1970 William Steig, renewed 1998.

Page 109, top: *I'm the one who's being reasonable!* Final drawing for *Sick of Each Other* (New York: HarperCollins, 2001). Pen and ink and

watercolor on paper, 7¾ x 9⅞ in. (19.7 x 25.1 cm). © 2001 William Steig.

Page 109, middle: *They'd believe me . . . people drown all the time.* Final drawing for *Sick of Each Other*, 2001. Pen and ink and watercolor on paper, 7⅝ x 8¼ in. (19.4 x 21 cm). © 2001 William Steig.

Page 109, bottom: "Relent!" Final drawing for *Sick of Each Other*, 2001. Pen and ink and watercolor on paper, 9⅜ x 12½ in. (23.9 x 31.8 cm). Originally published as a pen-and-ink drawing in the *New Yorker*, November 22, 1982. © 2001 William Steig.

Page 110, top: *Tree That Has Witnessed Historical Events.* Published in the *New Yorker*, October 31, 1977. Pen and ink on paper, 10 x 10⅜ (25.4 x 26.4 cm). © 1977 William Steig, renewed 2005.

Page 110, bottom: Untitled drawing (man with cane jumping rope), undated. Pen and ink on paper, 7½ x 11 in. (19.1 x 27.9 cm).

Page 111, top: "She's a distant relative," undated. Pen and ink and wash on paper, 9⅝ x 11�5⁄16 in. (24.5 x 28.7 cm).

Page 111, bottom: Untitled drawing (man reading newspaper on park bench), 1993. Pen and ink and watercolor on paper. 8¾ x 11 in. (22.2 x 27.9 cm). Collection of Maggie Steig. © 1993 William Steig.

Page 112, top: "Let me show you the ropes." Published in the *New Yorker*, September 10, 1990. Pen and ink on paper, 7⅞ x 10 in. (20 x 25.4 cm). © 1990 William Steig.

Page 112, bottom: *The Long Story*, 1980s. Pen and ink on paper, 9½ x 12½ in. (24.1 x 31.8 cm). Collection of Maggie Steig.

Page 113: Final cover illustration for the *New Yorker*, August 14, 2000 (man with fly swatter). Pen and ink and watercolor on paper, 12⅛ x 9⅞ in. (30.8 x 25.1 cm). © 2000 William Steig.

Page 114, left: *Paleolithic Venuses.* Similar version published in *Drawings* (New York: Farrar, Straus and Giroux, 1979). Pen and ink on paper, 9½ x 12½ in. (24.1 x 31.8 cm). Collection of Lucy Steig. © 1979 William Steig, renewed 2007.

Page 114, right: *Grace Smith, Grace Brown, and Grace Jones*, undated. Pen and ink and watercolor on paper, 9¾ x 11¼ in. (24.8 x 28.6 cm).

Page 115, left: *The Three Fates.* Similar version published in the *New Yorker*, April 13, 1981. Pen and ink on paper, 10 x 10¾ in. (25.4 x 27.3 cm). Collection of Maggie Steig. © 1981 William Steig.

Page 115, right: Preliminary cover illustration for the *New Yorker* (naked woman running into room). Final version published on May 24, 1993. Pen and ink and watercolor on paper, 13¹³⁄16 x 9½ in. (35.1 x 24.1 cm). © 1993 William Steig.

Page 116, top: Untitled drawing (stick figures walking on sidewalk drawings), undated. Pen

and ink and colored pencil on paper, 7 x 11½ in. (17.8 x 29.2 cm).

Page 116, bottom: Untitled drawing (three people with clown noses walking dogs), undated. Pen and ink and watercolor on paper, 6½ x 10 in. (16.5 x 25.4 cm). Collection of Lucy Steig.

Page 117, left: Preliminary drawing for *Movers and Shakers*. Final version published in the *New Yorker*, April 22, 1996. Pen and ink, watercolor, and colored pencil on paper, 11¼ x 8¼ in. (28.6 x 21 cm). Originally conceived as *New Yorker* cover. © 1996 William Steig.

Page 117, right: *Saucissons Alfresco.* From "Dining Out" series, published in the *New Yorker*, January 18, 1999. Pen and ink and watercolor on paper, 9¼ x 10¾ in. (23.5 x 27.3 cm). © 1999 William Steig.

Page 118, top: Untitled drawing (cat and mouse under crescent moon). Similar version published in *Drawings* (New York: Farrar, Straus and Giroux, 1979). Pen and ink on paper, 9¾ x 12¾ in. (24.8 x 32.4 cm). Collection of Lucy Steig. © 1979 William Steig, renewed 2007.

Page 118, middle: Untitled drawing (sleeping lion in pink pajamas), 1970s. Pen and ink and colored pencil on paper, 9 x 12 in. (22.9 x 30.5 cm).

Page 118, bottom: *Life Is Passing Him By.* From "Man and Beast" series, published in the *New Yorker*, May 2, 1994. Pen and ink and watercolor on paper, 8¼ x 10¾ in. (21 x 27.3 cm). © 1994 William Steig.

Page 119, top: *Hunting Accident.* From "Man and Beast" series, published in the *New Yorker*, May 2, 1994. Pen and ink and watercolor on paper, 8 x 11¼ in. (20.3 x 28.6 cm). Collection of Lucy Steig. © 1994 William Steig.

Page 119, middle: Untitled drawing (doctor at bedside of rooster patient), undated. Pen and ink and paper, 8½ x 10 in. (21.6 x 25.4 cm). Collection of Lucy Steig.

Page 119, bottom: *Old Clown.* Published in the *New Yorker*, July 7, 1986. Cover illustration for *Our Miserable Life* (New York: Farrar, Straus and Giroux, 1990). Pen and ink on paper, 8½ x 9¾ in. (21.6 x 24.8 cm). Collection of Lucy Steig. © 1986 William Steig.

Page 120, left: *The Catses.* c. 1980s. Pen and ink on paper, 7¾ x 9½ in. (19.7 x 24.1 cm).

Page 120, right: *Men with Balls*, undated. Pen and ink and watercolor on paper, 10 x 13 in. (25.4 x 33 cm).

Page 121, left: Untitled drawing (man contemplating bust of himself). Published in the *New Yorker*, October 7, 1985. Pen and ink on paper, 9¼ x 12½ in. (23.5 x 31.8 cm). © 1985 William Steig.

Page 121, right: *A Fork in the Road.* Published in the *New Yorker*, February 10, 1992. Pen and ink and wash on paper, 7⅞ x 10⅛ in. (20 x 25.7 cm). © 1992 William Steig.

Page 122, top: *Who Are We? Why Are We Here?* undated. Pen and ink on paper, 9½ x 12½ in. (24.1 x 31.8 cm).

Page 122, middle: Untitled drawing (man sitting on ground surrounded by possessions). Published in the *New Yorker*, February 27, 1971. Pen and ink on paper, 9 x 12 in. (22.9 x 30.5 cm). Collection of Maggie Steig. © 1971 William Steig, renewed 1999.

Page 122, bottom: Untitled drawing (interior with family), undated. Pen and ink on paper, 10 x 10½ in. (25.4 x 26.7 cm). Collection of Lucy Steig.

Page 123, top: *The People in One's Life*, undated. Pen and ink on paper, 9½ x 11½ in. (24.1 x 29.2 cm).

Page 123, bottom: *Family Structure*, c. 1980s. Pen and ink and watercolor on paper, 9½ x 11½ in. (24.1 x 29.2 cm). Collection of Maggie Steig.

Page 124: *Self-Effacing Self.* Similar version published as a pen-and-ink drawing in *Strutters & Fretters: Or the Inescapable Self* (New York: HarperCollins, 1992). Pen and ink and watercolor on paper, 8�5⁄16 x 6⅜ in. (21.1 x 16.2 cm). © 1992 William Steig.

Page 125, top left: *The Ever-Chattering Mind*, c. 1980s. Pen and ink and colored pencil on paper, 8 x 10 in. (20.3 x 25.4 cm).

Page 125, top right: *A Self in Love.* Similar version published in the *New Yorker*, March 9, 1992. Pen and ink and watercolor on paper, 7¼ x 7½ in. (18.4 x 19.1 cm). © 1992 William Steig.

Page 125, bottom left: *Man in a Deep Depression.* Published in the *New Yorker*, June 8, 1992. Pen and ink and wash on paper, 10¹⁄16 x 11 in. (25.6 x 27.9 cm). © 1992 William Steig.

Page 125, bottom right: *One Has But a Moment on Life's Stage.* Published in *Strutters & Fretters: Or The Inescapable Self* (New York: HarperCollins, 1992). Pen and ink and wash on paper, 6¼ x 6¼ in. (15.9 x 15.9 cm). © 1992 William Steig.

Page 126, left: Untitled drawing (man reaching for crescent moon). Similar version published in the *New Yorker*, April 1, 1974. Pen and ink on paper, 7½ x 10 in. (19.1 x 25.4 cm). © 1974 William Steig, renewed 2002.

Page 126, right: Untitled drawing (faces in windows), undated. Pen and ink and watercolor on paper, 7½ x 9⅝ in. (19.1 x 24.5 cm).

Page 127, top: *Aviary,* c. 1980s. Pen and ink and wash on paper, 9⅞ x 13 in. (25.1 x 33 cm).

Page 127, middle: *Fellow Inmates,* undated. Pen and ink and watercolor on paper, 8 x 10 in. (20.3 x 25.4 cm).

Page 127, bottom: *Division of Property,* undated. Pen and ink and watercolor on paper, 8 x 11 in. (20.3 x 27.9 cm).

Page 128, top: *Old Trysting Place.* Published in the *New Yorker,* July 24, 1978. Pen and ink on paper, 10 x 13 in. (25.4 x 33 cm). Collection of Lucy Steig. © 1978 William Steig, renewed 2006.

Page 128, bottom: Untitled drawing (family in rowboat), 1980s–1990s. Pen and ink and watercolor on paper, 9⅞ x 10⅞ in. (25.1 x 27.6 cm).

Page 129, top: *A Haven in the City.* Similar version published in the *New Yorker,* September 18, 1974. Pen and ink and pencil on paper, 8⅛ x 10 in. (20.6 x 25.4 cm). Collection of Maggie Steig. © 1974 William Steig, renewed 2002.

Page 129, bottom: Untitled drawing (family and dog in landscape), 1980s–1990s. Pen and ink and colored pencil on paper, 9¾ x 10⅞ in. (24.8 x 27.6 cm).

Page 130: Preliminary cover illustration for the *New Yorker* (farm scene with weather vane). Final version published on May 8, 1965. Pen and ink and watercolor, 14⅞ x 11 in. (37.8 x 27.9 cm). © 1965 William Steig, renewed 1993.

Page 131: Illustration for unpublished *New Yorker* cover (three farmers in landscape), 1980s. Pen and ink, watercolor, and colored pencil on paper, 11¼ x 8¼ in. (28.6 x 21 cm).

Page 132, top: *Animal, Vegetable, Mineral.* Similar version published in the *New Yorker,* June 9, 1980. Pen and ink on paper, 10½ x 13½ in. (26.7 x 34.3 cm). © 1980 William Steig.

Page 132, bottom: *Mother Earth (Hugging Ground),* undated. Pen and ink on paper, 10⅛ x 11⅛ in. (25.7 x 28.3 cm). Collection of Maggie Steig.

Page 133: *Chicken Fanciers.* Similar version published in the *New Yorker,* February 16, 1981.

Pen and ink on paper, 10 x 13 in. (25.4 x 33 cm). © 1981 William Steig.

Page 134: Untitled drawing (woman sitting on porch), undated. Pen and ink and watercolor on paper, 9 x 10⅛ in. (22.9 x 25.7 cm).

Page 135: *Ruminating.* Published in the *New Yorker,* October 24, 1983. Pen and ink and watercolor on paper, 9¼ x 12½ in. (23.5 x 31.8 cm). © 1983 William Steig.

Page 136, top: *Poet, Painter, and Musician by the Sea,* undated. Pen and ink and watercolor on paper, 9½ x 10½ in. (24.1 x 26.7 cm).

Page 136, middle: *The Sculptor and His Marble.* Published in the *New Yorker,* September 11, 1978. Pen and ink and watercolor on paper, 8 x 10 in. (20.3 x 25.4 cm). © 1978 William Steig, renewed 2006.

Page 136, bottom: Untitled drawing (dog painting a bone). Similar version published in the *New Yorker,* December 26, 1988. Pen and ink and watercolor on paper, 8 x 11¼ in. (20.3 x 28.6 cm). © 1988 William Steig.

Page 137, top: *Impressionist Receiving Impressions.* Published in the *New Yorker,* October 25, 1982. Pen and ink on paper, 9⅜ x 12 in. (23.9 x 30.5 cm). © 1982 William Steig.

Page 137, bottom: *The Russian Blouse,* undated. Pen and ink and colored pencil on paper, 7¾ x 10⅞ in. (19.7 x 27.6 cm).

Page 138, top: *Concert,* undated. Pen and ink on paper, 9 x 12 in. (22.9 x 30.5 cm). Collection of Lucy Steig.

Page 138, bottom: Untitled drawing (dog playing violin for man in armchair), undated. Pen and ink and watercolor on paper, 6½ x 10 in. (16.5 x 25.4 cm).

Page 139: Illustration for unpublished *New Yorker* cover (flutist and dragon), late 1970s. Pen and ink and watercolor on paper, 13⅞ x 10 1/16 in. (35.2 x 25.6 cm). *New Yorker* cover with flutist in flowered shirt published April 16, 1979.

Page 140, left: Untitled drawing (turkey with fortune teller). Published in the *New Yorker,* November 30, 1992. Pen and ink and watercolor on paper, 13⅛ x 9½ in. (33.3 x 24.1 cm). Originally conceived as *New Yorker* cover. © 1992 William Steig.

Page 140, right: Preliminary cover illustration for the *New Yorker* (football players). Final version published on September 23, 1985. Pen and ink and watercolor on paper, 12 x 9 in. (30.5 x 22.9 cm). © 1985 William Steig.

Page 141, left: Final cover illustration for the *New Yorker,* December 24, 1979 (angels dropping candy canes). Pen and ink and watercolor on paper, 14¼ x 10¼ in. (36.2 x 26 cm). © 1979 William Steig, renewed 2007.

Page 141, right: Illustration for unpublished *New Yorker* cover (woman driving sleigh with pres-

ents), undated. Pen and ink and watercolor on colored paper, 13⅞ x 9¾ in. (35.2 x 24.8 cm).

Page 142: *R U C-P? S, I M. I M 2.* Final illustration for *CDB!* (revised edition, New York: Aladdin, 2000). Pen and ink and watercolor on paper, 8⅞ x 7 in. (22.5 x 17.8 cm). Original pen-and-ink drawing published in 1968. © 1968 William Steig, revised 1996.

Page 143: Preliminary illustration for *Roland the Minstrel Pig* (New York: Simon and Schuster, 1968; "At night, before saying his prayers and going to sleep, he sang this sad song"). Pen and ink and watercolor on paper, 11 x 8¼ in. (27.9 x 21 cm). Collection of Lucy Steig. © 1968 William Steig, renewed 1996.

Pages 144–45: Preliminary illustration for *The Bad Island,* 1969 (republished as *Rotten Island* [Boston: Godine, 1984]; "This rotten, horrible island was set in a boiling sea seething with serpents"). Pen and ink and watercolor on paper, 12 x 17¾ in. (30.5 x 45.1 cm). Collection of Lucy Steig. © 1969, 1984 William Steig, renewed 1997.

Page 146, top: Final illustration for *Sylvester and the Magic Pebble* (New York: Simon and Schuster, 1969; "Sylvester Duncan lived with his mother and father at Acorn Road in Oatsdale"). Pen and ink and watercolor on paper. Photograph courtesy of the Eric Carle Museum of Picture Book Art, Amherst, Massachusetts. © 1969 William Steig, renewed 1997.

Page 146, bottom: Final illustration for *Sylvester and the Magic Pebble,* 1969 ("On a rainy Saturday during vacation he found a quite extraordinary one"). Pen and ink and watercolor on paper. Photograph courtesy of the Eric Carle Museum of Picture Book Art, Amherst, Massachusetts. © 1969 William Steig, renewed 1997.

Page 147: Preliminary illustration for *Sylvester and the Magic Pebble,* 1969 ("'Oh, how I wish he were here with us on this lovely May day,' said Mrs. Duncan"). Pen and ink and watercolor on paper, 10¾ x 8 in. (27.3 x 20.3 cm). Collection of Lucy Steig. © 1969 William Steig, renewed 1997.

Page 148, top: Preliminary sketches for *Amos & Boris* (New York: Farrar, Straus and Giroux, 1971). Pen and ink and watercolor on paper, 11⅛ x 14⅞ in. (28.3 x 37.8 cm). © 1971 William Steig, renewed 1999.

Page 148, bottom: *Amos builds his boat in spite of discouragement from his friends.* Preliminary illustration for *Amos & Boris,* 1971. Pen and ink and watercolor on paper, 11⅛ x 14⅞ in. (28.3 x 37.8 cm). © 1971 William Steig, renewed 1999.

Page 149, top: *Amos is seasick the first day out.* Preliminary illustration for *Amos & Boris,* 1971. Pen and ink and watercolor on paper, 11 x 14⅝ in. (27.9 x 37.2 cm). © 1971 William Steig, renewed 1999.

Page 149, bottom: *Amos's family tries to keep Boris moist.* Preliminary illustration for *Amos & Boris*, 1971. Pen and ink and watercolor on paper, 11⅛ x 14⅞ in. (28.3 x 37.8 cm). © 1971 William Steig, renewed 1999.

Page 150, top: Final illustration for *Dominic* (New York: Farrar, Straus and Giroux, 1972; "He saw a very old, very wrinkled pig, very unpink and unwell-looking, lying in bed"). Pen and ink on paper, 9⅜ x 12⅝ in. (23.9 x 32.1 cm). © 1972 William Steig, renewed 2000.

Page 150, bottom left: Final illustration for *Dominic*, 1972 ("Dominic woke in the morning, a blissful smile on his face"). Pen and ink on paper, 6¼ x 9½ in. (15.9 x 24.1 cm). © 1972 William Steig, renewed 2000.

Page 150, bottom right: Final illustration for *Dominic*, 1972 ("Sitting with the doll in the rosy light of the setting sun, he knew he would be pleased with his future"). Pen and ink on paper, 6¼ x 9½ in. (15.9 x 24.1 cm). © 1972 William Steig, renewed 2000.

Page 151: Final illustration for *Dominic*, 1972 ("High up on a hickory not far ahead of him, he was startled to see a goose hanging by the feet"). Pen and ink on paper, 10⅜ x 9⅜ in. (26.4 x 23.9 cm). © 1972 William Steig, renewed 2000.

Page 152: Final illustration for *The Amazing Bone* (New York: Farrar, Straus and Giroux, 1976; "Later she sat on the ground in the forest between school and home"). Pen and ink and watercolor on paper, 11 x 19½ in. (27.9 x 49.5 cm). Collection of Maggie Steig. © 1976 William Steig, renewed 2004.

Page 153, top: Final illustration for *The Amazing Bone*, 1976 ("The bone made the sounds of a trumpet calling soldiers to arms"). Pen and ink and watercolor on paper, 11⁵⁄₁₆ x 9¹³⁄₁₆ in. (28.1 x 24.9 cm). Collection of Maggie Steig. © 1976 William Steig, renewed 2004.

Page 153, bottom: Final illustration for *The Amazing Bone*, 1976 ("The wily fox was not as easily duped as the robbers"). Pen and ink and watercolor on paper, 6¼ x 10 in. (15.9 x 25.4 cm). Collection of Maggie Steig. © 1976 William Steig, renewed 2004.

Page 154, left: Final illustration for *Abel's Island* (New York: Farrar, Straus and Giroux, 1976) ("Drenched, cold, exhausted, he still held on to his nail"). Pen and ink and wash on paper, 11⅛ x 7½ in. (28.3 x 19.1 cm). Photograph courtesy of the Eric Carle Museum of Picture Book Art, Amherst, Massachusetts. © 1975 Willliam Steig, renewed 2003.

Page 154, right: Final illustration for *Abel's Island*, 1976 ("If the owl was offended at Abel's insults, it didn't show that it was"). Pen and ink and wash on paper, 11⅛ x 7½ in. (28.3 x 19.1 cm). Photograph courtesy of the Eric Carle Museum of Picture Book Art, Amherst, Massachusetts. © 1975 Willliam Steig, renewed 2003.

Page 155, top: Final illustration for *Solomon the Rusty Nail* (New York: Farrar, Straus and Giroux, 1985) ("Then that tricky rascal would turn up out of nowhere, looking smug and innocent"). Pen and ink and watercolor on paper, 12 x 9 in. (30.5 x 22.9 cm). Collection of Melinda Franceschini. © 1985 William Steig.

Page 155, bottom: Final illustration for *Solomon the Rusty Nail*, 1985 ("When things settled down, Solomon told them his story and finally revealed his secret"). Pen and ink and watercolor on paper, 12 x 9 in. (30.5 x 22.9 cm). Collection of Melinda Franceschini. © 1985 William Steig.

Page 156: Final illustration for *Gorky Rises* (New York: Farrar, Straus and Giroux, 1980; "That did it! The thick stuff sank to the bottom of the mixing glass and he had a reddish golden liquid"). Pen and ink and watercolor on paper, 10¼ x 11 in. (26 x 27.9 cm). © 1980 William Steig.

Page 157: Final illustration for *Gorky Rises*, 1980 ("It was early summer; everything was fresh and fair"). Pen and ink and watercolor on paper, 7⅞ x 10 in. (20 x 25.4 cm). © 1980 William Steig.

Pages 158–59: Final illustration for cover of *Gorky Rises*, 1980. Pen and ink and watercolor on paper, 13¼ x 19¾ in. (33.7 x 50.2 cm). © 1980 William Steig.

Pages 160–61: Final illustration for *Doctor De Soto* (New York: Farrar, Straus and Giroux, 1982; "For extra-large animals, he had a special room"). Pen and ink and watercolor on paper, 12 x 18 in. (30.5 x 45.7 cm). Collection of Melinda Franceschini. © 1982 William Steig.

Page 162, top: Final illustration for *Doctor De Soto*, 1982 ("'Please!' the fox wailed"). Pen and ink and watercolor on paper, 12 x 8⅞ in. (30.5 x 22.5 cm). Collection of Melinda Franceschini. © 1982 William Steig.

Page 162, bottom: Final illustration for *Doctor De Soto*, 1982 ("That night the De Sotos lay awake worrying"). Pen and ink and watercolor

on paper, 12 x 8⅞ in. (30.5 x 22.5 cm). Collection of Melinda Franceschini. © 1982 William Steig.

Page 163, top: *CDC?* Final cover illustration for *CDC?* (New York: Farrar, Straus and Giroux, 1984). Pen and ink and watercolor on paper, 10 x 13 in. (25.4 x 33 cm). © 1984 William Steig.

Page 163, bottom: *A 2-R F D 4-M.* Final illustration for *CDC?* (New York: Farrar, Straus and Giroux, 1984). Pen and ink and watercolor on paper, 10 x 13 in. (25.4 x 33 cm). © 1984 William Steig.

Page 164: Final illustration for *Brave Irene* (New York: Farrar, Straus and Giroux, 1986; "She laid the box down and climbed aboard"). Pen and ink and watercolor on paper, 7¼ x 11 in. (18.4 x 27.9 cm). © 1986 William Steig.

Page 165: Final illustration for *Brave Irene*, 1986 ("What a wonderful ball it was!"). Pen and ink and watercolor on paper, 11 x 18⁵⁄₁₆ in. (27.9 x 45.9 cm). © 1986 William Steig.

Page 166: Final illustration for *The Zabajaba Jungle* (New York: Farrar, Straus and Giroux, 1987; "One more whack and he breaks through"). Pen and ink and watercolor on paper, 11 x 19¾ in. (27.9 x 50.2 cm). © 1987 William Steig.

Page 167: Final illustration for *The Zabajaba Jungle*, 1987 ("Leonard takes some fireworks out of his knapsack and sets off an awesome display"). Pen and ink and watercolor on paper, 11⅛ x 19⅝ in. (28.3 x 49.9 cm). © 1987 William Steig.

Pages 168–69: Final illustration for *Shrek!* (New York: Farrar, Straus and Giroux, 1990; "He dreamed he was in a field of flowers where children frolicked and birds warbled"). Pen and ink and watercolor on paper, 11⅛ x 18⅛ in. (28.3 x 46 cm). © 1990 William Steig.

Page 169, top: Final illustration for *Shrek!* 1990 ("His mother was ugly and his father was ugly, but Shrek was uglier that the two of them put together"). Pen and ink and watercolor on paper, 11¼ x 10 in. (28.6 x 25.4 cm). © 1990 William Steig.

Page 169, bottom: Final illustration for *Shrek!* 1990 ("And sure enough, a little way into the woods, a whopper of a dragon barred his path"). Pen and ink and watercolor on paper, 11⅛ x 10¼ in. (28.3 x 26 cm). © 1990 William Steig.

Pages 170–71: Final illustration for *Shrek!* 1990 ("All around him were hundreds of hideous creatures"). Pen and ink and watercolor on paper, 11⅛ x 17¾ in. (28.3 x 45.1 cm). © 1990 William Steig.

Page 172: Final illustration for *When Everybody Wore a Hat* (New York: HarperCollins, 2003; "This was Mom's best friend"). Pen and ink and watercolor on paper, 6¾ x 7½ in. (17.2 x 19.1 cm). © 2003 William Steig.

Page 173, top: Final illustration for *When Everybody Wore a Hat*, 2003 ("We moved a lot.

The moving men were very strong"). Pen and ink and watercolor on paper, 9 x 8⅜ in. (22.9 x 21.3 cm). © 2003 William Steig.

Page 173, bottom: Final illustration for *When Everybody Wore a Hat*, 2003 ("I got my first haircut at Ditchick's Barbershop"). Pen and ink and watercolor on paper, 10½ x 11 in. (26.7 x 27.9 cm). © 2003 William Steig.

Page 175: Untitled drawing (the inescapable self). Similar version published in the *New Yorker*, January 28, 1991. Pen and ink and watercolor on paper, 7½ x 7¼ in. (19.1 x 18.4 cm). © 1991 William Steig.

Page 176: *Brothers.* Published in the *New Yorker*, September 20, 1982. Pen and ink and wash on paper, 9⅞ x 12½ in. (25.1 x 31.8 cm). © 1982 William Steig.

Page 179: Untitled drawing (teacher with students). Published in the *New Yorker*, January 24, 1977. Pen and ink on paper, 10 x 12¾ in. (25.4 x 32.4 cm). © 1977 William Steig, renewed 2005.

Page 181: "I'm Virgo. What are you?" 1980s–1990s. Pen and ink and wash on paper, 9⅞ x 10½ in. (25.1 x 26.7 cm).

Page 182: *Guilt.* Final drawing for *All Embarrassed* (New York: Duell, Sloan and Pearce, 1944). Pen and ink on paper, 11 x 9 in. (27.9 x 22.9 cm). © 1944 William Steig, renewed 1972, 2000.

Page 185: Preliminary illustration for *Roland the Minstrel Pig* (New York: Simon and Schuster, 1968; "Roland became world-renowned and wealthy enough to suit any pig's fancy"). Pen and ink and watercolor on paper, 11 x 8¼ in. (27.9 x 21 cm). Collection of Lucy Steig. © 1968 William Steig, renewed 1996.

Page 187: Untitled drawing (man seated on pier), 1970s–1980s. Pen and ink on paper, 8 x 10 in. (20.3 x 25.4 cm). Collection of Maggie Steig.

Page 188: Final illustration for title page of *Gorky Rises* (New York: Farrar, Straus and Giroux, 1980). Pen and ink and watercolor on

paper, 7¾ x 10 in. (19.7 x 25.4 cm). © 1980 William Steig.

Pages 190–91: Sketches for *Dominic* (New York: Farrar, Straus and Giroux, 1972). Pen and ink on paper, 9⅜ x 12½ in. (23.9 x 31.8 cm). © 1972 William Steig, renewed 2000.

Pages 192–93: Untitled drawing (seven figures in two rows) (details), 1980s. Pen and ink on paper, 7⅞ x 11 in. (20 x 27.9 cm). Collection of Maggie Steig.

Page 194: Final drawing for *Amos & Boris* (New York: Farrar, Straus and Giroux, 1971; "Amos came racing back with two of the biggest elephants he could find"). Pen and ink on paper, 9½ x 21¾ in. (24.1 x 55.3 cm). © 1971 William Steig, renewed 1999.

Page 196: Untitled drawing (crying chickens) (detail), undated. Pen and ink on paper, 8¼ x 11 in. (21 x 27.9 cm).

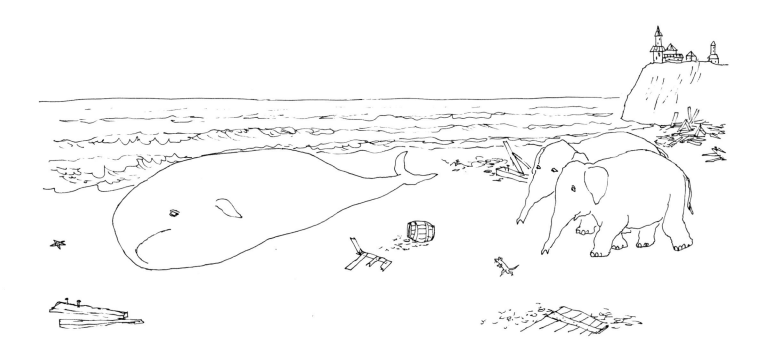

Index

The Jewish Museum
Board of Trustees

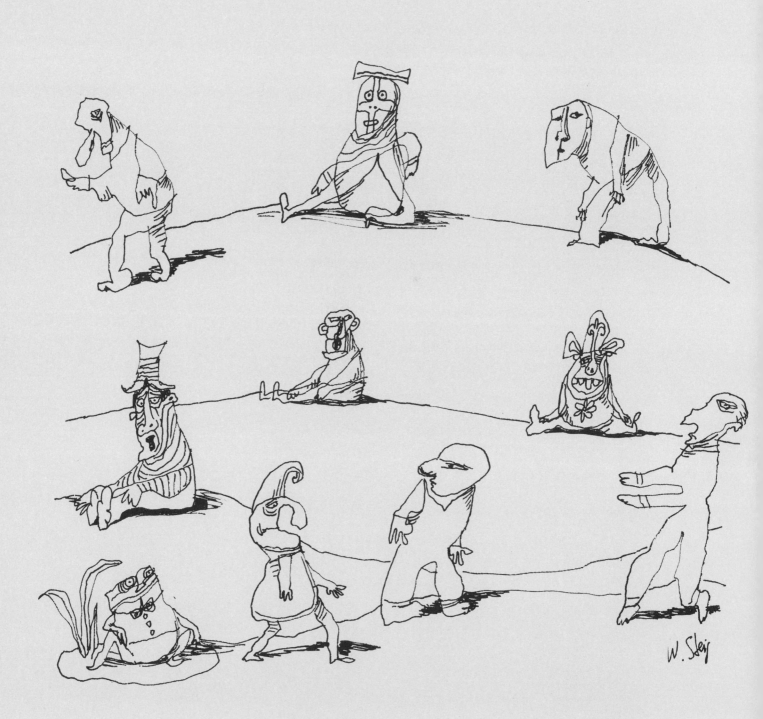